headpress23

edited by david kerekes

HEADPRESS 27

Published September 2007
by Headpress

Headpress
Suite 306, The Colourworks
2a Abbot Street
London, E8 3DP
United Kingdom

Email: office@headpress.com
Tel: 0845 330 1844

Editor/Centaur: David Kerekes
Layout/Design/Covers: Hannah Bennison
Service Engineer: Caleb Selah

A CIP catalogue record for this book is
available from the British Library and
Minton's the Chemist

SBN13 9781900486583
SBN10 1-900486-58-X
SSN 1353-9760

Join our online community at www.headpress.com

Contents

The Black Forest Editorial

by David Kerekes...

Files that we keep at HEADPRESS in no order
were being moved around the office when out of
a file fell an old envelope containing a book
proposal submitted years ago. It was a mid
April morning but already a furnace up on the
top floor of the Abbot Street office and a bee
had recently flown down the neck of my shirt.
 Similar to the manner in which I exited the
bee, the proposal was a jar to my memory.
 The proposal came from one Frank Blum, who

had introduced himself in an irregularly spaced
letter as a German actor from the seventies
with a fondness for German exploitation cinema
of that era. I had no reason to doubt him or
the 1970s publicity photograph that accompanied
the proposal, which one could assume was Frank
in his moody acting days. Frank Blum's idea was
to write a book on German exploitation cinema,
as told by one who lived it. But Frank's com-
mand of English was not good and he had no PC,
and the reality was that any manuscript would
be executed on a typewriter with bad type bars,
the same as his proposal and letters to me. I
considered the heavy editorial work necessary
to transcribe Frank's poorly written delibera-
tions on obscure Germanic comedy stars such as
Didi Hallervorden, whose films sounded all the

same and had soundtracks with songs like I Am
No Snick-Snack-Snuckelchen For You on them. A
"fun song," according to Frank, "a linguis-
tic crossover of the German word schnuckelchen
(appr. Sweetie) and snack."

But the proposal I liked, no less because in
it Frank compared Rolf Olsen to Russ Meyer.

Over the weeks we exchanged ideas and out-
lines until finally I wrote to ask Frank to
start writing his book and paid him a small
advance to do so.

Frank cashed the advance. I suspect he got
poorly and died shortly afterwards because that
was the last I heard from him.

Welcome to HEADPRESS 27, in which wonders can
always cease and Heaven is like a furnace with
a bee.

SONAR 2006

3 DAYS OF ADVANCED MUSIC IN BARCELONA # 1 EPIPHANY

by DAVID KEREKES

Sónar is a festival devoted to music and multi-media arts that is held each year in the city of Barcelona, Spain. Neither event nor city had I been to before, and while three days and two nights of "advanced" — predominantly electronic and dance — music with international DJs didn't exactly set my heart ablaze in anticipation, I sensed something more in the air. That said, we begin our adventure where I suspect it will end — not back in Stansted airport, shuffling forward towards the departures lounge, but with the phrase: "Well? What did I expect?"

WE START WITH OUR DEPARTURE…

Before getting so far as passport control, a police officer at Stansted airport pulls me over and checks my documents. Mr Caleb, my business associate, finds this humorous and is pulled out next. I am wondering whether we must look like potential hooligans given that the World Cup is underway and the both of us have shaved heads. A small notice on the wall warns football fans travelling to Germany to be respectful of the host nation's troubled history and that certain signs and gestures are deeply offensive and unlawful. Actually we look nothing at all like hooligans. Our little band of travellers falls outside such stereotyping remits — we don't fit the social DNA structure and are simply the people that must be watched.

Loaded with Valium and booze, Mr Caleb — or Caleb, or Cal — is behaving in the manner of a.

6

man slightly detached and comfortable in the knowledge that — beyond the Valium — the sundry pharmaceuticals in his holdall are legitimate for a change: pain killers, a high fibre orange drink, aqueous cream and diarrhoea relief tablets. In my own bag is a herbal concoction in ampoule form, purchased from one of Dalston's several Chinese alternative medicine emporia. Like so many other people that have taken the free non-English speaking consultation, it appears I have "fire" in me; which I believe once on the protracted road to recovery and the hole it burns in my pocket. In the airport I ponder on the legality of the medicine, momentarily struck by the awful notion that perhaps it contains a borderline extract of some indistinct origin, perfectly legal in China and Dalston, but dubious enough to result in a search when crossing international borders. Perhaps the ampoules contain a little too much of a regulated compound? I don't know; I don't profess to be an expert on drugs. At least Cal got (most of) his from Boots.

Reaching the Stansted security check my bag is searched. With its contents spilled across the table I notice that I don't have many clothes with me. *How did that happen?* A lot of socks but not much else. A vacuum cleaner scans my socks for evidence of explosives (so we are informed following a subtle but loaded question from Alex to the officer in charge). My bag is taken away and run through the x-ray machine a second time. No explosives and my ampoules appear clean.

We will come back to the idea of security and of being watched later in the story.

Surprisingly we make the flight — our group of Alex, Tara, Caleb and me. Everything is delayed anyway because of my socks (not really). I settle into my seat with a warm in-flight beer and put on my headphones for the Butthole Surfers.

"*The white man sold Quaaludes to the monkeys,*" sings Gibby.

Consulting the guidebook Cal and I plan the evening's entertainment, a selection of bars and clubs with names like Fonfone, Panams and Sincopa. I think of Sónar and satsumas and squeeze my toes; squeezing toes being good for you in a plane. An unsuccessful attempt is made to synchronise our landing with Os Mutantes singing Panis Et Circenses (Reprise), "*The music lighted with the heat of the sun.*" We hit Barcelona at night, the sun having gone down an hour ago, which is some consolation for the musical fuck up.

DEAD MAN

The Hotel Fira Palace in which we have a room booked — the largest rooms in the city and parking space for 235 large cars — is quite an extravagance for the likes of us, and something that Cal is particularly torn up about. Addressing the dichotomy of a working class lad made good, a lamentable state of affairs in his eyes, Cal's first words on arriving are: "I've never had this much money in my life before." The foyer of the Fira Palace is as big as a small train station (or a palace), with plenty of leather armchairs and large vases. On stepping through the slowly revolving doors into the air conditioned expanse of marble and gold leaf, some sense can be made of the curious attitude of the taxi driver that brought us here. Hailing a cab at Barcelona bus terminal, the driver appeared bewildered as to the location or even the existence of the hotel we wanted. Maybe it was our bad Spanish? "Hotel Fira Palace?" he responded to our request. "*Hotel Fira Palace?*" he repeated, stopping the cab to check the note the hooligans in the back had hastily scrawled in affirmation. "You have reservation?" he shrugged, before continuing the journey.

Tara and Alex are staying elsewhere in the city. They won't get much sleep in the apartment they have rented and the group with which they share it. The countdown to their eviction has started.

It is midnight when Cal and myself leave the hotel to savour the nightlife of La Rambla, the busy main street on and around which many of the bars and clubs are located. Decent music is in order but we suspect that the festival may have influenced the turntable policy of many a venue, and what is referred to in the guidebook as soul, funk, rock or "*successes 60s*" turns out to be electro, electro and more electro. In the Fonfone, which we find quite easily, men dance like they are in the 1970s, accompanied by women with shopping bags. Things are different on the continent. Not a moment too soon do we leave in search of some other place, my eyes starting to fix on the large video screen that plays film of jumpsuited disco dancers on a tight, repeating loop.

We buy beer from one of the guys selling cans of beer on street corners. Convincing Cal that a nightclub called Fellini's looks dreadful, we end up at City Hall, a venue whose marquee advertises "animal rock" every Wednesday night. In spite of the promise, once inside it's more

of the electro — but at least there is a pleasant adjoining outdoor bar area, where I am able to introduce the wealth sensitive Cal to schoolgirls in eyeliner as "the richest man I know."

A blur of characters pass through City Hall, all with a musical history, all excited by the prospect of Sónar, which starts at midday tomorrow. One individual that I think may be a girl but is a boy speaks to me at length of the innovative music he makes, but even through a haze of beer and spirits, long before I actually get around to checking out the MySpace address he hands me on a piece of paper, I resign myself to disappointment. His enthusiasm is infectious but there is no way his innovative sound will not be locked into a groove of someone else's making.

Cal has made the acquaintance of a stranger with a hat who scores some MDMA for him from a guy around the corner. The money that leaves Cal's hand is swift to disappear into the cipher of respectability afforded such nefarious exchanges: money for drinks, money that is owing, money that may not have even been there in the first place. A deal with strangers in a strange place doesn't bode particularly well, but Cal enters into it on the understanding that he has likely just been burned so that no outcome can prove a disappointment.

Back at the hotel, Cal tests the drug to his satisfaction; indeed he is beside himself with joy. It is pure crystal; he has never seen anything like it. Explaining the big deal, he chops the crystal into a fine power before snorting a line through a rolled bank note. I don't want to end up with that bank note, I think to myself, given my luck with security of late.

I try a small amount soaked in a wet balled tissue — this after a long detailed account of the effects of the drug from Cal, of how I would feel, of its ups and downs and of its duration. The rest of the drug Cal keeps for himself. It has gone six in the morning and I slide into bed, leaving my buddy happily arched over the bureau like a physicist studying the results of a successful test. I guess I sleep through the expected high and wake in time for the comedown, because the extreme mood lift, willingness to communicate, feelings of comfort and appreciation of techno all pass me by, leaving me in the midst of an unfolding nightmare with a hangover.

Having spent half the morning enlightening me on what to expect of my own trip, Cal had failed to say anything at all about his own condition following his compara-

tively colossal intake, and the fact in a few short hours he will take on the appearance of a corpse.

I dream of the day before, of the man getting on the train to Stansted airport with eyes like Rudolph Maté, the 1950s film director. On his seat he finds a copy of *Locomotive Consequence*, the train magazine that is free, and goes to no small length to find a rack so that he may replace it. Mine is an Action Man phone. It's a small, outdated black Motorola with facility to do nothing but make and receive calls and text messages. No picture messaging, no camera, no music, nothing fancy at all. In Poland it was next to useless (I had taken Mike to Auschwitz; the least I could do in return was accompany him to a drum and bass club). In Spain it will prove to be useless. Someone calls it an Action Man phone on account of its size. And then I awake abruptly.

Momentarily disorientated, I consider that I must also have dreamt I was in a hotel room in Spain with no one but Cal in my company. In which case, where am I now and who might this be on my bed, hugging me tight?

I open my eyes to the mid morning sun cutting through the curtains, but harsher still is the realisation that it is Cal who is pressed behind me, sweating down my ear and attempting to kiss the back of my head. The sweat pours off him in rivulets and the clothes he wears and the bed sheet that separates the two of us is drenched. He is mumbling and quite delirious. I say without menace that I am not his girlfriend, in the soft controlled manner one might address a somnambulist. Like a somnambulist, he gets up, detached from the reality that he inhabits, and crashes from one end of the room to the other, mumbling… constantly mumbling.

Bonding is all very good, but here we have an excess of it. Later, in defence of heterosexuality, Cal will say, "There was no funny business going on… *down there*."

What he says is gobbledygook, but tuning myself I can pick out several dialogues running concurrent and sometimes simultaneously. These are random but some familiar names provide an angle that not all is gibberish. This may be the way our brain works each and every minute of each and every day, filtering through what is necessary and what is not, but its physical manifestation is a terrifying thing to behold. I consider Cal must be overloading a half dozen circuits the way he is racing, and so I shake him. "Don't fall asleep!" I tell him. "Get up!" He momentarily slips into consciousness. "Hey, Dave," he says. "I feel great!"

And now he is babbling and flailing, unable to stand upright. He may be feeling great but his balance is all to cock, and everything in the room that isn't locked down gets tipped over by the big guy rolling through it. I believe that he has overdosed. I think that I am watching before me a man whose life is slipping away. I shake him. "Wake up! Drink some water!" He takes a heavy gulp from the glass I fill with water from the tap in the bathroom. Momentarily I consider the purity of Spanish tap water but weigh the importance of rehydration above the possibility of him getting a stomach bug. "Drink some more!"

"You don't understand what is happening to me," Cal says, perfectly lucid. He tells me that he is in a cognitive state and it is good. The body is rejecting the poison, which is natural and accounts for the heavy sweating. And then he is gone again, babbling, knocking things down, trying to sleep. The best thing I could do, I later discover, is let him sleep it off, but here I am keeping him awake. Like Regan in *The Exorcist*, I see Cal trapped within a body possessed by a demon spouting platitudes to confuse and deceive — such as "I feel great!" Or a Hollywood war movie in which the life of an affable GI slowly ebbs away, the clutches of a supporting player impotent in the battle torn final reel. I attempt to call G— in the UK and ask his advice but my Action Man phone won't make the call – in Spain my phone proves to be useless. I attempt the same call on the landline in our room but, head not on right, the international dialling code for the UK eludes me. I dismiss the idea of an ambulance when in a blinding flash I see the reason for my being here and the road that stretches out ahead — beyond this room, beyond this physical plane. This is a test for me to endure alone through to the bitter end. How I deal with it, and if Cal lives or if Cal dies, is another trial for my score in the great final exam, whatever that might be. Bela Lugosi as God commands from above, "Pull de strings! Pull de strings!"

I grab Cal, hug him tight and say into his ear: *"Don't you fuckin' die on me."*

Cal crashes into the bureau and everything on it spills over the floor. "Whoops," he says shakily, before deciding a good idea would be to go out for a walk. "Let's go into the sunshine," he says. There is folly in this suggestion: a man who can barely stand because he is so very clearly tripping off his tits wants to go out for a walk. Sweat still pouring, his jaw spasming every few mo-

ments, I try and take his mind off anything that would lead us to venture outside of this room and into a public place.

"Here, drink some more of this." I put the glass back into Cal's hand as he recounts to some unseen presence the fact that Rick and Dean are always arguing, to himself some intelligible thing about rooms, and to me with clarity the words: "Dave, every time I ask a question it would be good not to answer it with 'Would you like some water.'"

I consider that perhaps it would be good to go outside after all; to keep walking might help prevent death. Unable to co-ordinate his limbs properly, I change the shirt that Cal is wearing for another that only remains dry for an instant. I unwittingly put it on him back to front but don't notice, an oversight that Cal later thinks probably attracted undue attention.

Steering him out of the room and into the corridor towards the elevator, Cal asks whether I managed to tidy up behind us. The lamp and its fittings have been righted and the floor isn't quite such a wasteland, but the room remains one of destruction and ruin. Of course, "tidy up" means "discretion," and what remains of the powder is safely secreted away.

As we exit the foyer of the grand Fira Palace onto the streets of Barcelona, we have arms around one another, which I am hoping looks less like my vain attempt to physically support a space cadet and more like happy-go-lucky booze brothers out for a morning stroll. (A horrifying prospect on any other day.) In my heart of hearts I don't suspect we will get far. Sure enough, having travelled no more than eleven paces I apologise on Cal's behalf when he nearly walks over a woman's small dog. Not surprisingly the look on her face is one of abject horror, being confronted by man whose shirt is on back to front…

Cal wants to go somewhere "green" and soon we reach the sanctuary of a nearby park through which we are able to stroll in relative peace and quiet. Whenever any stranger steps into our rambling trajectory, I lead us in a different direction. Ultimately we end up near to a sandwich kiosk, where I figure strong coffees are in order. Sitting Cal down on a bench, I tell him not to move but to wait for me while I go to the kiosk. He nods in the affirmative — a little too enthusiastically; in the manner of a child promising to be good for ice cream — and is talking to himself as I leave. From the kiosk I hope that

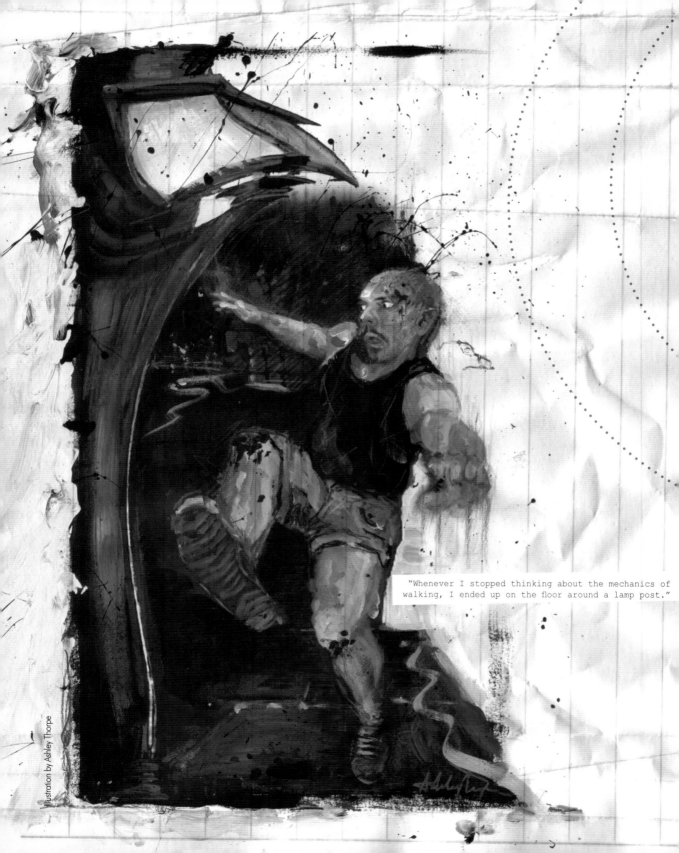

"Whenever I stopped thinking about the mechanics of walking, I ended up on the floor around a lamp post."

nobody will notice him.

The girl behind the counter is smiling as I order two large espressos. When her smile drops like the time lapse petals of a dying flower I turn to face the sight I know she is tracking: the slow, staggered approach of a strange looking man with his shirt on backwards. On arriving at the kiosk, Cal insists that the Turks are a very nice people and that he knows a lot of them, an attempt at charm that is companion to some uncontrolled chattering of teeth and profuse sweating. The girl is mortified by this travesty of small talk and by the weirdo engaged in its delivery. With paper cups in hand, I see sense in hastily retreating.

Shortly after this encounter I begin to suspect that we are being followed. The lone figure with rucksack and camera tails us as we make our convoluting way from one end of the park to the other. A plain-clothes police officer, perhaps? Maybe a lout patrol, something to do with the World Cup? When he disappears from view — snapping pictures of us probably — a second man replaces him, but with the same detached attitude, the same respectable distance, the same wayward glances.

I tell none of this to Cal for the moment, lest it freak him out in his cognitive state. Later, when I do tell him, he considers me to be suffering a paranoid delusion: mine are the observations of a man who spies a conspiracy, Cal says, and not a symptom of the MDMA. For the next couple of days, whenever we leave the hotel, the question is a mocking, "Are we being followed?"

Not having died, Cal will eat his words on Friday.

SUN BLOCK

We have no idea of how long it will take to reach Tara and Alex, who have an apartment near to the port and are presently waiting for us in the centre of town, but when they call we give them an arbitrary figure of two minutes. When they call again, it's ten, fifteen and twenty minutes — we really have no idea. Two hours later we arrive and go in search of sun block before we dare brave the Palau de la Virreina and its long, unsheltered queue for the Sónar ticket office.

The young men who wander Barcelona's city centre with cans of beer for sale, double their price for the captive market at the Palau de la Virreina and refuse to haggle. Our little group has grown in size following the acquaintance of the "Weymouth Crew," people I don't know but whose reputation precedes them; they look suitably chanceful and together — big and bald headed — we have no problem in jumping the queue. Cal, our spaced out Moses, leads us forward on the transparent pretext of examining inconsequential notices on the entrance to the building.

It is less than twenty four hours since we landed in Barcelona, but with festival tickets in hand the moment we sit down to regroup, the combination of anxiety, lack of sleep, the comedown and booze depletes what energy is left and leaves me with a bone dry tank. This manifests itself in sudden irritability and a pair of sunglasses that don't sit straight on my nose.

"Before we start this conversation," I announce, starting a conversation, "I don't want you to disagree with me."

"We are such cunts as a race," Cal retaliates.

The sunglasses I sort out without further ado; replenishing my energy levels on the other hand takes until three thirty in the afternoon, which is when we drag ourselves over to Sónar by Day at the CCCB (Centre of Contemporary Culture Barcelona) where awaits a refreshments tent and a staff whose rudimentary grasp of English meets my rudimentary Spanish half way. No matter what I think I order, I get the same token for beer. "Ejection, eight times my weight," I say, paraphrasing a lyric from Hawkwind's *Doremi Fasol Latido* album, making a gesture that I want two of them. Sure enough: a couple of beer tokens I get in return.

Cal is on the look out for people in dreadlocks with a red nose when I find him, a sweeping caricature of the drug dealer that makes me think of Comic Relief. We have six beers in plastic cups between us, one of which goes to a guy in return for a spliff for my incorrigible partner.

I am taken by the wealth of t-shirts on display: Defying the laws of probability, of the thousands of revellers in the auditorium there are no two shirts alike and almost all are branded with a unique slogan or a DJ whose name is meaningless to me. The exception is a fey looking man in plain white who dances to the Scissor Scissors, an impromptu festival appearance by a band not featured in the programme notes. There are some people wearing shirts adorned with rock and indie band names that I suspect may be an ironic statement for a festival of advanced music such as this. AC/DC, Sonic Youth and Motörhead catch my eye. From the merchandise hall Cal buys a replacement for his own top,

dishevelled and stained from the adventures of the last few hours. It has the word "SNUG" emblazoned across it, but curiously I discover later that I am completely wrong and instead it has only a simple graphic, representative of the famous saying about the one-eyed man being king in the kingdom of the blind.

We need to leave the festival when the red nosed people in dreadlocks are not forthcoming. Following a sign for an exit on the other side of complex, one that will take us to the Plaça dels Angels, near to where we came in, we make our way through the crowd. Wherever we go at Sónar — not that we go to much of it — we seem to arrive between performances, in time for an act just finished or one just about to start. Consequently we see no one but the Scissor Sisters in the whole three days and two nights. The sign for the exit takes us into the SónarDome area, where one act has just finished and another is setting up about to start. Some guy in a group to our right says to me as we pass, "Can I touch your beard?" I snap a flat no; Cal elaborates: "If you touch his beard I will kill you." This has an arresting effect on the guy and his group, particularly when we reach the exit, find it locked, and have to retrace our steps.

The Weymouth Crew are in a bar that takes a good while to reach for all our efforts once the call comes through. We leave Sónar by Day and drunkenly go in search of a landmark that we are informed is easy to find. Weaving a way down La Rambla against a tide of dizzy tourists, we are clueless as to where and exactly what we are looking for and consequently cut into the rendezvous time with diversions to such unlikely landmarks as a large street lamp.

Cal quips, "Are we still being followed?"

I throw a backward glance and reply, "Actually, I think we are."

"Shit, I think you're right!" he says of the couple walking several paces behind, looking suspiciously like tourists, with shoulder bag and camera in hand, but emanating the cold attitude of purpose in our direction. Spinning on our heels, Cal takes a snap of the couple on his phone, who stop and react with complete indifference — no fear, no panic, no anxiety, no curiosity given the sudden face-off — and simply cross the road and continue on their way.

Trying to coordinate his phone with his pocket, Cal manages to drop a bag of grass at his feet.

The monument when we find it — essentially a colourful orb on a stick, representative of Barcelona's eccentric Gaudi architecture — stands at the far end of the port. In its shade, some people I know from earlier in the day and some I don't are waiting. I understand that Stuart, another member of the Weymouth Crew, is a wild character and known to cause understandable consternation when he runs screaming, dreadlocks flowing, through public places, as he is occasionally wont to do. Together we retire to a bar where cash and more drugs are set to change hands. The place has the crumbling façade of respectability and an unmistakable air of trepidation about it; passersby are still drawn by the cool interior and a menu of light lunches but we are clearly not the only people here today for dodgy dealings. Watching the door are three English guys whose interest is piqued by the arrival of our group and my arrival in particular it seems: one of them makes a concerted effort to shake my hand and check me out, his strained eyes two pin pricks of barely contained psychosis. We converse about absolutely nothing of any relevance for several minutes, building a fragile allegiance that I consider is better than none at all given the circumstance, and one that will prove useful later in the day.

Outside the bar, around a table by the roadside, it may be a considerable wait for somebody else's man but the time passes quickly with the Weymouth Crew. When the English guy with the pinprick eyes asks to join us, the mood changes; no one knows quite what to make of the stranger but it's clear he has malice in mind when his attentions turn to Stuart. A situation that starts badly, with the stranger demanding to know why he cannot wear Stuart's sunglasses, degenerates to a point where a fight seems inevitable. There is racism in the visitor's remarks and attitude, ambiguous in delivery but clear in intent. Evident is the fact that he is playing a game at which he has had considerable practice, and he smiles wryly when an irate Stuart, about to kick off, has to be held in check by his friends. Whether he tires first of the game or of my continued distraction on matters that bare no relevance, I don't know, but when he does leave and everyone asks, *"Who was that?"* I inform the collective with a straight face that the stranger is Cal's best mate.

BITCHES BREW

Cal tells Alex that if we were to join the crew in going to a techno club I would probably wail like a baby. It's true,

a black cloud would cross my sky and I would feel very bad. We end up at the Real Club Danzatoria instead, a nightclub situated within the walls of a genuine castle that has a problem with the sound system when we arrive and, up until I leave, plays music at a fraction of the usual volume. There are no drawbridges in the club, which is a bigger disappointment to me.

Asked whether he likes the (quiet) music at the Real Club Danzatoria, Cal tells one woman that he'd rather be listening to *Bitches Brew* — a reference to Miles Davies that sinks like a stone and possibly comes across as a statement of intent, given the supercilious manner in which the woman backs away. A young bank clerk from Sheffield introduces himself and asks if we have any drugs. Drugs, a good conversation opener, is also a good conversation killer — if you have none, end of conversation. We have none, but Cal still engages the guy with his recent MDMA experience and the possibility of more to come, which keeps the guy sweet and soon he is introducing to us his girlfriends, who will "do anything for pills."

"Me love you long time," I say to one of the girls, but she doesn't get it. I'm not sure I do, either.

The Sheffield guy explains — for no reason that is immediately apparent — how he is confident enough in his own sexuality to wear a pink top and pink trainers.

It's not techno, but a black cloud descends anyway, and soon banal small talk with former students who once lived in Manchester and Sheffield guy revisiting his pink clothes and sexual identity drives me to distraction. Off I go through the onslaught of dancers with arms aloft and out the gate where a girl is shouting, "I've come all the way from Ireland and this is a disgrace… the music is not loud enough… this is a disgrace…"

I am looking for a bar, but at this time of the morning on Barcelona's dead streets I find only pastries filled with custard cream at an all-night petrol station.

A PORTAL

Sónar by Night takes place at L'Auditori on the outskirts of the city, a complex the size of a major aircraft hanger that is divided into SónarPark, SónarClub, SónarLab, SónarPub and numerous other areas. There are fairground dodgems in the middle of it all. Of the evening's entertainment, Giles Peterson and Nightmares on Wax promise to be worth a look, which gives the drunken Cal and me an incentive; something to aim for in the throbbing mass of bodies and hard beats. But shambling from one hall to another trying to locate the stage on which either artist is performing proves arduous. Through eyes clouded in booze and a lack of sleep, neither of us considers simply asking someone. Instead we inadvertently sit in one hall for a fraction of a performance by Linton Kwesi Johnson, and wait briefly in another because it has a sound system that Cal considers may belong to Nightmares on Wax. Nothing happens here; we tire and move on, starting the process over again with the first hall we tried upon arriving, until a text message from Alex directs us to the crew, apparently situated some thirty yards from the right hand speaker in a room where Nightmares on Wax are about to play…

I don't make it that far. With a steady stream of people coming through the doors and the place beginning to resemble more a festival of international repute than the void of an hour ago, it seems inevitable that we will lose track of each other. Moments before the crowd does finally get the better of us, running through our orbit and cutting us adrift, I say to Cal: "Remember, you can call me but I can't call you."

Drunken inertia hurls us helplessly and increasingly apart. It will be another twelve hours before we make contact again, and Cal will be covered in blood when we do.

Standing thirty yards from the first speaker I find but spotting no one that I recognise. I realise the futility of trying to find anything in my present state. A disembodied apology for some infraction that I miss catches my attention, as does another voice acknowledging something that I don't hear, with "*Oh, um, um, um, um…*" I continue to wander aimlessly until the weak smell of overcooked hotdogs from without L'Auditori gets the better of me: I leave behind Sónar by Night for a succession of fast food stalls and the first solids I have had all day.

It is some time in the early afternoon when I awake on my hotel room bed, fully clothed with a compound of red and yellow relish etched into the front of my t-shirt. Somehow I managed to convince the taxi driver of the night before that, yes indeed, it was the Hotel Fira Palace for me. It comes as no real surprise to discover Cal is nowhere in sight and his bed untouched.

I call his mobile number on the hotel line. Not expecting a reply, I get none. The line is dead.

Nothing more to do here, I take to the city.

Barcelona has a sizable South American community if my detour off La Rambla is anything to go by: pornography and music are a good anthropological measure, and the record shop I find has a large selection of Brazilian imports (but not much pornography). Moving further away from the tourist quarter, I hit a series of small, dilapidated side streets on which a procession of curious characters move in and out of doorways. One street in particular might well belong in *Locomotive Consequence* as a place to avoid, with each of its inhabitants suffering a physical defect of some description. Included in their number are buxom, thinly dressed prostitutes with bellies bigger than the biggest football, who openly ply their trade from the gutters. They make no attempt to communicate with me however and leach instead onto many a local man passing through. All the other men on the street appear to be pimps or husbands to the whores or both. The women hang back from these invariably short, skinny creatures with a hint of shiv, occasionally holding furtive dialogues with them in shaded areas.

I find it impossible to think that any person, no matter how great their need or level of intoxication, might be drawn to find solace in these arms. One woman, wearing a floral dress pushed awkwardly into the front of her underwear, hobbles by in a Ballardian display of sex, a deep, ugly wound crawling its way from the top of the filthy cast that covers most of her right leg.

Outside a cigarette kiosk I contemplate the lane ahead that creeps around a narrow bend and out of sight — a portal through which the misfits traverse this dimension and their own. Standing still serves to attract more attention my way; the wary streetwalkers and small men are closing in, so I move on.

At around six in the afternoon, my mobile rings. It is Cal calling from the hotel.

"Hey, Cal!" I say, happy that he is not dead. "It's me!"

"I know it's you, I'm calling you!" he says, which is correct. "Just letting you know I'm back and I'm ok. Man, I've had an adventure. I'll tell you about it later, but now I'm going to wash the blood off me."

I'm guessing it will take me an hour to find the hotel, but then it's taken Cal twelve so no rush.

The television is tuned to the porn channel when I walk

in and a dozing Cal lies on the bed with one hand down his trousers, stirring long enough to say "Hey" before blacking out and snoring again. I leave a note on the floor that says I am in the hotel bar.

In the hotel bar, where a waiter refers to me as "Ruskie" on account of the tattoo I wear on my arm, I drink coffee and beer as a football match plays on the flat screen TV that hisses. During the game, which is Italy vs. the USA, the excitable Spanish commentator hits fever pitch when not much at all is happening and repeats often the phrase, "Spaghetti western." A corporate party from the north of England turns up for an aperitif before their gala luncheon elsewhere in the building. The bar, which had one person in it when I arrived, is now full of overdressed men with underdressed women on their arm. "Stupid machine," says one woman who asks for help with the cigarette dispenser. I wonder what it is with the cigarette machine when the next person to use it quietly talks himself through the process. The gala occasion has a novelty in that human statues — those people that adopt a pose for protracted periods and loose change in public places — point the way to the dining hall when a bell sounds, a little hand bell. The place empties quickly and the dull conversation slipping out the door resonates to the waiter's machine gun fast attack on a fellow member of staff: "*Si?*" he says. "*Nonononononono!*"

Upstairs Cal lies asleep in the bath. "Italy vs. America," I inform him through the bathroom door, "one all." "That's not very good," he splutters. Twice I try to wake him and twice I succeed, but with eyes opening only long enough to fleetingly search the events of a different plane, I know it unlikely that he realises where he is, or that he will arise. "You're in the bath," I say to a grunt of an acknowledgement. "You can't sleep in the bath." The water turned cold four hours ago. From the bedroom with the TV on low I am able to monitor Cal's condition by the heavy snoring, amidst splutters. I know that so long as I hear this there is life in Cal. After an hour however, I can't stand it any more and retire to a bar. I imagine the phone call in which I have to announce that Cal has sadly passed away in the bath of a hotel room — like Jim Morrison, but in Barcelona not Paris.

CAL'S STORY

Spending the better part of the early morning on the top floor of the Fira, looking like a prune now that he's out of the bath and taking swigs from a bottle of red

HEADPRESS The gospel according to unpopular culture NEW in 2009

april
IT'S ALL GOOD // John Sinclair's tales of Detroit, MC5, White Panthers. Includes CD. "Free John Sinclair now!" John Lennon

may
TRASHFIEND // B-movies, trading cards, model kits, comicbooks & other disposable horror product from the era of trash.

BAD MAGS VOL 2 // More of the strangest, most unusual, and sleaziest periodicals ever published!

july
MEZZOGIORNO // Three generations of Southern Italian life set against peasant riots and the collapse of the Fascist Party.

september
SUN RA // Transcending time, space & place, the legacy of the musician from Saturn.

november
DARK STARS RISING // 26 interviews. Includes Divine, Teller, Tura Satana, Dennis Cooper, Alejandro Jodorowsky, and more.

All new. All illustrated. Exclusive books from

wine, Cal is attracting appalled attentions as he watches the sun rise over the city. He regales me with the story of what happened to him after we got separated at Sónar by Night. It's an experience he describes as an epiphany. For all the drama and fancy that a word like epiphany carries, there is a truth to it here: Cal will take home from this trip something he didn't have on arriving. "Falling down in Barcelona," he says might be an apt title for this piece I am writing.

I ended up with the cigarette butts of the Weymouth Crew, recalls Cal of his lost hours, and saw three seconds of Nightmares on Wax — which had been the whole point we went to Barcelona in the first place. The big guy, Sykesy, kept going off with money and buying drugs. I was meant to go back with Sykesy, but I'm fucking glad I didn't given the insect repellent situation. [Keep reading.] *We ended up in this room that was dark and had strobes. Stuart spilled all this shit down his shorts, so there's this funny scene of Stuart taking off his shorts and sucking on them with this other guy, much to the terror of onlookers.*

Just as it was getting daylight, around five in the morning, I realised the crew weren't there anymore and the place was shutting and there was no fucking chance of getting a taxi with thousands of people spilling out onto the street. So I started walking, swallowing the rest of what I had on me so I didn't get arrested or anything.

And that was the death march.

The first time I fell down was a bit odd because I was thinking about things other than walking and the next thing I know I'm on the floor. I didn't think that much of it — you're walking and you've fallen — but after it happened about ten times it started to get quite irksome because it started hurting my knees. I realised that whenever I stopped thinking about the mechanics of walking, of placing one foot in front of the other, whenever I stopped concentrating on doing that and started thinking about higher things, I ended up on the floor or spread around a lamp post.

By this time I must have looked a bit of mess in my shorts and t-shirt, blood coming out of my knees and shit. I realised I was in trouble when I wasn't able to turn corners; I wasn't getting the right angle thing at all and I ended up smashed into this wall. I lost my glasses at this point with a cut across my forehead — it wasn't a particularly big cut, more of a scratch, but I picked the bits and kept wiping the blood up my face, which stopped anyone

from helping me: there's this drunken English idiot that can't stand, covered in blood! I remember thinking this is getting out of hand when I fell down again and heard about five people go 'Owwww!'

Right, I know it's hot and shit but you've got to sit down.

I had no power on my phone, which was a fucker. I don't know if I had to cross a road to get to it but I remember focussing on this park to find a place to sit down, and this park bench looms towards me, and that's how I got this cut on my leg, smashing into the bench and falling face down.

OK, I made the bench. That's good.

I was sitting there, inspecting the damage, when this tramp — a Vivian Stanshall type, really ragged long red hair and beard, lots of teeth missing — starts screaming at me in Spanish. I was waving him away with my hand, so he went. This younger person turned up, looking a bit like Michael Elphick in Quadrophenia. Kind of normal hair, just a bit scruffy — and he sat down next to me, asking me if I'd been to Sónar. I said no, and he hooked his finger under my belt to pull me up and I said, "Yeah, so what?" and started talking to him in French, which I know a little of but in the state I was in wasn't getting very far. I kept saying, "Taxi. Get me a taxi." He gestured to get up, that I would get arrested if I stayed here, and helped me to stand up. I had my arm around his shoulder. We crossed this road, which was quite busy, and came to this huge metal door. I said, "Oh, fuck, what's going off here?" He pushed open the door and led me inside this completely derelict warehouse with no roof to it. Scattered around the place were shopping trolleys and lots of cardboard. He led me across all this debris to a corner that had an armchair and some cover, and plonked me down on it. I thought, "Yeah, whatever — what have I got on me? Phone, wallet?… Fine." He gave me a small beer, which I necked in one and then he gave me another. Well, what am I going to do here? I'm probably going to doze off and he'll go through my pockets; I'll wake up, be able to walk again — everything will be fine.

I must have dozed. The next thing I know I am in exactly the same place, no idea what time it is and I start going "Tempo tempo." They manage to get across that it's five o'clock in the afternoon. By this time you've got this old toothless Vivian Stanshall look-alike with his dog, the Michael Elphick look-alike, joined by this skinny edgy looking type and this woman. They are chatting and

laughing, and I'm beginning to get more French out by this point.

I subtly lean back and check my pockets — yeah, phone, wallet still there.

I start to get a bit worried about you, because of the night before, and you probably thinking, "What the fuck's going on?" I became quite insistent that yes, you've been very nice but I really must be getting off. They tried to mop this blood off my face but it was stinging. They impressed on me that it would be very difficult to try and get a taxi with a head covered in blood, and sure enough it was fuckin' impossible to try and get a taxi — I mean, we found it difficult ourselves at the best of times. We were standing outside their warehouse for probably about twenty minutes. I was getting very dehydrated, so we walked up this side road and went into this supermarket where I bought a two litre bottle of orange juice, which I drank in the checkout, and two bottles of wine. We walked up to the top of the road, where we continued to try to hail a taxi. We had these cigarettes and I remember these two very posh looking Barcelona girls walking towards us with a light, which we didn't have, and this guy turning round to them and asking "Could we have a light, please?" and these two girls sneering "No!" I felt a certain kinship with these guys at this point, which I'd been feeling all along, because they had looked after me.

Finally I managed to get a cab to stop, and I did that classic goodfellas thing of rolling a bank note into a square in the palm of my hand and, just as I was getting into the cab, shaking the guy's hand. The tramp — the Michael Elphick guy — is banging on the window as we are setting off, going "No! It's too much! Too much!"

THE ENVIRONMENT

I had left a card on my pillow that morning notifying the chambermaid not to bother replacing my bed sheets. The card, on each bedside table of each room, clipped my conscience with the bold statement "HELP US PRE-SERVE THE PLANET" and its display of facts pertaining to the huge quantities of water and detergent being used daily in hotels around the world. I left the card on my sheets and the sheets got changed anyway.

In my dream someone outside the door, pacing the hotel corridor up and down, is humming Tequila loudly and for a long time.

I am awakened not by Tequila but by the sound of my mobile phone ringing. The phone is in my trouser pocket, but I am unable to reach it before the caller hangs up — this because I have been sleeping awkwardly and both my arms are lifeless beneath me. Moments later, from elsewhere in the room, cutting into the sound of snoring, Cal's phone begins to ring. Something tells me this call might be important and so I roll out of bed, shaking my arms to life. It's early morning and my head for the last three days has been in a state of fuzz. The missed calls are from Alex, who I eventually reach on the hotel landline. At first I think there is no one on the other end.

Someone in the corridor is humming Tequila.

"Can we come to stay at your place?" says the weak, weary voice on the other end of the line, deliberating over each word as if the sentence has become the hardest thing in the world to form. "We've been kicked out of our place for smoking crack."

"We are checking out this morning," I apologise.

Silence.

Rarely have I spoken with anyone sounding quite so bad, so dissolute, so close to death. Barcelona has become a byword for potential death and the illusion of death, with me in the middle. I ask the redundant question: "You ok?"

"No, I feel terrible," comes the reply.

The events leading up to the eviction and of Alex's present condition could only have been meted out by minds in a considerably advanced state of narcotic twist: I find out later that on returning from Sónar by Night, Alex and other members of the Weymouth Crew had decided it would be good to continue the party on crack cocaine. Lacking any ammonia in the apartment with which to break the coke down, Alex or Jid or Sykesy hit on the idea of trying to extract ammonia from insect afterbite repellent, quantities of which they had found lying around. The words "insect" and "repellent" together carry an authoritative red light weight and would have sent a warning signal to any right thinking, sober individual. But few in the morning of Sónar by Night fit this criterion. Having managed to extract an impure substance (ammonia from insect repellent ammonia) in order to break down an impure substance (cocaine), and overheating the result on a gas stove for a spoon of brown muck that has to be chiselled off with a fork, the crew are blessed with an impromptu visit from the

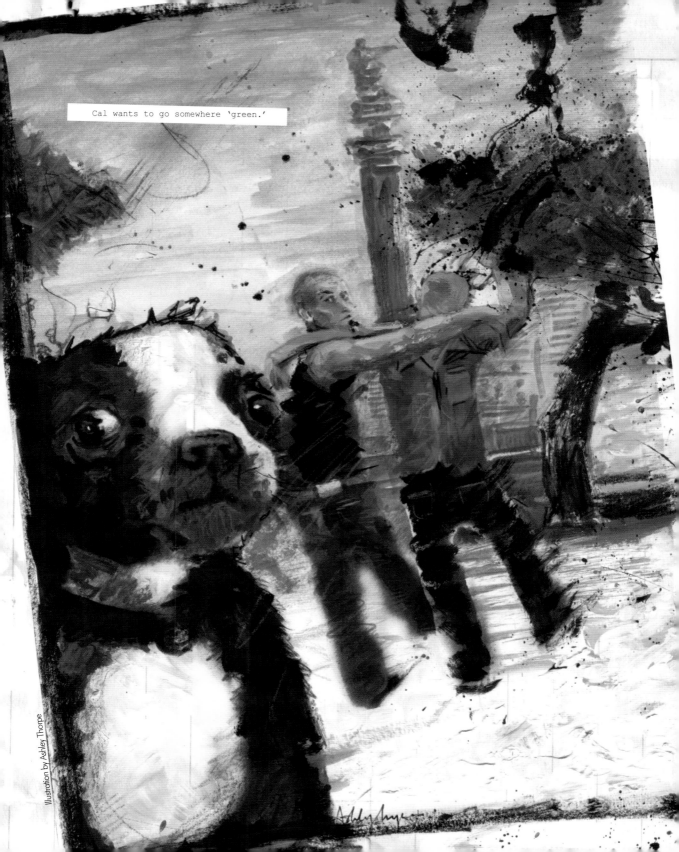

Cal wants to go somewhere 'green.'

Illustration by Ashley Thorpe

landlady. "It smells strong," Alex remarks in the mobile phone video he has recorded for his children's children, while Jid draws on a punctured beer can that acts as a makeshift bong. At this point the landlady orders everyone out. Those in the apartment oblivious to the recreational shenanigans are rudely awakened, having slept no more than an hour in three days, and informed they all have to vacate the premises immediately. This doesn't make anyone very happy.

The next time I see Alex it is at the airport with a resilient Tara for the flight home. His voice is a rasping wheeze and he looks unwell, a man clinging desperately to the appearance of normality in order to get back home. I understand that his paranoia and guilt will have rocketed into the stratosphere as a consequence of the bad crack; feelings magnified a hundredfold. Benchmarked against my own normal, everyday feelings, an acute sense of penitent introspection is not something I would particularly care to experience; indeed the notion is ghastly enough to keep me on the good path.

The good path. I am absentmindedly peering at an airport sign — at nothing — in the middle distance, a thousand yards stare cut back to five- hundred feet. Our group don't fit the social DNA but nevertheless we try to look as normal as we can given the circumstance: Alex is coming down with all the grandeur and spectacle of a burning space shuttle, Cal is armed now with an epiphany and life affirming residuals, and me, well I am pissed on bottles of cheap chilled champagne consumed on the poverty stricken streets where I first encountered the portal — a fond farewell toast to Barcelona and the doomed from Caleb and myself. Destiny and my scorecard are calling.

I am absentmindedly peering at an airport sign when into my focus comes a group of three young girls. They are walking away from me and are scowling, throwing back a gesture that I should "fuck off" under the illusion that it is their collective ass I am looking at, not possibly something that might not be them. When I realise this I think of nothing but airports and the way in which the brain works every minute of every day, that my higher thoughts have been cashed in for the simple mechanics of being here, and that somewhere, someplace on high, Bela is marking my scorecard while pulling de strings. I think this and begin to smile broadly, a big fucking shit eating Sónar grin that nearly cuts my face in two. I stare at them and their ass and smile. FIN

"Give yourself a weekly treat..."

WIN A HOLIDAY IN THE SUN FOR TWO

WEEKEND
and TODAY · Sixpence

ARE WIVES WORTH TALKING TO?

MYLENE DEMONGEOT

Weekend and Today magazine (undated)

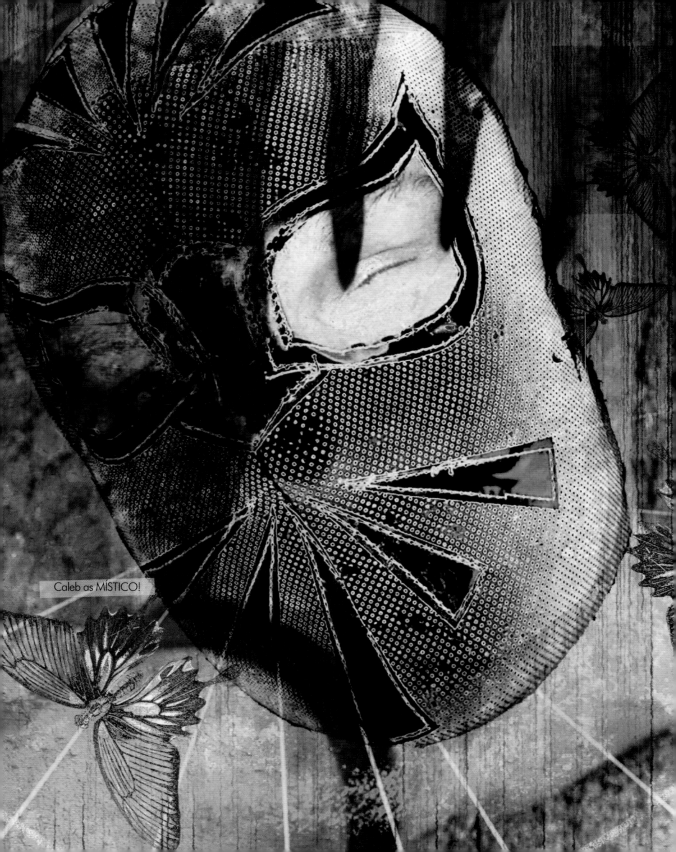

Caleb as MÍSTICO!

BALLS THE WOMB AND MEXICO CITY

OCTOBER 2006. TOGETHER WITH BUSINESS ASSOCIATE CALEB SELAH, AND BEN (LAWMAN), DAVID KEREKES WITH NOTEBOOK DEPARTED LONDON GATWICK FOR CANCUN, THE SOUTHERN GATEWAY TO MEXICO ON THE TIP OF QUINTANA ROO STATE. THE THREE OF THEM POINTED THEMSELVES ON ARRIVAL UP COUNTRY FOR ADVENTURE, PRIMED WITH NOTHING MORE THAN THE LONELY GRINGO GUIDE TO MEXICO AND AN AGENDA TO KEEP MOVING. THINGS STARTED WELL ENOUGH, IN CANCUN AND VERACRUZ, BUT BY THE TIME MEXICO CITY ARRIVED, THE CRACKS STARTED TO APPEAR.

"Here is my hand in the sky, my body a conductor down to ancient times, and a labyrinth of power and dead children."

"Esto es un lugar muy peligroso,"

says our driver, self appointed minister for tourism, as he pulls his cab away from the Terminal del Norte bus station, making a left toward Mexico City, or irrevocable change as I like to call it, the flat city, the largest land mass of people of any one city in the world city. "This is a very dangerous place," he adds redundantly.

It is nighttime. Black and white time, with hues of grey. The three hour bus journey from Veracruz had been plagued by homosexuals contemplating the ring tones of their mobile phones, and a strange, disjointed conversation between the three of us concerning female anatomy and whether one should focus on the camel toe in public.

 CALEB: "It's a wonderful invention."
 ME: "What's that? The television?"
 CALEB: "No, the laughing Danny."
 BEN: "He had a machine in the back of his house that would rattle loudly in the middle of the night."
 ME: "Is it camel *toe* or camel *foot*?"
 BEN: "It's a dehumidifier."

 And so on, to the accompaniment of polyphonic bursts of the Village People performing YMCA.

Our introduction to Mexico City is a commentary from the taxi driver on life having no value, as well as good advice on all the "places to go for a murder and a mugging." Life has no value, life has no value, he repeats in the mannered way a lunatic will attempt to qualify his sanity. Life has no value life has no value but our purpose is to reach the Hotel del Angel in the busy social area of the city known as Zona Rosa, the "pink zone," pink representing gayness of the safe kind and the colour of many of its buildings. This is our destination, but our driver instead takes us ten blocks north

of the Zocalo to a dead land known as Tepito.

If _La Santa Muerte_ had a holy land, Tepito would be its bruised and bloody shame. Ben, who has visited seventy two countries, has never seen anything like it. Not even in Rio de Janeiro, he says.

This puts Ben in mind of Rio de Janeiro and the curiously agitated cop who stopped him there two years earlier for a routine search, a strange affair that comprised nothing more than Ben having to take off his shoes and socks and place his feet in the lap of the noble officer for a ten minute shake-down of the toes.

"He was clearly getting his jollies," Ben recalls of the cop with a big 10-4.

But Tepito is not jolly, it is a wasteland exhibiting the kipple of a burned out planet with bleak streets that con-verge for an 8PM curfew on the _vecinclades_, the temporary shelters that spilled over and became permanent homes with rent fixed at one cent a month. The economy of Tepito has grown and collapsed with black market trade, a seismic shift that has had a more devastating impact on the cultural land-scape than the earthquake that tore through it two decades ago.

Economy now of course is drugs and some of the _vecinclades_ are replaced with apartment blocks whose rotten cramped dwellings with paper thin walls breed psychotic neighbours with howling dogs. The authority in Mexico City conveniently ignores Tepito, as it ignores the trash that is piled knee high beneath the extinguished street lamps. The only illumination is the timorous beam of our dipped headlamps as they bore a lonesome path.

Ten murders a day in Tepito and a police force not willing to respond to a single one of them, not since the riots in November 2000 when the police where forced out of the neighbourhood by a mob refusing to let them haul away the stolen electrical goods and handguns that had been confiscated that morning.

And then — _el conductor del taxi está loco_ — the driver stops the car.

He cab driver sweeps his hands as if to signal that we have arrived and have to get out. This isn't what we expected of Zona Rosa, the safe, pre-dominantly gay inner sanctum of Mexico City where our hotel is located. We don't believe that this is Zona Rosa at all. In fact we know it isn't but get out anyway when the driver produces a gun, surveying the scene with its black barrel.

My only desire is to see _lucha libre_, a Mexican wrestling match, you cunt. How do you say "you cunt?"

There is no protest song, no choice but to give it up, to leave the hors-es and continue the climb on foot. Making no sudden moves the three of us are out of the old Chrysler Le Baron and out on the streets of dread, where not a true soul can be seen but maleficent threat hangs in the air, a fetid fog. In 1945 this barrio was marked as one of the worst places to live in

Mexico, and if there has been any improvement since we are going to have to get on our knees and claw beneath the shit with our fingers to find it.

"Have a good life, my friend," says Cal as the cab pulls away with our 700 pesos tip. Quick-draw McGraw is travelling so slowly through the rubbish it would be easy to wade through it and reach the vehicle and question him about Tepito and whether it has seen change for the better over the years. Perhaps even indulge in a little chaos and violence, if we were foolish and so inclined.

The first rule of travel is to travel with purpose in one's stride. Striding with purpose is how we had travelled through the Terminal del Norte bus station, a bleak place but not as bleak as Tepito, arriving purposefully at the glass front of the desk that dealt with the _sitios_ taxis, the legitimate taxis.

The desk was empty and remained empty, causing a queue of people requiring transportation to form that signalled to the wolves on the periphery that fresh tourist meat was about. We wanted not to be around when any strays from the pack got gobbled up and so sought an alternative route.

Andres at the Bartola in Veracruz had warned us to be careful in Mexico City and the Internet said always take the right kind of cab. The tail lights disappearing into the night ahead of us this minute belong to one of the wrong cabs, a Chrysler Le Baron with beat up paint work that we skipped the queue at Terminal del Norte to find outside on the street.

I am wishing I had a leather-coated mind when considering safety in numbers is merely an illusion. This isn't happening. Where the night breathes the precise sound one would expect of a Third World sprawl that spans one hundred and twenty blocks, _up and down the streets only debris. Above us a terrible sky_ this isn't happening.

"Well, I'm safe," I suddenly decide of our predicament. "I have the heart of _Santa Muerte_ on my chest."

Sure enough that heart is now also bleeding, having been cut into my flesh only this morning. Itching and bitching, too, Luis and Andersson. Itching like a bitch.

We begin to walk with purpose towards the first exit we can find, luggage on our shoulders, the Tepito death rattle vibrating in our souls. Only true delinquents accept a life here, everyone has a gun and anyone who doesn't have a gun performs their hold ups with a rabid pit bull on a short leash. Cal is a betting man: he wagers that we don't make it out alive, but he is proven wrong and we do make it and Cal loses the wager, what comes next in Tepito is the strangest sight we will ever see.

Through streets that police and even whores will not tread, in and out of shadow a young woman sweeps lightly towards us holding a baby to her chest. She has been transposed through this time from another, of this we are certain. She moves in a flowered blouse unaware that she has faded from her beautiful place and arrived in this one.

Our paths touch fleetingly.

"_¿Está bien usted, el fallo?_" asks Ben. "Are you okay, Miss?"

"_Un pequeño animal que encoge sus hombros muy muy lejos un más grande uno uno uno_," she says without stopping, not smiling and not sad and not making sense, simply moving toward the dangerous epicentre of the dangerous city from whence we came. "A small animal shrinking its shoulders very far away a larger one one one."

From nowhere to nothing, alone with the infant she clutches tightly she is gone in a moment, into the maze of tragic housing, her words trailing behind her. In search of meaning, in search of space, in search of place, who knows? If we could stop her and tell her to go back we would. Not unlike Elvis down at the end of Lonely Street however, it is too late for that. Not that way, Miss. That way is only heartbreak and misery, keep away from it. Come with us.

And when we make it to the other side of Tepito we are alive, find the exit and beyond that is Zona Rosa and the Hotel del Angel.

Nothing can hurt us now. Nothing can hurt us anymore.

And so begins our ascension.

At 4:54AM Cal paints a picture of the events surrounding his balls, but first the staff in the hotels of hate and lucha libre.

A passport is not a requirement when checking into a hotel in Mexico, so if one ever commits a murder, Mexico is the logical place to run to and hide. We contemplate friends that may benefit from brutality back home and then dismiss the idea on the realisation that nobody running the hotels in Mexico likes us very much, and would gladly give us up to the police. In Mexico City the people running the hotels detest us with a passion. Here in the flat city, we aren't able to leave our room without the electronic key code being changed to prevent our re-entry, which more often than not results in harsh words and gestures. It happens so often during our two days at Hotel del Angel that we are forced to arraign the receptionist at every available opportunity. It really isn't worth our time to take the elevator to the second floor to check the state of the door to our room because the door to our room will be locked. The night watch receptionist, so stoned he literally doesn't know what day it is and cannot remember how to find out, suffers the worse of our indignation when we return from the VIP gentleman's club early one Saturday morning.

"By Cal's crushed balls, you've changed the lock again!" we yell at him the instant he buzzes us through the entrance.

We flip the plastic credit card size key onto the desk with a flourish that suggests we come from Tepito but we do not belong there. A bounce takes the key into the air and as it descends so collapses the rapport we have been systematically destroying with the Hotel del Angel. The receptionist goes insane and curses blind that we should have died in that taxi and furthermore our mothers enjoy sexual pleasures from rabbi dogs, a hostility symptomatic of the hostility we encounter from Mexican hoteliers in general, hating us not because of who we are but who we are not. _We are not you_, we appear to be saying to them, _we gringos are the opposite of your hard working selves with the money to prove it and you would like to be us_.

We are gringos, if a little less gringo than the American gringos, who belong to a genus as removed from us as it is from Mexicans, but we are gringos all the same.

We decide to celebrate this new understanding with cigars from Cuba.

Down a road that takes us in the vague direction of Arena Coliseo where _lucha libre_ — the wrestling — can be found on any given Sunday we come across a man with Cuban cigars. In a bright yellow "athletica" t-shirt but looking like the one least likely to succeed he pulls back his lips for a grin of big gums when Cal shows an interest in his wares. Ben wades in immediately, able to smell blood, and starts to haggle over the established price of five cigars for US$30. Ben will haggle over the wind and the rain and anything because he hates to feel as though he is being ripped off, which he claims is what everyone is about when it comes to money, his or ours. He can't help himself, something to do with three years in law school and a voracious appetite for fat sex. Snatching pennies from the smashed souls of paupers is a disposition of the inhuman, we tell him. But still it gives us pleasure to watch Ben at work, so effortlessly does he do the snatching.

The haggling has been going on for fifteen minutes.

CIGAR SALESMAN: "Hangover. Hangover. My head hurt."
BEN: "Really? That's why it'd be better if we gave you twelve dollars; that way you could go home and buy a cure for your hangover."

CIGAR SALESMAN: "I tol' you. I no want to rip you."
BEN: "You do! That's your main aim!"
MR CALEB: "We're Puma fans as well. We're Puma fans."
CIGAR SALESMAN: "I tol' you, I tol' you—"
BEN: "If you sell us this for twelve dollars the Pumas will win on Saturday."
CIGAR SALESMAN: "Let's make a deal: twenty three."
BEN: "Twenty three? Twenty three! Is that how you treat all your friends?"

And so it goes until the cigar man with gums wants no more a part of it and gives to Cal a box of five Cuban cigars in exchange for a quart of tequila and a ten dollar bill.

Six girls we later meet in a club called Cortesia tell us they cannot understand why we should want to go to see *lucha libre*. To them *lucha libre* is something of an embarrassment and they cannot understand. Big men in face masks throwing one another around is a thing of a generation past, it is old Mexico from which they are distanced, being modern people with internet access. *Lucha libre* has yet to reach a state where it stops being what it is and becomes what it is to understand irony.

Inside the Arena Coliseo it is a capacity crowd and the excitement is mounting. We have good seats, we have good seats four rows from the front in the stalls, next to a young mother with a three month old infant on the one side of us and on the other side a girl of eighteen, but probably twelve, about whom I should say no more advises Ben.

Given the cheers, rattles and air horns all around, it is a relief that the delicate ears of the infant are protected by delicate infant ear plugs, which we would have noticed sooner had we not been held up by police.

The police found us easily in the market square, three gringos bothering fish selling tradesmen for directions to the Arena Coliseo, and they made a great pantomime of checking our papers, as if to show to the world that everything in Mexico City was under control now that they were checking our papers.

"Nobody laugh or run," Ben whispered as the police signalled stop with a leisurely left hand and beckoned us over.

He meant it. These cops were young and moved effortlessly through people that feared and hated them, their mirror shades representative of the worse kind of hate filled eyes.

They carried enough weaponry to immobilise a tank in a military coup and it did not bring us joy to have our passports looked upon as if guilt was waiting to be found therein.

Your papers are in order, the cops said with a simple nod of the head. Now go.

The centre of town in Mexico City doesn't serve the visitor much beyond a litany of woes around the next corner. There is no Louvre, no Pantheon, no changing of the guard, the land marks of famous cities around the world, only fish stalls with a police force marching throu them primed ready to split a skull or two.

And around the next corner is the Calle de Peru, where stands the Arena Coliseo. It is no a proud street, it was probably once a functional street but nowadays it isn't even that, and the only traffic through it is the traffic of a wrestling day.

We find a place to eat on Calle de Peru, a cantina built around a big iron simmering pot containing mole (pronounced moh-lay; a type of sauce not the cuddly myopic), with an entrance that is a crude hole knocked into the wall that faces the street. Overhead the hole is a cru-cifix that has undergone many repairs, with Polyfilla enough to kill a man should the crucifix fall.

Inside the cantina are eight tables, and at the far end a kitchen where three generations of woman prepare rice and beans. The women look up when we enter but the diners do not. The din-ers are wary of us and even stop talking amongst themselves so that they may concentrate bet-ter on their food and ignore us altogether. The only acknowledgement of our presence comes from a young man with a vicious swollen eye, who draws his woman closer to him, as if to say "she's mine" and thus prevent her flight in the company of strangers. He wears dirty white clothes to the woman's black, which serve to accentuate his manhood once his legs part for our benefit and the slouch into machismo gets underway. A dirty manhood is not what we want when we eat but because there are no other places to eat on the Calle de Peru, we have little choice but suffer the indignity and fear of prolonged periods in Mexican toilets.

There is no menu to speak of. The man tending the "tables" brings to us three helpings of mole, followed by rice and beans. We don't have any choice. The water in a colourful plastic

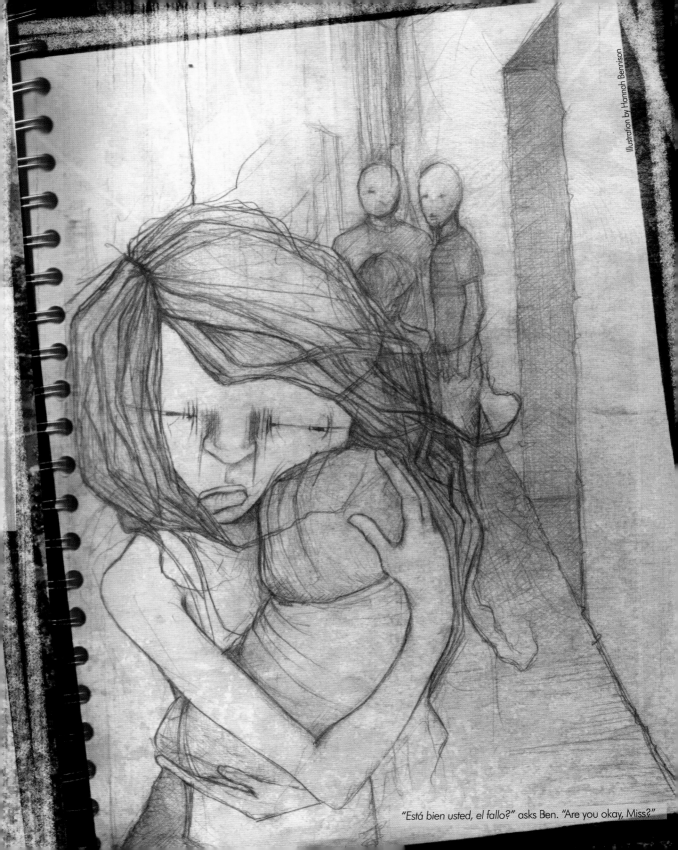

"Está bien usted, el fallo?" asks Ben. "Are you okay, Miss?"

pitcher we avoid.

"*No somos gringos Americanos*," we feel obligated to tell the man waiting "tables." "We are not American gringos."

Through the hole in the wall beyond the crucifix a community is building on the street in anticipation of the wrestling. Families make their way to the Coliseo box office, by-passing the scalpers that claim to have bought up all the tickets, to a window covered by a steel grille. Here, cash and tickets are exchanged through a slot not big enough for anything larger to pass.

The seats in the Arena Coliseo are hard pressed plastic, but not as hard as the Mexico City cops that won't go to Tepito. Unlike us. And our hard asses.

CONSEJO MUNDIAL CMLL DE LUCHA LIBRE, reads the sign over the arena.

Stored in buckets of ice and brought to one's seat by fellows wearing white lab coats, cerveza poured from a bottle into a paper cup costs 2 pesos. Water costs 1.50 a cup, which would explain why nobody at the wrestling is drinking the water except for Caleb, who is beginning to feel a little weird after three solid days of alcohol without sleep and a jet lag that he says is "catching up." He denies the Valium is anything to do with it. Vehemently.

"Don't fall asleep here," I tell Cal, whose jetlag he hopes is hidden behind his sun-glasses. "You'll get us lynched."

The canvas ring holds court even when empty and a packed house bay, yell and stamp their feet in its direction. The house is here to witness Ultimo Guerrero, Black Warrior, Hombre Sin Nombre, Alex Koslov, Sangre Azteca and all the other mighty warriors pound a head or two in the afternoon. But most of all they are here to witness Místico. Up in the cheaper seats a wire mesh protects heads below from the detritus hurled at it, mainly body parts and spicy po tato wedges from the street vendors, who smell heavily of sweat and carbolic soap, as corrupt ing on the nostrils as sulphur.

The Sunday match starts early at the Coliseo, a more intimate and informal arena than the Mexico arena, which is across town near to the Balderas metro. We buy *mascara* — masks — and other wrestling paraphernalia in anticipation of the afternoon's entertainment.

The woman's name is Karen Gonzalez Cruz and the man hanging onto her with a vicious swollen eye is American Mike.

American Mike cannot speak much Spanish and so the two of them communicate through impass-ioned glances that are as sickening a display as Mike's manhood. Thus we exit the cantina fo a street suddenly much more inviting than when we left it, leaving with Mike an offer that th

lovers should come and party in our hotel room.

American Mike says by way of a reply: "You've got to deal with all the problems."

"I'll think about what that means in the next life," Cal fires back.

It's a bad sound going down but we have got American Mike all wrong, and what we perceive as balls is actually a cry for help, as we shall find out soon enough.

This is a particularly good day for the fans and families who suspend all disbelief and worsh each Sunday at temple lucha libre. The formidable Místico is headlining, the people's champion.

Místico was born and raised in Tepito, like Luis "Kid Azteca" Villanueva, José "Huitlacoche" Medel and a generation of tough fighters before him. He started his career at age fifteen, wres-tling under the name of Astro Boy and winning. From underdog to the largest drawing wrestler in the world and the biggest star of all of Mexico, Astro Boy turned to religion and changed his name to Místico and wrestles this very day in Arena Coliseo with a new jewel to his crown: Best Flying Wrestler of 2006.

When they say "flying" they do mean flying and not jumping. Místico's aerial based offence is

something to behold, a lesson in what happens to a man weighing 167lbs when he leaves the force of gravity under a silver face mask.

A Top-Rope Rocker Dropper.

Bout after bout, down the aisle come the tag teams to the sing-song announcer whose shoulders are arched beneath a garish tweed jacket, and who says *formidable* at every opportunity. Everything is "formidable" in lucha libre.

The fighters bounce down the aisle in order to throw themselves majestically into the ring. These leaps into the ring are almost as spectacular as the flips out again when Místico or Heavy Metal or La Mascara take the upper hand with a *plancha* move, a flying cross body press, and send one of their opponents clear out across the ropes. These fuckers are fucking big and spectators scatter ring side when projectiles the size of a small village hurtle their way and smash apart seats upon impact.

Occasionally the grappling continues outside the ring, which is technically illegal and gets the audience even more fired up than they already are. Little wonder that sometimes the fighters sustain genuine injury, and some of them, covered in blood and shame, are left no option but to quit and hobble unceremoniously out of the stadium. When a wrestler leaves this way there is no cheer or applause, no show of appreciation from the crowd. It is as if the wrestler was never really there in the first place, because injuries are for mortals. These fuckers are balletic pugilistic pantomime artists, far greater and more colourful than life beyond the Coliseo, and they are duty bound to carry on their big hulking shoulders the ideation of a thousand people or more. When they fail we mortals must die a little.

The female tag team don't have anywhere near the same hulk to their shoulders, and as a consequence command less respect than the male wrestlers. When the female wrestlers arrive it is to a chorus of "*putan!*" from the women in the audience. "Prostitute!"

Dark Angel is the favourite *putan*. She fights alongside Lady Apache and Princesa Blanca, locking necks between powerful legs and making Princesa Sujei or Hiroka or Rosa Negra slam a hand into the canvas in defeat.

For the "formidable" final bout, which stars Místico — everyone's favourite — a dwarf wrestler dressed in a monkey suit and a blue afro wig beneath gladiatorial armour joins in purely to be gently hurled around the ring and generate lots of laughs. It's an unbelievable sight, not dissimilar a sight to that of Maximo, who generated uproarious laughter in an earlier bout when he minced about the ring in a very short tunic in a farcical caricature of camp. When I nudge Cal awake and he sees the monkey he knows he's dreaming.

Whenever Místico raises a fist or lands a pile driving blow, some of the women in the audience cannot contain themselves. The woman in the front row blocks the view of men suddenly timorous in the company of other people's glances when she jumps out of her seat with great excitement and hollers, "MÍSTICO!" Which goes on up until the moment Místico loses and everybody in the arena turns to one of the several exits and leaves: The grown ups with their children, the children with their friends and their photographs signed by Dark Angel and the other wrestlers for a few cents. Místico loses. There is no discussion of events, no match analysis, no sound at all but the mental echo of what is, I suppose, a cold hard slap to the face of this week's dreams.

The beer vendor that owes me 10 pesos from an hour ago dutifully returns my change and then it's out through the turnstile, where a battered bus takes away everyone not leaving the Calle de Peru on foot.

We decide to crush the anguish of Místico's defeat with Cal's new cigars and alcohol. Because of a fruitless stroll through Zona Rosa, however, a predominantly gay area of

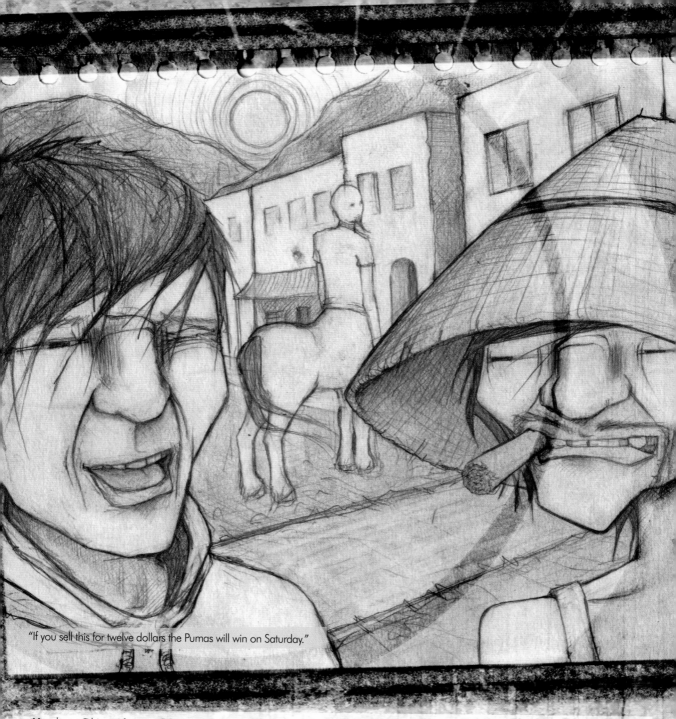

"If you sell this for twelve dollars the Pumas will win on Saturday."

Mexico City that offers no bars we want to visit, packed only with people we do not want to meet, despondency falls like a rain to make us feel even worse. To accompany our despondency is a tout on every corner peddling the promise of "the best club in Mexico." *"El major club en Mejico."* I tell one tout to *dejame en paz!* and push him to a wall when he grabs my arm and attempts to draw me to a red door. He slides quickly away, troubled by my reaction. As indeed I am myself.

Nothing can hurt us now. Rise.

We haven't gone far down the road when a man who I shall call Knuckles starts to cough and follows us around like a lost puppy dog until there is nothing left for it but the VIP gentleman's club he tirelessly recommends. The nature of the club involves the presence of beautiful ladies, but that's about the only constant in a description he shapes like putty to better take our fancy. If we don't like it, he says, we can leave. Which, of course, is rubbish.

Naturally, the VIP gentleman's club isn't at all as he described but exactly what we expected. That is, a place of men of good standing beaming like juveniles in the company of young ladies. It has all the sex appeal of an executive luncheon, where the thrill of flesh for top price drinks is the trade, and people wearing nail polish and neckties have replaced the grease stained plebs of the factory floor.

Our eyes are still adjusting to the gloom of blue strip lighting in the stairway by the time Knuckles has whisked us upstairs into the club. Here the guides of the inner circle take over and lead us to the tables. To the tables. What we see as we approach the tables, when our eyes catch up and the room unfolds, are a pole dancer whose enthusiasm has yet to arrive and white feathers and bare midriffs. We are almost ensconced at the tables, the tables that breed idiot men with gold charge cards in female company, when we come to our senses and snap free of the silk cogs of well oiled motion to take our leave. This isn't for us. What we want are Místico and Dark Angel victorious.

The ranks of the inner circle are alerted to our premature departure in an instant and tighten around us like a noose to thwart our passage down the blue strip stairway. Men in suits and ladies without many clothes are an obstacle to our exit, and fire at us telekinetic mind bolts warning that money in the VIP can but travel one way, and that way is not out. Not out, not now. _Get yourselves back to the tables_, they are saying, _or the beautiful woman shall become the bad woman_, mala mujer, _and you shall feel her wrath_.

But the circle doesn't anticipate such resistance, such brute determination and sheer velocity, and the ranks crumble beneath our unwavering flight out.

"Get out of our way, man," our battle cry. "We really mean it!"

Our exit from the club is unceremonious: We tumble from it onto the pink streets of the Zona Rosa in a heap. But some kind of dignity remains intact and with that we are happy.

"Beautiful," says one guy in English. "_Hermoso_," he translates for the Spanish fluff on his arm. I don't know what exactly might be beautiful, whether it's me or the streets or the state in which we arrive on the streets but I thank him all the same, and he smiles jubilantly before pointing us in the direction of Cortesia, a place we can go for a drink and where

the missing things start for Caleb.

From the deep void beyond our galaxy down the road we travel, past La Cantina de los Remedios, where no waiter cracks a smile and a sign on the wall advises parents not to let their children play with their guns. Wherever music is played people will dance in Mexico, and music plays and people dance at La Cantina de los Remedios, next to their table as they wait between courses. Further we encounter for the first time Haf-fa, an elderly black dude in a flat cap dressed for a Dalston winter trying to get himself arrested by a dozen armed police officers. The cops are perplexed by his English demand, "Arrest me now! Arrest me now!" But when they move in I am compelled to try and help him out. So I take hold of Haf-fa's arm and tell him our bus is coming, which is an anagram for stop digging for yourself a hole because you got moved on for pissing in the street. The cops brush me away with the flip of a back hand, the way one might throw a fly from a sugar bowl. That's all the warning I need from mean cops and I walk away, knowing instinctively that our path will cross again with Haf-fa's.

From the deep void beyond our galaxy down the road is a house that has been converted into a club called Cortesia, where upstairs a DJ plays drum and bass, and downstairs another DJ plays the most unrelenting techno imaginable, as far removed from drum and bass as can be. Drum and bass is music that appeals to mathematicians and computer programmers, who admire the engineering of low frequency bass response that doesn't distort the sound around it, whilst analysing it in binary. I have a broken conversation about this with hairdressers, who go on to regard my name with interest and recount to me the story of a musical group also named Kerekes that had a hit with a song they sang in Polish.

"Any funny stories about Selah?" Caleb Selah asks the hairdressers before hitting the dance floor with a slurred stagger.

Because I don't much like the music they play in the Cortesia I spend the evening up and down the stairs with a succession of large whiskeys, until I find my spot in a corner. It's a short lived reverie, shattered when Caleb crashes into the room clutching his balls and searching for space.

He ploughs through a group of people seated on the floor and howls: "Jesus Christ! I need to lie down! I need to lie down!"

Cal's howling is ineffective against the pounding music, and so — a curious sight — he flails his arms in a tight circle that drives everyone back several paces and falls to the floor in the space this provides.

"Some bird just crushed my nuts!"

"Why'd she do that?" I ask.

"I've got no fucking idea!"

As Cal paints a picture of the events surrounding the cruel and harsh treatment of his balls, I recall the curiously tall hairdresser he speaks of, the one with the long fingers and a predilection for gay guys on the dance floor. Maybe therein lies the explanation, I say to Cal, who will have none of it. Maybe it was a gay thing, or a straight thing, or maybe twisting a stranger's balls till his eyes bleed is a form of courtship in these parts. The very thought of those long fingers makes me uncomfortable. They may

The residium of Aztec Gods

Later Cal discovers that his phone is missing, so maybe his balls were nothing but a distraction for hairdressing pickpockets. Two sore balls and no phone.

The following day, American Mike turns up at the Hotel del Angel in clean clothes and black eye. But he is alone, and not much of a party comes out of it.

American Mike is one of a group of young architects from around the world visiting Mexico City, and not American at all but Polish. Now he is jittery because he is in love and hoping to arrange a romantic candlelit evening with Karen Gonzalez Cruz, the girl who is beautiful, perfect, and sends him crazy with desire, whom he fears may fly away. He needs our help because American Mike is in love and knows only one inappropriate Spanish phrase and so cannot produce a sentence to arrange much of anything at all.

"Did this woman crush your balls by any chance?" I ask. But Mike looks more deflated than amused by my very humorous comment.

We agree to help him out. Mike dictates the conversation he would like to have with Karen and Ben translates it for him, writing down the Spanish words phonetically on Hotel del Angel headed notepaper. As long as Karen on the end of the phone line doesn't stray from the projected script and answers simply "yes" to each of his questions and nothing more, then paradise for Mike should arrive tomorrow evening in a meal and a thong.

The script reads as follows:

O-LA / hello
SOI MIKE / its mike
K TAL? / how r u
KOMO TU SEE-ENTES OI? / how ru today?
MAY GUS-TA-REE-A MUCHO ENCONTRAR TAY I-AIR? / i really enjoyed meeting you yesterday
E-REZ MOI SIMPA-TI-KO? / u are very nice
KERO VER TE! / i want to see u
KONYOCES EL RESTAURANTAY 'LA CASA DE LA-SI-REN-SES'? / do you know the xx restaurant?
ES EN EL CENTRO HISTORICO / its in the historical centre
KERES VENIR AL RESTAURANTE CONMIGO ESTA NOCHE? / do u want to come to the restaurant with me tonight?
YO VOY YEVAR MI DICIONARIO! / i'll bring my dictionary!
VAI SER MUY DIVERTIDO / it'll be a lot of fun
YO KERO MUCHO VERTE OTRA VEZ / i really want to see you again

It takes most of the afternoon to sort it all out and when it's sorted, with script in hand a shy and reserved Mike locks himself behind the door of the bathroom in our second floor room to make the call. He makes the call and she doesn't pick up. But he keeps trying and finally he gets through and when he does Karen Gonzalez Cruz doesn't understand one single syllable of any one word he utters. It's a mess of a conversation and in no time Mike is hopelessly lost in a language he cannot understand. Set

adrift on the terrible sea of lustful
loins with not a port in sight, he says
the word "goodbye" softly and hangs up.

A disillusioned architect is a ter-
rible thing to behold, much worse than a
sad plumber, and with the script torn to
shreds at our feet I see new buildings all
over Mexico falling down in years to come
as a consequence of the visiting inter-
national architects and their one Latino
loss.

The raging flame of personal tragedy,
they say, sometimes forges men into some-
thing more than human. American Mike be-
comes simply a vegetable. The name of the
girl is Karen Gonzalez Cruz, he blubbers
like a baby. Her name is —
*something is wrong and I don't know what
it is*

A dog is protesting on the street. I be-
lieve the dog is rabid. *Not guilty*, barks
the dog.

A man with yellow hair.
A man with a ball of yellow hair.
A man whose head is a ball of yellow
hair hails the taxi. Kicks the dog.
It comes and he goes.

Ben likes to barter first thing in the
morning, it helps invigorate him and sets
up the day well for him, and taxi driv-
ers are his favourite. So it is the very
next day when we check out of the Hotel
des Angel — hotel *incommunicado* — and into
a full blown war over one peso between
Ben on the one side and on the other José

Manuel Guzman, cab driver, in possession of the most
luxurious cab in the whole of Mexico. We like José
Manuel Guzman and confound Ben, whose battle isn't
over, when we hire him to take us to the central bus
station in Mexico City and the bus that will take us
to Zona Arqueológica de Teotihuacan. José doesn't
much like to be referred to as a cab driver. "*Servi-
cios de Transportación Turística y Ejecutiva*" is
what he provides, he tells us gravely.

He is very careful about his doors.

Had we met José sooner, our perception of Mexico
City might have been very different. The levels of
poverty and crime, according to José, are a gross

exaggeration. Mexico City is a beautiful and safe city, he says, except for an area so small as to be almost insignificant. We wonder where this small insignificant area might be given the poverty we see all around us, on streets that even the local people avoid like putrid hole in the ground.

"The bad districts I can count on one hand," he says when pressed on the point, a little embarrassed by his own admission. "Four years ago it was very different. Now you are safe to walk anywhere."

We ride over an overpass and I wonder of the buildings below, the shacks made of wood beneath the squalid houses made of weak concrete, how many of them will contain people having a fist pushed into their face. José adds quickly that in Mexico City "there are nice ladies from all over the world." In this I arrive at the answer to the flat city: A building with a nice lady is better than a building with a broken face or no building at all.

Time on this trip ebbs and flows in the heat. Above the space that occupies the sky is starting its transmission. It is God. And smog.

Exhaust fumes and the terrific heat have cooked up smog, something else for which Mexico City is famous, and it settles on the traffic like a thick broth. When the car stops at a set of lights, a miscreant whose eyes hold the ground wanders over and taps on José's window. He wants to know whether José would like to make some money taking his fare a different route. That's all we hear but I don't suspect the different route would do us many favours.

José is rightly proud of his city, but prouder still of his fine car, whose doors and windows he keeps locked tighter than a virgin's ass until it is absolutely necessary for them to be open.

A good man, José Manuel Guzman does us no ill and dismisses the guy whose eyes are on the ground. At the very least he has saved us the embarrassment of being robbed a second time in as many days.

We tip José well, giving him twice the money Ben had saved us with his haggling over the fare, as is now Caleb custom, and check our bags into left luggage. In the few minutes before boarding the bus that goes to Zona Arqueológica in Teotihuacán, I buy a pin that has the flag of Mexico made out of enamel and fasten it to a belt loop on my trousers, upon which I determine that my trousers are obscenely loose and liable to fall down. This eventuality I am pondering when Caleb and Ben call for me to get a move on, because we have a bus to catch for the City of the Gods.

Teotihuacán is in a valley some fifty kilometres northeast of Mexico City. Its archaeological zone holds what remains of Mexico's biggest ancient city, dating back to the time of Christ, and perhaps the first great civilisation in central Mexico. Here can be found the Pyramid of the Sun, the third largest pyramid in the world, and the residuum of Aztec gods, including Quetzalcóatl, which was the inspiration for Larry Cohen's movie _Q: The Winged Serpent_.

Despite Larry Cohen and ancient greatness, the bus we take to Teotihuacán is stopped and searched by the police. Not that this is clear to us when the two cops climb on board and walk down the aisle to us at the seats at the back. The Federal Preventive Police in their blue uniform wait for something from us, saying not a word. We respond in kind, looking into the face of bewilderment and unease for two long minutes.

Outside my window a sign painted on a wall reads SUPER TORTAS HAMBURGUESAS, the relevance of which I ask myself. Maybe we dozed off a mile back because we seem to be missing a piece integral to the puzzle, the one with a clue about cops on the bus.

Ben says eventually, "_Hola. ¿Cóma está?_" which may be a greeting or Ben inviting them to suck my motherfucking dick. "Hello. How are you?"

The cops look at one another, summarising their relief with a shrug of the shoulders on discovering that our obstinacy is actually only ignorance and we are not from these parts. With this they turn to the rest of the bus and systematically begin to search the other male passengers. They don't search any of the women on board and they don't search us, just the other male passengers, who stand in turn without question with their arms outstretched.

The officers pat down all the men and finding nothing get off the bus.

We pay the Zona Arqueológica entrance money of 45 pesos each and I tie my shirt around my waist to conceal the fact my trousers are falling down. I contemplate a belt from one of the _callejones_, but the belts all have big buckles with the word "Teotihuacán" engraved upon them and that I don't want. I join the others in buying a sombrero, however. We hand over a bundle of notes and some loose change. When Ben thwarts an attempt to short change us, the assistant says under her breath "_el carbon no sabe contar_," which translates as "The fucker can count."

Zona Arqueológica has hundreds of hawkers, badgering visitors with trinkets and souvenirs, but only one hawker has a big black onyx cock for sale.
"A souvenir for your mother-in-law," he says as we pass him by. We physically restrain Ben from haggling.

In the heart of the ancient city, at the starting point on the roads that define the godly places, stands the magnificent Pyramid of the Sun, the third largest pyramid in the world. It is located on the Avenue of the Dead, between the Pyramid of the Moon and the Ciudadela, the house of the supreme ruler, and is built on top of a cave located six metres beneath the earth that was considered by the Aztecans to be the birthplace of man. Some people argue that the cave is actually a tomb. It is not possible for visitors to go inside the cave or go inside the pyramid itself, but somewhere inside are the bones and remains of innumerable children, appropriate behaviour to the ancient ones when buried strategically.

Climbing the steep 248 steps of the Pyramid of the Sun, clutching my falling trousers and with a shirt around my waist, we stop regularly to take in the view, and for me to adjust myself and for Caleb to perform deep breathing exercises. He swears he will get fit again back in Britain. I swear that I should have bought that belt.

There is a better class of hawker at the pyramid, and the sound of panpipes rising from the base of the ruins is less atonal than the pipes at the entrance to the site, where the pipes are blown by hawkers not as comfortable with wind instruments as they are their pendants and black fake cocks.

A biting wind greets us when we reach the top, and against the wind are the sightseers who circle the summit and survey Teotihuacán for clues to a meaning. Here at the top are gringos and New Age hippies from the continent talking about Iraq and better tasting latte at Starbucks.
"They are on it, you bet," says one American with great authority.

The city that once spanned 20km, with its great and noble founders forgotten to time, is observed now by a tribe of lost idiots. There is nothing else for it and so Caleb draws the mask that he bought at the wrestling from his red shoulder bag of drugs and places it over his head. An eerie calm falls over everyone when he throws his hands up into the air and yells at the top of his voice, "MÍSTICO!" For evidence, I snap a picture of him framed against the Pyramid of the Moon at the north end of the Avenue of the Dead.

On the top of the Pyramid of the Sun once stood a temple with an altar where human sacrifice took place. The temple was painted red for blood, red for the setting sun. Destroyed long ago by man and by nature, now in place of the altar is a silver key embedded in the stone, a physical point of reference over which I place my fingertip, and also a spatial point, because here is the vertex for the celestial sphere.

I place the finger of one hand upon
the silver key and hold my other hand
high, in the manner shown to me by a man
from Colombia, who is on holiday. "You
can feel energy," he tells us. Here is
my hand in the sky, my body a conductor
down to ancient times, and a labyrinth
of power and dead children. Here is
space and here is place. The Pyramid of
the Sun has existed since 100AD, which
brings to it almost two thousand years
of joy and bloodshed, wisdom and igno-
rance; men have lived and died by and
beneath this stone, beneath its three
million tons, packed into shape before
the invention of the wheel. And beneath
it all, some six metres below ground,
is a tunnel that leads to the cave that
birthed all the inhabitants of the
earth.

Archaeologists found the cave in
1971. The ancient ones believed it to
be the womb of the world, the origins
of life. It had writing on its walls.

"What can you feel?" Ben asks from a
distance, refusing to partake because
he doesn't believe in it.

"Nothing," I say, my finger on the
key, my hand in the air, disappointed
that no stars explode, no sky turns
black, no Jack Kirby crackle bursts out
from the frame.

No Quetzalcóatl, the winged serpent.
No Super Tortas Hamburguesas.

The focus of all energy brings to me
nothing but the woeful song played by
a woman on the slow bus back to Mexico
City. One might assume that a woman in
a white blouse would have the voice of
an angel, especially in Mexico, where
the mariachi was invented. Let me tell
you this is not necessarily the case.
It was horrible to endure.

Cal says to the man from Colombia as
we start the mission back down the 248
steps: "Have a good life, my friend."

"May he order His angels to protect
you wherever you go," the man says by
way of a reply, the biting wind silenc-
ing the words so they sound like noth-
ing at all on earth.

And that's when it hits me. ↗

"Balls, The
Womb, and
Mexico City"
and "Sónar
2006" are
extracts
from a
forthcoming
book by Dav-
id Kerekes.

Sachet
containing
the "Offi-
cial powder
of the Holy
Death."

Legitimo Polvo de la
SANTISIMA MUERTE

Alicornio Vencedor

ALAN MOORE

RIK 03

Illustration by Rik Rawling

FROM THE LEAGUE OF EXTRAORDINARY GENTLEMEN TO LOST GIRLS AND BEYOND. JERRY GLOVER SPEAKS WITH ALAN MOORE, ONE OF THE MOST ENDURING FIGURES IN THE LITERATURE OF COMICS, ON THE RELEASE OF HIS AND MELINDA GEBBIE'S EPIC WORK LOST GIRLS.

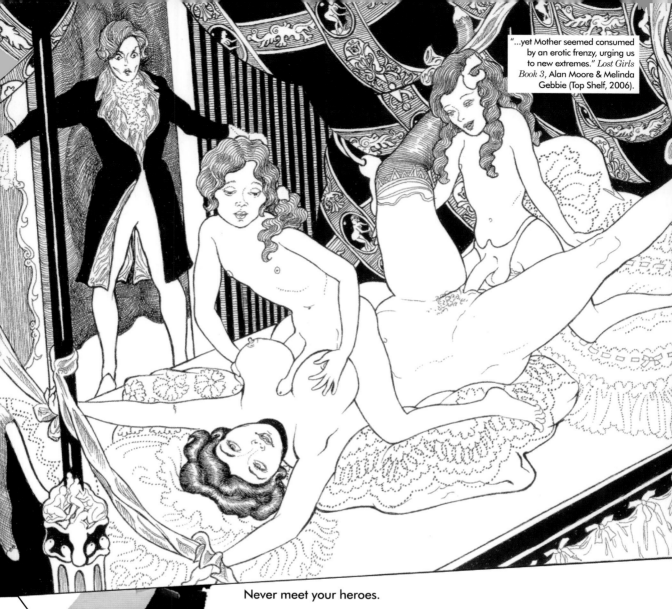

"...yet Mother seemed consumed by an erotic frenzy, urging us to new extremes." *Lost Girls Book 3*, Alan Moore & Melinda Gebbie (Top Shelf, 2006).

Never meet your heroes.

Especially the writers. Writers whose books have enthralled you the most are the ones you should really avoid. There is no mystery to this. Writing involves sitting quietly alone in a room, not cultivating charisma or honing conversational dexterity. The writer is not typically the person at the party who is the one captivating a throng of admirers with their wit and wisdom. You wouldn't want to talk to a lot of writers a couple of minutes after having bumped into one.

Well, I don't know many parties Alan Moore gets to but if what I read is true it doesn't sound as if he leaves one corner of his house much. Good job then that when he interrupts his reveries in order to talk to someone about his work he's got something to say about it. A lot to say about it. The feeling of talking to Alan Moore is like breaking open one of his books, as I found when I phoned him to discuss <u>Lost Girls</u>, a book published recently in the US after many years in the making. Having read a number of anodyne interviews with Moore around the time <u>Lost Girls</u> was being readied to print,

LOST GIRLS

Alan Moore
Melinda Gebbie

Lost with the girls: LOST GIRLS by Alan Moore & Melinda Gebbie

Review by Jerry Glover

The history of pornographic books is interesting because... Well no, reader, it is not. The history of pornographic literature is very, very boring but I thought I'd better orientate myself in order to do this review some justice. After pouring over rare (and often vividly illustrated) documents in the Bodleian, Bibliotech Nationale, and Vatican libraries, sometimes in VIP private rooms, where the normal restrictions on photography do not apply (or were discreetly waived), I can honestly say that pornography is a dull thing to talk about and, for you, to want to hear about. Take it from me. I thought I'd mention it since the story we're going to get into here — Lost Girls — makes reference to a number of notorious erotic works. Which is curious given that the three heroines central to the story are from children's fiction. It's what makes this book as much a descendent of the Rupert Bear strip in the Oz 'School Kids' issue as it does the works of Cleland, de Sade, Sappho and co. Was it really such a good idea to incorporate treasured characters from the best known and best loved literature of children and show them having orgasms? I don't really have a simple answer to that.

It's been a great awful wait has this book, its three volumes lavishly packaged in a slipcase. Announcement, postponement, announcement, silence, reschedule, reschedule. Almost every year since 1999 Lost Girls has been on the cards for imminent publication. You could only guess at what was happening behind the scenes. Was it really such a good idea it hard going? Was she seeing with fully unveiled eyes what it meant to enter into a pact to make a comic with

struggled to think of questions that would stretch him. With just a few hours to go to the interview I began work on another interrogative gambit. I would forget all pretence of serious questioning and open my interview with, "Alan, what would you say if I said that I hadn't read any of your books?" or "What would you say if we didn't do the interview and I fictionalised the whole thing?" A few minutes after I thought this would be a chortlingly surreal opening, and picturing myself sniggering along with it like a kid in a Beano strip while Alan harrumphed his approval at my daring, I pulled myself together. I was about to speak to a man who had written and published more words than a lot of well read people had even read; a writer of comics, poetry and publications of many kinds since about the year I was born; a man credited with redefining the possibilities of a medium; a man whose stories had enthralled me since I was a child; the kind of writer you grew up with, then went back to as you grew older; a children's writer, an adult's writer, a writer's writer; one who blew minds with words… What the hell was I going to ask this person, this… really great writer?

At two minutes past the allotted hour I dialled the number, and the telephone was answered before the third ring by the voice of the man behind the curtain, the wizard of words, the cartooning wonder himself. There was that burr of the English midlands, the voice of Northampton. Before I knew it he had asked me what I thought of his new book, Lost Girls, a book I had been awaiting far longer than was good for me. I was all ready to begin my interrogation, and he was asking me what I thought of his book. I felt like the kid at the premiere of Yellow Submarine who found himself being asked by

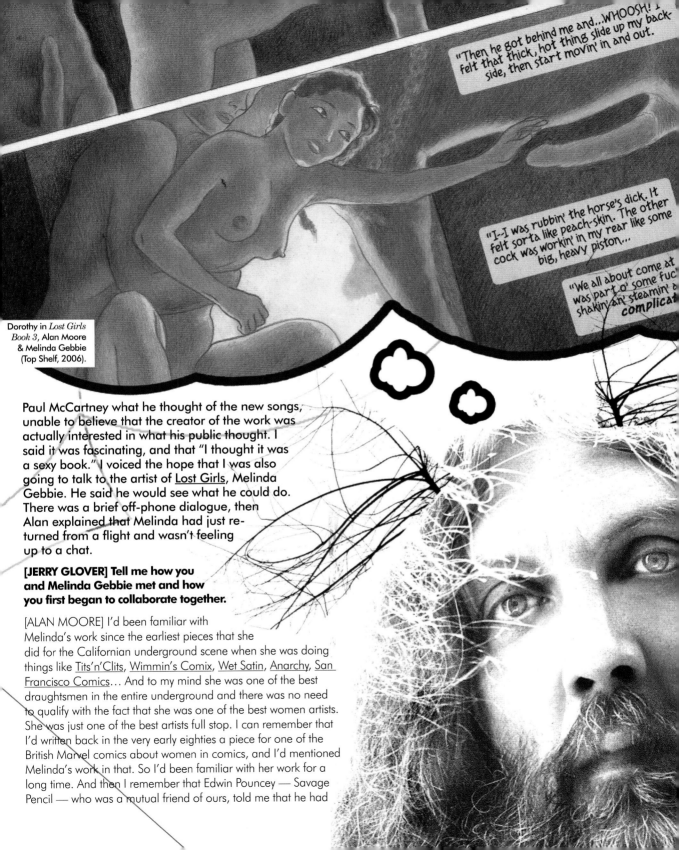

Dorothy in *Lost Girls* Book 3, Alan Moore & Melinda Gebbie (Top Shelf, 2006).

Paul McCartney what he thought of the new songs, unable to believe that the creator of the work was actually interested in what his public thought. I said it was fascinating, and that "I thought it was a sexy book." I voiced the hope that I was also going to talk to the artist of Lost Girls, Melinda Gebbie. He said he would see what he could do. There was a brief off-phone dialogue, then Alan explained that Melinda had just returned from a flight and wasn't feeling up to a chat.

[JERRY GLOVER] Tell me how you and Melinda Gebbie met and how you first began to collaborate together.

[ALAN MOORE] I'd been familiar with Melinda's work since the earliest pieces that she did for the Californian underground scene when she was doing things like Tits'n'Clits, Wimmin's Comix, Wet Satin, Anarchy, San Francisco Comics... And to my mind she was one of the best draughtsmen in the entire underground and there was no need to qualify with the fact that she was one of the best women artists. She was just one of the best artists full stop. I can remember that I'd written back in the very early eighties a piece for one of the British Marvel comics about women in comics, and I'd mentioned Melinda's work in that. So I'd been familiar with her work for a long time. And then I remember that Edwin Pouncey — Savage Pencil — who was a mutual friend of ours, told me that he had

How do you know when the work of a lifetime is the work of a lifetime? This Lost Girls thing had been brewing for fifteen years, only two years less than Finnegan's Wake. What were Alan and Melinda doing all that time? Discussing panel layouts in the bath? More to the point, is the finished work worth the wait, and does this notion about putting Dorothy from The Wizard of Oz, Wendy from Peter Pan, and Alice from Wonderland all in the same place so that they might share carnal adventures, really come off.

Structurally it's elaborate. This is a good thing since most of it is set in a hotel in Austria in 1915. The three heroines assemble: Dorothy, who first gets tongued by Bauer, a mysterious guest with a spiv moustache. Wendy is with her husband, the terminally dull and unfortunately named, Harry Potter. The atrophied state of their marriage means that sex is constantly on her mind. There is also Lady Alice Fairchild, a single lady of a certain age who looks like a pre Raphaelite pinup girl turned granny, and sounds immensely sophisticated and cynical. When she isn't putting her tongue to even more enjoyable use. While their partners hitch up with the other guests and staff, the three legendary heroines get down to their own carnal business all over the hotel and grounds.

Dorothy opens up to the ladies her former life in Kansas. The tornado that carries Dorothy to Kansas merges with her first sexual awakening. Thereafter she is still on the Kansas farm where a series of encounters with farm boys, who, according to their demands and the situation, correspond with the characters the Scarecrow, Cowardly Lion, Tin Man etc. (You can guess for yourself how.) Dorothy is practical, forthright, and likes to instigate.

The story of Alice, the most elderly of the characters, is slightly disturbing. She is first seduced by her father's friend, a Freud like figure who fondles her on a sofa. While becoming more excited Alice disassociates into the mirror hanging over the mantelpiece, a moment that marks her life in the looking glass world. Her school is a hotbed of schoolgirl sapphism and unrequited feelings towards her teacher, Miss Regent. When school ends, Alice and her teacher, who is married to a very respectable sort, become lovers, a relationship in which Alice is helplessly and completely dominated. Miss Regent introduces Alice to the debauchees of the London monde, who turn her onto opium. Over years of sex and drug taking, Alice slowly loses her mind but not her memory, luckily for us.

Last is Wendy. Hers is something of a nature trip, like Dorothy's except in an urban setting that allows the emphasis to be on voyeurism and the danger of being disturbed. Wendy is sexually awakened by Peter, of course, who is bold and impish enough to first have her in her own bed. Later Wendy meets him in the free outdoors where, watched by her siblings, she fucks Peter until the claw handed, fag smoking Captain Huxley from the stock exchange interrupts their fun. Wendy is a complex character, where the desire to transgress co-exists with feelings of shame and animosity. Meanwhile, her husband is finding that the dashing Bauer has a taste for older men.

The three ladies are a deeply involved ménage à trois and there are drugs in the mix...

Now this wouldn't be Alan Moore if there wasn't more going on and here in the opening books it is the assassination of the Archduke Franz Ferdinand and the opening performance of

Melinda stopping over at his house (which I was incredibly envious of) and then we met up a couple of times when Melinda was living over here in the later eighties. We met at gatherings, things like that, bumped into each other; we didn't have any lengthy conversations but I think we liked each other well enough. Finally we got together when there was a proposal for an erotic anthology published over here that I think was called Lost Horizons of Shangri-La, which has since melted into non existence — it never came out but it was instrumental in getting me and Melinda together, and Lost Girls kicked off in that they [the publishers] both approached us independently asking if we wanted to make an eight page comic strip for the anthology. Now me and Melinda had always been used to writing our own work for the underground but I am in many ways similar to a Dalek in that I am immensely powerful but I can't go upstairs, y' know, I need an artist to actually produce a piece of comic strip work, and I know that Neil Gaiman had happened across Melinda and suggested that maybe I could collaborate with Melinda upon this eight page strip. So he gave Melinda my number, she called me up. She came up here a couple of weekends to just hash out the idea and probably, yeah, the first couple of weeks we were discussing things we didn't want to do and ideas started to emerge and I think it was probably a kind of weird fusion of two half-notions that we'd come up with. I'd got the idea that it might be possible to do an erotic version of Peter Pan, mainly because of the flying scenes in Peter Pan and Freud's assertion that dreams of flying are dreams of sexual expression. It was nothing very complicated, or clever, it was just a half-idea. And Melinda mentioned she was interested in stories that had got a dynamic of three women characters. She'd done a couple of pieces for the underground that had worked on that kind of structure. And these two ideas kind of interbred and it was a fairly logical step from thinking if Wendy from Peter Pan was one of these three proposed women, who would the other two be? It was a fairly short step from that to thinking of Alice and Dorothy, and once we'd got those three names in place the idea just snowballed massively from that point very quickly. I think that probably within another week, or two weeks at the very most, I'd got the entire story roughly planned out and I knew that we weren't talking about an eight page inclusion in an anthology, you know, so Lost Girls pretty much kicked off from there.

Was Lost Girls more character driven, to see what happens to these characters in another narrative? Or was it more the concept of taking the characters and giving them a sexual life?

It was all of those things. I mean, the initial idea of putting those three characters together was exciting enough. Bear in mind that this was a long time before I did anything with The League of Extraordinary Gentlemen. In fact, it was Lost Girls that was certainly one of the main parents of The League of Extraordinary Gentlemen. I found that I was having so much fun using other people's characters in this kind of literary afterlife… and it seemed to work so well in terms of pornography… I thought, hey, maybe this would work for an adventure book as well. And that was pretty much where the whole thing with The League of Extraordinary Gentlemen came from. But once we had the idea for those three women it seemed that they would serve our purposes sublimely in terms of the kind of sexual narrative we wanted to tell, in that they provided an immediate source of identification for most of the readers. We all grew up reading about these characters when we were at a very young and impressionable age and to a certain degree… We read about them as children, now we're adults reading about them as adults. There's a certain sort of identification you can get there… To a certain degree every single one of us was once a beloved children's fantasy character, even if only to ourselves. All of us, our own lives, our own childhoods, we mythologise them, and we probably sentimentalise them. So these characters that we first encountered when we were young, they almost become a kind of shorthand for ourselves. That was what we were hoping. And the fact that each of these three female characters are suddenly plunged into this bizarre world in which nothing makes sense in the way that it once had done, which seemed like a kind of a no-brainer in terms of being a metaphor for how all of us, to a certain degree, enter into sexuality. Then there was the characters themselves and those specific narratives seemed to offer such a lot of material that could be interpreted sexually. I'm not suggesting for a moment that any of them intended anything sexual in those narratives. I think quite the reverse, with the possible exception of Peter Pan, which is the darkest of the three stories and it does seem to have an awful lot to do with growing up. But even if the authors didn't intend anything sexual in their stories they were drawing imagery from their own unconscious so it's not really surprising that there are going to be sexually symbolic elements that creep into the original imagery. It seemed like fair game. It seemed like whether the authors had intended the sexual element or not that was at least a reasonable interpretation, amongst many, that could be drawn from that material. And it provided us with a quite interesting intellectual puzzle, taking these events from these three stories, how can you possibly decode this part or that part and make it into something that is both sexual and meaningful? When it works it works wonderfully, you know, the final scene with Captain Hook where we made sense of the alligator and the clock in its stomach in terms of

the anxieties of a predatory paedophile. When it worked it really seemed to work well, you know, it seemed like these were obvious ideas, almost, to be drawn from the original texts and it seemed sort of natural, even though they did take an awful lot of contrivance. We've had a few people that have said that when they're read the scenes in Lost Girls they have a strange sense of deja vu because they are so familiar with the regular versions of those particular scenes.

There's a kind of intersection that happens between the original narratives and what you've created that forms something special there.

Hopefully, yeah. We wanted to be as true as possible to those original stories and characters because both the characters and the stories we respect a great deal. So we very much tried to make it a realistically conceived notion of what Lewis Carroll's Alice, for example, might have grown up into. We had to make assumptions about the class of the three characters because we were delighted to find that not only were they three different ages, that they also come from three different class backgrounds, which was something that we wanted to emphasise. But we tried to project those childhood characters forward. You know, Wendy the way JM Barrie portrays her is a very respectable, almost prudish, middle class little mother, whereas Alice could conceivably come from a fairly well heeled Oxford background. That seems conceivable. Dorothy, of course, is from rural Kansas and it's a fairly blue collar existence. We tried to extrapolate from what we could believe about these characters… and our Alice, yes, she is semi addicted to laudanum but that really wasn't something that we just pulled out of thin air. Of all the three books, the one that seems to have the most overt drug references is Alice in Wonderland, as Jefferson Airplane so wisely pointed out for us in White Rabbit. She does seem to eat and drink a lot of substances that change her size; there is that hookah smoking caterpillar… so that seemed to be an element along with the general psychedelia of the Alice story itself. It is very opiated and strange.

I was going to ask you about that, wondering what part drugs played in the creation of the books — if at all.

Well, about the same as they play in any of my work. I've been smoking hashish since the age of fifteen, so that's, what, thirty seven years now. Christ! Is it really thirty seven years, well, well. So it's something throughout all of my work… I am probably sitting there and smoking while I'm doing it. It's something which is pretty much like eating or breathing to me now. It doesn't really disable me in any way. I don't think that I am a traditional stereotyped pothead in that I don't just sit on the sofa all day, I do quite a lot or work, and I find that it really helps with the work. That said, it probably also colours certain perceptions in the work, so if I was writing about Alice I prob-

Stravinsky's Rite of Spring, both events strangely mirrored by the pokings and probings of the three heroines. Later, in Book Three, as the lust becomes more dreamlike and trangressive the counterpoint narrative is Trois Filles de Leur Mère, a book that tells the story of a family's incestuous times together, an apparently genuine, extremely scarce work written by Pierre Louÿs, a French poet and Romantic writer. The images (not by Louÿs) are drawn with great skill, and sit well alongside Gebbie's feminine pastels and paints. As you can read in my interview with the author, I truly didn't realise that these pictures had been done by Melinda Gebbie; they are that different from the hand that guides the rest of her panels. They reach the summit of pastiche, oozing with high Victorian detail, every frond and pattern in the fabrics and decor as vivid as a hallucinatory episode in Huysman's Against Nature.

This is one of those Moore books that's different from all his other books, one that stands at the shoulder of V for Vendetta, From Hell, Voice of the Fire, Halo Jones and Watchmen. Does it matter that The League of Extraordinary Gentleman used exactly the same conceit? In Lost Girls, the meta fictional universe is framed within itself by a Russian Doll shape to the stories. It is self consciously artificial, revelling in its fantastique so much that J K Huysmans would be jealous. But so what? This is erotica, so what you want to know is: Is it sexy and how far has Moore achieved his aim to create a 'respectable' pornographic work that is beautiful, a more innocent eroticism, unbound from the lazy, degrading conventions of the body literature? On the first count I would say he has done well enough for me. As ever, the frame compositions are carefully chosen, less adventurous than you might hope for given the unlimited possibilities of views and angles. A single camera approach is the best way I can describe it, as if this was a storyboard for a film. As is so often the case with Moore's plan. There is much playfulness and invention and I admire the way Melinda Gebbie has brought it resplendently to life. Her figure drawing varies between fair and very good, and she does not devote the same amount of attention to crowd pleasers such as volume and shading as she does to experimenting with mixed media. The results build to a masterly display as the whole great work unfolds before your eyes. She has put in a positively Greek act of dedication. What she is supremely great at is design, patterns and layout. The aesthetics are strongly guided by the art deco, later on by Beardsley and the Symbolists. The artist's transmutation of all this into her own style succeeds very well. Her silhouette work on the Wendy chapters is very fine indeed. These three books contain many of Gebbie's finest artistic achievements.

Much emphasis is placed on drug taking. Whether it is more of a turn on to know that the characters are exploring their passions on drugs is open to question. This added naughtiness does not disguise the fact that there is a sexual

ably tend towards more florid and drug influenced language because that would seem to be more appropriate to the character. Beyond that it certainly wasn't a work where I would be doing magickal rituals involving drugs as I would have done for, say, Promethea or work like that. It's whatever's appropriate to the work in question. But with Lost Girls it was just the general default tons of hashish really.

I was wondering about you and Melinda in the process of creating the books, about how your relationship developed.

It's interesting. It's a good question. Obviously, the book has taken us, what, sixteen, seventeen years to do, and there's a lot of relationships that don't actually last that long. So it's the first time that I've collaborated on anything major with a woman, but it's certainly the first time that I've collaborated on anything with somebody that I'm in a relationship with. It would seem that there might have been all sorts of problems but actually we found that the reverse was true, that to some degree there was a kind of — horrible modern word — but there was a kind of synergy in it in that I think that the book certainly helped our relationship in that if you're going to be doing this kind of material then a prerequisite is that both collaborators have to be completely honest about their reactions to various ideas. So right from the very start there was a kind of sexual frankness that was existing between us that was almost demanded by the work and there's a probably a lot of people who can have relationships for years who never achieve that level of frankness which was the level we started out at.

You must have found out things about each other that surprised you both.

I can imagine you possibly thinking of a scene and then thinking, "I wonder how this is going to play with Melinda."

During that sixteen or seventeen years we had endless conversations about almost every conceivable aspect of the work, about almost every conceivable aspect of <u>each panel</u>. Sometimes I would suggest a scene for way down the line, and Melinda would perhaps suggest that she had some reservations, maybe, so we'd discuss that and I'd try and think of ways to adapt the scene so that <u>I</u> still found it as exciting and so that Melinda found it exciting as well. It was a good acid test for the material, if we could after great deliberation both arrive at a point where we thought that yes this is the scene and this is how both of us feel comfortable with it and how we best imagine it. That happened an awful lot. Actually we disagreed on surprisingly few things. That's possibly because we both have very similar agendas that we arrived at independently. We were talking about this the other day, that actually, looking at it, <u>Lost Girls</u> is pretty much a perfect product of the agendas of the 1960s, which was the time when me and Melinda had our most formative experiences politically, and in terms of life experiences. If you look at <u>Lost Girls</u> it's got an incredibly strong anti war message, it is pro sex, it is dripping with art nouveau, it's about Alice in Wonderland and children's fantasy stories. These are all classic motifs of the 1960s, everything was in art nouveau, we'd only just discovered Aubrey Beardsley at the time, or at least in <u>faux</u> art nouveau. There's even a lot of flowers throughout <u>Lost Girls</u>, it's a very flower powered narrative. It's talking about Victorian times, Edwardian times, but I think the agendas behind <u>Lost Girls</u> pretty much do boil down to make love not war… Given that we both have this almost identical agenda: sex is good, war is bad, all these other simplistic hippie notions that are so dear to our hearts. And so there were very few points at which we disagreed upon. I can't really think of any major points of disagreement… Melinda was very concerned that all of the scenes have an inviting warmth — if that was appropriate — to them.

There must have been — I'm guessing — there was a point where you were thinking during the creation of it that this is going to be quite strong; that this is going to have ramifications wider than with people who ordinarily read graphic novels.

This occurred to us right from the start because the subject matter is so universal. You don't have to know the complete back story of Superman to enjoy reading about sex. You don't need all of that cluttering continuity that affects most genres. There has been nothing like this actually done before, not just in the first person, not as far as we know, but in the wider field of erotic art, I don't think there's been a work of this ambition… There might be something that might turn up but I couldn't think of anything, not this sustained and like I say not with this much ambition. Given that, we were aware that this was going to be something pretty spectacular and something fairly new. We couldn't even let ourselves even think about… I mean, obviously we knew there might be a huge negative reaction to it. That was always a possibility. But it seemed that if we took our time with it and if

coy-ness running through the book. I wouldn't place myself in anything like the same league as Moore as an inventor of fiction but I know that if I was writing a pornographic book, I'd think twice about the restrained forays into S&M and the amount of mutual masturbation evident here. It may well be that I expected too much of Moore (as the Weeping Gorilla knows), although I should qualify this by adding that the story more than makes up for it in other aspects.

There is a confounded conundrum with From Hell and this book, the way the pair mirror each other but are fatefully divided. From Hell is an odyssey through some very dark places in the male psyche; a very dark and rampant demon wrote that book. (Is From Hell more shocking because of what happens in the narrative, or because of the amount of effort it took for it to be created? That is the real secret of the Occult, Jack the Ripper, etc. everyone. It's a publisher's game about fancy editions. Ha ha ha, laughs Jack.) Lost Girls has the influence of Venus and celebrates love and sexual joy as a creative means. In From Hell, the feminine aspect was either absent, or in the process of being obliterated, not just from the characters, but from the entire universe of the book. Lost Girls is as much about ideas as any of Moore's stories. It sets out a co-active conspiracy of partnership, where the characters move into and out of one another, not through and around. They taste, explore, and enjoy one another, almost without the conflict that would normally be a narrative propellant. It makes for a rare kind of story, and Chris Staros and Brett Warnock at Top Shelf Comix are to be admired, having taken an enormous gamble by publishing this book. Despite certain shortcomings, Lost Girls is the most interesting work written by Alan Moore in a long time, surpassing the good (yet vastly overrated) League of Extraordinary Gentleman project. And while not as visually bold as Promethea, another dazzling work from this era, the language of Lost Girls surpasses that work as literature with exquisitely beautiful writing, showing again how Moore is one of the most creative and versatile practitioners of English phraseology. This writer has lost none of his ability to blow minds with words; if anything he becomes more fertile, more inventive as he matures.

Can we ever expect to be treated to the mysterious Lost Girls 'lost book,' the Book Four tale of how the Von Trapp children turned up in 1950s Shanghai and became prostitution and heroin barons? Doubtful. But I wouldn't put it past this creative team.

Lost Girls
Published by Top Shelf Productions, September 2006
264 pages
ISBN 1891830740
UK £45 / US $75
[w] www.topshelfcomix.com/

we did it to the best of our abilities that we might be able to take Lost Girls and pornography into some completely new area where pretty much all bets would be off. I remember that during the sixteen years there have been various comments upon Lost Girls from the comics press. I remember reading somebody saying that, "You know, this is a work that I'm really looking forward to, it's a pity that because of its subject matter it probably won't get a very wide audience," and I was thinking I really can't understand that point of view. I mean, the guy was being very sympathetic towards Lost Girls but it seemed to be such an insular comic book viewpoint: the idea that something that is based around sex is automatically not going to get a wide audience, whereas if it had been based around superheroes, of course, in comic book terms they would be thinking the sky's the limit.

Did an English writer say that?

I can't remember to be perfectly honest. I remember it struck me as odd because right from the beginning I was kind of thinking that, actually, if we do this well enough this could be massive. We got a lovely postcard — if you can just excuse me bragging for a moment, I'm as smug as hell about this — we got a lovely postcard from Brian Eno, who'd got a copy of the book and was describing it as epoch making or at least epoch shaking, which might be over egging the pudding a bit but it's a very nice thing to say… We also started to see parallels as we approached the publication of the book that we hadn't originally intended to be there but these parallels had started to emerge with Stravinsky. Originally, when we included the Rite Of Spring — which is one of my favourite pieces of Melinda's artwork in the entire book — when we originally included that at the end of Book One it was purely for structural reasons and historical reasons. It seemed like a great way to end the first third of the book with this ominous suggestion that all was not right in Europe, that there was sort of an emotional storm brewing, that the attending Rite of Spring had somehow kicked off or played into, and that as we've approached the publication of the book… I'm not equating the Rite of Spring with Lost Girls in any way, except that they're both about quite primal things, they're both about sex and death, they're both being released into a world that is, at least in terms of America, is probably more repressed than in any time in — well, certainly in my lifetime, since the Eisenhower years. There's an incredible level of repression, sexual repression over there, and there's also all of these political tensions existing in the world. It is obviously overripe for war and this is coming out of the early years of the twenty-first century. Rite of Spring came out in the early years of the twentieth… you know, it struck me that there might be a couple of interesting parallels there…

There's already plenty of reaction on the Internet to it. There's already a lot of debate,

both pro and against what you've done from people who haven't read the book.

This is the thing. Leah, my daughter, was telling me that she'd been looking on some of the messageboards and websites, and she said that, "You've got some people who have not read the book who are reacting to the concept of the book," or overreacting to the concept of the book. And there was apparently some string of commentary that kicked off with someone saying "Alan Moore is fucking sick," and going on about how this was a foregone conclusion given the nature of Lost Girls, and Leah said that actually developed into a really interesting message strand, lots of other people joined in with the debate and she said that it was generally illuminating that there were people discussing issues that they would perhaps otherwise not have discussed, and she said that the end result was actually fairly informed and intelligent which is a good thing. Whatever the outcome of the debate if these things are even being talked about then that is certainly is step in the right direction. One of the main things we wanted to do with Lost Girls was to transform pornography into something that might actually have a social and human function, something where pornography could become an arena, a forum in which our sexual ideas could be discussed openly and without shame and guilt, and could be discussed harmlessly. There aren't really any such forums, other than the current generally dismal regular pornography, or the antiseptic sex manuals, neither of them representative of the way most of us feel if we're actually thinking about our sexuality.

I wondered if it might possibly inspire some couples to attempt to create pornography together with each other.

I would recommend it. We were saying a while ago, I thought the fact that me and Melinda were working upon Lost Girls was an incredible benefit to our relationship, and I would recommend it, yeah. The secret of a long and happy relationship: work on a really complex piece of pornography together and I guarantee it will work wonders. On the other hand, I think that there was feedback the other way in that I think that the fact that me and Melinda were in a relationship together brought something to Lost Girls that would not always have been there. I think that there was a warmth and a kind of compassion in Lost Girls that is not generally there in other pornography, and I think that to a certain degree that probably came from the fact that me and Melinda were in a loving relationship.

The other books that you quote from… I think it's in Book Three in the chapter "A Merry Crew Beneath The Setting Sun," with the book by Pierre Louÿs… Now that's a real book, isn't it?

Well, "A Merry Crew Beneath The Setting Sun" is actually a quote from one of the three source books — probably from Peter Pan. Now, Pierre Louÿs, he's a real author as were all of the authors we were pasticheing, and it was a pastiche, it wasn't really by Pierre Louÿs but he was a fantastic pornographer. I mean, he had early literary success with, I think, Love Song of the Lotus, which got him immense literary acclaim and a lot of money, and literary acclaim so disgusted him that he spent the rest of his life writing pornography that he knew was so over the top that it could not be published. Nevertheless, there were a few pamphlets of his work that were published. But I thought that was very committed, you know, to actually brush aside respectable literary fame and just devote himself purely to pornography. His most available pornographic work is The She-Devils, which is published I think by Creation Books. That is probably a lot stronger than we made the supposed Pierre Louÿs section in Lost Girls, and the illustrations for that section, that was the Marquis Von Bayros illustrations. Those were the ones that nearly

Moore's homage to the House of Ideas. *1963 Book One: Mystery Incorporated*, Alan Moore, Rick Veitch & Dave Gibbons, and *1963 Book Five: Horus, Lord Of Light*, Alan Moore, Rick Veitch & John Totleben (Image Comics, 1993).

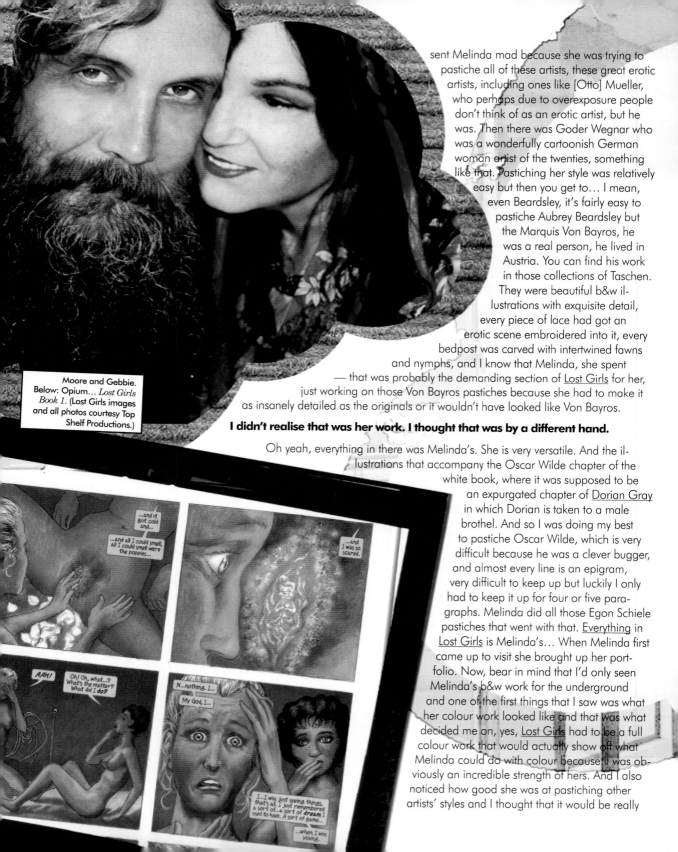

sent Melinda mad because she was trying to pastiche all of these artists, these great erotic artists, including ones like [Otto] Mueller, who perhaps due to overexposure people don't think of as an erotic artist, but he was. Then there was Goder Wegnar who was a wonderfully cartoonish German woman artist of the twenties, something like that. Pastiching her style was relatively easy but then you get to… I mean, even Beardsley, it's fairly easy to pastiche Aubrey Beardsley but the Marquis Von Bayros, he was a real person, he lived in Austria. You can find his work in those collections of Taschen. They were beautiful b&w illustrations with exquisite detail, every piece of lace had got an erotic scene embroidered into it, every bedpost was carved with intertwined fawns and nymphs, and I know that Melinda, she spent — that was probably the demanding section of <u>Lost Girls</u> for her, just working on those Von Bayros pastiches because she had to make it as insanely detailed as the originals or it wouldn't have looked like Von Bayros.

Moore and Gebbie. Below: Opium… *Lost Girls Book 1*. (Lost Girls images and all photos courtesy Top Shelf Productions.)

I didn't realise that was her work. I thought that was by a different hand.

Oh yeah, everything in there was Melinda's. She is very versatile. And the illustrations that accompany the Oscar Wilde chapter of the white book, where it was supposed to be an expurgated chapter of <u>Dorian Gray</u> in which Dorian is taken to a male brothel. And so I was doing my best to pastiche Oscar Wilde, which is very difficult because he was a clever bugger, and almost every line is an epigram, very difficult to keep up but luckily I only had to keep it up for four or five paragraphs. Melinda did all those Egon Schiele pastiches that went with that. <u>Everything</u> in <u>Lost Girls</u> is Melinda's… When Melinda first came up to visit she brought up her portfolio. Now, bear in mind that I'd only seen Melinda's b&w work for the underground and one of the first things that I saw was what her colour work looked like and that was what decided me on, yes, <u>Lost Girls</u> had to be a full colour work that would actually show off what Melinda could do with colour because it was obviously an incredible strength of hers. And I also noticed how good she was at pastiching other artists' styles and I thought that it would be really

good… I know that she enjoyed doing it as well, it was a lot of fun to recreate the style without actually swiping anything, you know. It's a challenge and it's a lot of fun. So that was more or less the genesis of the whole idea of the white book, of this kind of porno Gideon's bible that's in every hotel room. We wanted to give a kind of potted history of erotica included within Lost Girls.

It helps to make the main characters' stories stronger, more believable if you like, when they are reading stories in embedded narratives; it's a very powerful technique.

Well, it also manages to make a very strong contrast between pornography as it is conventionally understood and pornography as we attempted to make it in Lost Girls. I mean, one of the nice things Neil said in his review was that in pornography generally there are no consequences. There are no pregnancies, there are no emotional consequences. It's a pornotopia in which these stories occur, whereas in Lost Girls there are all sorts of consequences. So it was interesting to have our kind of pornography in the foreground and to contract that with these imaginary but fairly typical other forms of pornography, these worlds in which — you know, in the Pierre Louÿs and the Von Bayros story in which you've got unbridled incest and everybody's completely happy with it, which of course is something that I don't think happens in the real world, it only happens in the realm of pornography. So it was interesting to contrast that with the different form of pornography that we were attempting to construct with Lost Girls where these are real characters or as real as we can make them, where they do actually have character which is more than can be said for the protagonists of most pornography, and where the things they are doing and the things that have happened to them has emotional consequences. It's a fairly small alteration to the pornography formula but perhaps quite a vital one. I mean, if you actually care about these characters it's sexier, isn't it? And at the same time it's more fulfilling in other aesthetic senses. I'm not anticipating that Lost Girls is going to set off a wave of beautifully rendered and literate pornography but it would be nice to think that we've provided some sort of benchmark, something that says that this is possible, it is possible to produce something like this from the human imagination, something in which sex and sexuality are treated with the beauty that they deserve. To read Lost Girls you'd think that there was nothing shameful about having thoughts concerning sex, which is the kind of impression that we wanted to give because it strikes me that the way people generally regard pornography is a kind of — at least in cultures such as here or in America — the way that pornography generally functions in those cultures is as a kind of control leash. In cultures such as Holland or Spain or Denmark where they have a completely different relationship to pornography, where pornography is widely available and is so ubiquitous that people hardly notice

it… Those countries have a much lower incidence of actual sex crime than Britain or the United States. In our cultures we've got just as much pornography as they've got in Denmark or Holland or Spain but we've got a different attitude towards it. We have all of this immense reservoir of guilt and shame that is seemingly hard wired to our sexual imagination, and we exist in highly sexualised societies in which every Pot Noodle advert is dripping incongruous sexual imagery. And the sexual imagery in a Pot Noodle advert is not just selling Pot Noodles, it's also selling sexuality itself. It's helping to increase the sexual temperature of the entire culture, as if every twelve year old girl in a "Porn Star" t-shirt, this kind of post Spice Girls sexualising, of self sexualising of the nation's nine year olds, which of course all The Media cheerfully go along with 'cause it's, "Aw, isn't it cute, she's got a belly button ring and lurid suggestion on her t-shirt." So, we end up with these very sexualised societies and some people under the pressure of that are going to try to find some sort of release, probably in pornography, and the moment that they have achieved that release they will immediately be plunged into feelings of shame, wretchedness, self disgust, loneliness. It's a bit like a B F Skinner lab experiment only crueller. It's like if you've got your behaviourist rats in their boxes and you've given them the stimulus, you've shown them Britney Spears in her schoolgirl outfit in that video enough times so that they're really charged up, you've given them the stimulus. Then they press the lever and they get their brief couple of seconds of orgasmic reward, and then immediately after that they get an electric shock, immediately they've got the reward they've got the punishment: shame, guilt, wretchedness, loneliness.

Those are emotions that you have your characters experiencing, and that for me helps make it sexier because it feels more believable. They have these wonderful scenes of sexual abandon, and then afterwards they feel shame and guilt, and real human emotions, and that's something that's absent from ordinary pornography.

Almost anything that isn't involved with… plumbing and meat mechanics is absent from most pornography. If you look at the way that pornographies are structured you'll find that most writers of pornography, they start at full blown orgy level and they continue at full blown orgy level, and they end at full blown orgy level, with an exhausting number of repetitive permutations in between. With Lost Girls the first book is almost innocent. I don't think there's any penetration in the first book. It's in the second book that the action becomes a bit faster and a bit more frequent. And it's not until the third book that we sort of crossover all lines and plunge into the full blown sexual hinterlands, which was intentional, y'know? An ordinary novel would have a structure and build to a climax, so surely pornography should build to a climax — any genre should. We wanted to do all the things that regular writers, proper

writers and artists, do in order to engage an audience's attention, and we thought that this would only enhance how sexy the book is. You don't want to hear about the mundane concerns of somebody's life in the middle of a hot sex scene, no, that wouldn't work, but that doesn't mean that you don't want to hear about their personality or their experiences. It's possible to write stuff that is sexy where there's other stuff going on as well. As long as you can keep the readers' sexual interest engaged then all of the other stuff can be absorbed around the periphery, they'll be picking up the rest of the stuff subliminally, they'll be starting to find that they like one of the women more than the others, they're finding out about the three different characters. They're actually interested in the characters rather than who they're having sex with and how they're having it.

Would you be intrigued by the possibility of a filmed version of it?

Er, no. I think that you know the answer to that one before you asked the question… That said, I have — I mean, just because I'm cranky with the whole idea of film adaptations, that doesn't mean that my collaborators should be penalised. I've stated that I simply don't want any of my works to be filmed but in the cases of collaborative works it wouldn't really be fair for me to say that therefore Melinda should forego anything like that, so what I'll do is I'll put the choice firmly in Melinda's lap, that should someone express an interest in making Lost Girls into a film — although I can't think why, it would be pointless, when it's so beautiful as a book.

And the language would be a problem, and —

Everything would be a problem. When I did From Hell, y'know, I was aware that comics was the only medium that I could get away with From Hell in. The frankness with which we approached the whores in From Hell, you could only do that in a comic book. If you did that in a film it would unbearable. Like the same with Lost Girls. Considering that comics are still thought of in some quarters as a medium for children it's amazing what we can get away with in comic books but you could never get away with in film. It's an incredible freedom that the medium does give you, which we've tried to exploit with Lost Girls, so you know, there probably wouldn't be a lot of point in trying to realise it on celluloid. I am kind of notoriously cranky on films. That's probably just as much to do with my psychology as to do with anything rational. No, if somebody did want to make a film I wouldn't have any objections as long as I didn't get any money for it and my name wasn't anywhere near it.

I'll just pick up on a detail that struck me from one of the chapters, which is when Peter Pan says to Wendy… I think she mentions that he's using "fairy language"

when he used words like "fuck" and "cock."

That's a nice little scene wasn't it? I was quite surprised at how that came out. I was trying to equate fairies with the working class in some way, I suppose. I mean sometimes I do these things and then have to unravel them afterwards: What did I actually mean by that? I probably just wrote it because it sounded good.

I wondered if maybe it had sprung from your magickal experiences.

Not really… To a certain degree everything that I do and everything that I write springs from my magickal experiences in the sense that magick these days, twelve years into my magickal career, has become indistinguishable from the rest of my life, it's no longer a weird place that I visit at weekends. So I suppose that all of my outlook and to a certain degree all of my art is gonna be influenced by it, but I think in that particular instance it was more the — I was more trying to present Wendy's view of a child from a traditional middle class Edwardian background of the kind of working class scum that her and her brothers had happened upon playing in the spinney. To them, the working classes would almost seem like a strange other race, a fairy race perhaps, and that the traditional coarseness of working class language, words like "cunt" and "fuck," might seem, at least — I could imagine that to certain ears they could almost seem like a forgotten ancient language that was spoken amongst the fairy folk… That was a passage that stuck out to me when I was rereading it. I was quite pleased with that one.

I'm going to ask you about a couple of other works. You're working on a novel called Jerusalem.

That's right. Probably the best thing I've ever done… at least to my mind. And almost certainly the longest that I will ever do. It's looking to be over half a million words, which I've been told is about fifteen hundred pages, which has gotta be getting close to the actual physical limits of how big and thick a book can be because this is not something that can work as separate volumes. It is divided into three parts but they're not parts that would stand separately as volumes. It's a very strange piece of work and it's completely devouring my entire life. I've been working on it for about the past eighteen months.

Are you doing historical research for it?

To a certain degree. I've probably already done most of the historical research. Because of the nature of the book it's all about the area that I grew up in, which is an area in Northampton called The Boroughs. If you go back to the 1200s The Boroughs was Northampton. Most of the early history of Northampton, which is quite colourful, happened in The Bor-

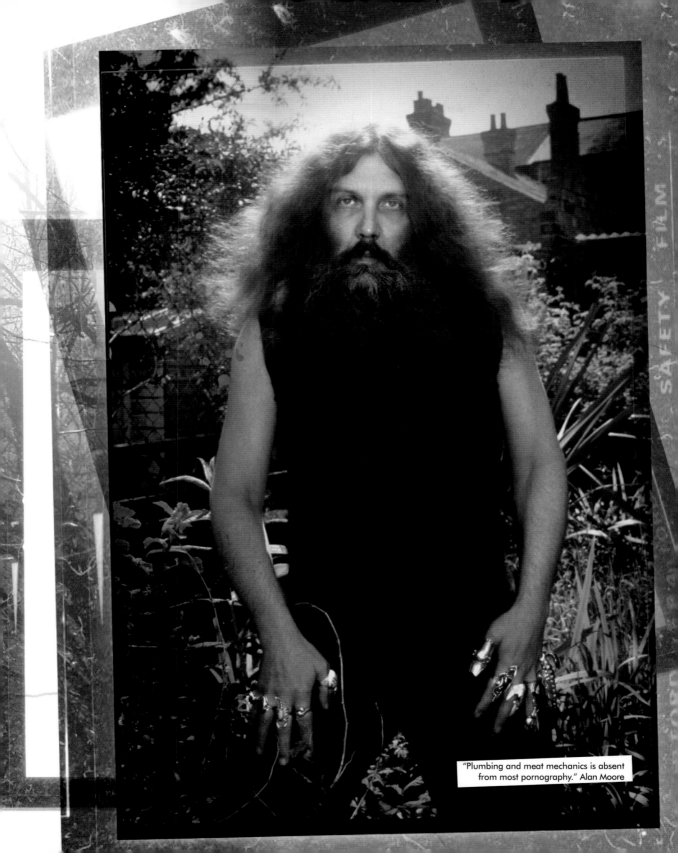

"Plumbing and meat mechanics is absent from most pornography." Alan Moore

oughs, which means that at the end of the street that I was born in, St Andrews Road, there was Castle Station which was formerly Northampton castle which was formerly the castle of bad King John, as mentioned in the opening scene of Shakespeare's <u>King John</u>, therefore it was the castle in which Richard the Lionheart raised the first Crusade, the western world's first major contact with Islam — and we all know how that worked out. Oliver Cromwell stayed in The Boroughs… We're talking about half a square mile of ground here, of dirt. Oliver Cromwell stayed there the night before he went to Naseby. The War of the Roses was concluded just outside The Boroughs in Cow Meadow. Charlie Chaplin began his career in The Boroughs. He was born and raised in Lambeth, as was my grandmother, but he did one of his first performances at the age of seven at the bottom of Gold Street in Northampton, right on the corner of The Boroughs with The Seven Lancashire Lads. He gets a chapter, although I don't identify him as Charlie Chaplin because that would be over egging the pudding, so I've just got a chapter from this particular character's point of view, and he never identifies himself as Charlie Chaplin but the audience will probably catch on. And all these astonishing things… I mean, Thomas à Beckett and Northampton Castle was the castle where Henry II invited him, apparently as a gesture of reconciliation, but Henry was selling him out to all of the barons that were baying for his blood and his property, so that was just before Beckett fled the castle and by circuitous route went to Dover and went to France for three years before he was persuaded to come back and got martyred at the abbey… Samuel Beckett, he makes an appearance —

Playing cricket!

Well, he came to Northampton to play cricket, he's mentioned in <u>Wisden</u> for his innings at the county ground, which is just at the bottom of the street where I live now. But fascinatingly, while the rest of the cricket team were out that evening sampling Northampton's other famed attractions, which was drink and prostitutes, apparently Beckett decided that he'd go on a weird nocturnal walk taking in all of Northampton's fantastic churches, because the three oldest churches in the country are in Northampton, two of which are in The Boroughs. So yeah, one night Samuel Beckett was creeping round all of these ancient churches as an alternative to drinking and whoring, and so that night gets an inclusion. Lucia Joyce turns up in the book, James Joyce's daughter who was in the mental home next to the school that I was at <u>all</u> the time that I was there. I didn't realise it but she was there for about thirty five years. Lots of strange historical presences and more recent figures, and all of the actual people who lived in The Boroughs, which is where I've been not so much doing historical research but doing kind of living memory research. I've been down to visit a couple of the old ladies who I know who still live down The Boroughs, or who used to live down The Boroughs, and I've just got this <u>fantastic</u> material that is unbelievable. Some of the facts I've picked up about this area from the ordinary and extraordinary people that live there.

It sounds wonderful, very unique.

It's got everything in it. I've got a black slave who'd been liberated from a plantation down in Tennessee in 1865 at the age of about thirteen, and who still had the brand of the slave plantation on his shoulder so they must have branded them early. But Ian Scarlet Wellstreet in The Boroughs is a rag-and-bone man, riding along on a bicycle that had rope instead of tyres. And I've got a fantastic chapter that deals with him and so I'm dealing with race

Archetypal big-guy superhero Supreme is turned into modern art in a chapter from
Supreme: The Story of the Year, by Alan Moore and various artists (Checker 2002).

and with the black population in Northampton with what has happened to The Boroughs because it is the red light district in Northampton now, it's an absolute running sore of a neighbourhood, it's always been the poorest neighbourhood in town but there was an incredible sense of community when I was growing up there and that has completely gone. It's a kind of a moral crater, y'know, which is partly what the book's about. But in amongst all this, the main core of the book is an argument that hopefully answers the questions of life and death and what it's all about. Do we go anywhere when we die? To which my answer is, no actually, we stay here and we very probably have our lives over and over and over again down to the last exact detail, which is something I've since found out is something that Nietzsche talked about in Thus Spoke Zarathustra. I was thinking about space and time as modern physics would have us understand it, and it struck me that if I understand Einstein or the rest of them as well as I think I do, then they're talking about space-time as a four dimensional solid in which there are the three dimensions that we recognise and there is a fourth spatial dimension which we do not perceive as a spatial dimension, we perceive it as the passage of time, and if that is true that means the whole of the universe is kind of coexistent. All the moments that ever were or ever will be are happening at once in some giant hyper-instant that's got a bang at one end of it and a crunch at the other, and every moment in between is suspended there unchanging forever. Change in the universe would be something that is only apparent to our consciousness as it moves along the time axis. And that struck me as, well in that case if every moment exists unchangingly forever that includes all the moments that makes up our individual lives in which we are demonstrably alive and conscious. And so if they're unchanging then we have to be alive and conscious in that tiny little filament of space-time that is ours… forever. And it struck me that it would certainly explain deja vu, wouldn't it?

What you're saying is something very close to my thinking over the past few years about change, about place, and about how so much is spoken about change. We're always told that things are changing all the time, but the more I consider this the more I think that very little changes in terms of human beings.

Things appear to change but pretty obviously things work out how they were going to. The thing that apparently Nietzsche and my favourite artist Austin Osman Spare balked at was this idea of recurrence, the thing that they really couldn't accept was that it implies that there is no such thing as free will, which they found too upsetting to tolerate, which I'm fairly relaxed about. I've been reading some interesting stuff in New Scientist about the mathematician Gerard t'Hooft (who's got one of the loveliest surnames I've ever I've had the privilege of pronouncing). He recently proposed (this is in science-philoso-

phy and we haven't actually got a way of verifying it yet) there was a sub strata underlying the quantum level in which all the ideas of quantum uncertainty are actually resolved, so that there is no quantum uncertainty, which would also mean that there is no free will. So it's a contentious theory, one that I'm playing with in Jerusalem. And I've gotta say, whether this idea is true or not, I find it a very likeable idea because —

It takes a lot of pressure off.

In some ways it does and in some ways it certainly pressures on you. This is a completely secular idea, at least potentially. It doesn't require a god. It just requires us, our consciousness running on this endless loop in our little filament of space-time. Now there are interesting moral dimensions to that. For one thing, the best moments of your life forever. That is surely your eternal reward, that is Heaven. The worst moments of your life forever, that is unending damnation, isn't it? That is Hell. And so I think there's enough Heaven and Hell in this idea to satisfy even the most fervent brimstone preachers, and there's a sort of a moral sense that you can extract from it in that, if you're going to be living this moment, this moment right now, forever — potentially — then live it as joyfully as possible. Try not to do anything that you cannot live with — potentially — forever. It's not saying that there's gonna be some god who's watching you and is going to come along and judge you. It's saying that actually you're going to be judging yourself… at almost every moment.

And it focuses all responsibility on the individual. You can't dump any of it onto another —

— A devil or even society at large. You can't say it's my parents' fault, it's society's fault, government's fault. It's saying, this is your life. This is your life, live it. Live it with responsibility, take responsibility for each second of it, and take responsibility for who you are because it might be who you are eternally. Because of course this wouldn't be the first time we've been through it, would it? That's not very likely. I mean, it suggests that, in a sense, we've already, all of us, been dead for centuries. We are being looked back upon in some funny coloured photo album by people not yet born at the same time that we've not yet been born, and most of our ancestors have not yet been born. I've put the idea to a number of people, and they've either found it incredibly comforting, while some of them have found it incredibly frightening, they've really not liked the idea at all, and I think that's interesting that response. It seems that there might be something to this idea. So I'm kind of unfolding this idea throughout this half a million word novel. There's outrageous fantasy in there, there's ghosts, there's demons, there's angels, there's fairies, but not quite as they're normally depicted.

Would they be based on your magickal practices?

Yeah, a lot of them are based on magickal insights but that said they're not gonna conform to any kind of Golden Dawn or comparable view of magick. There's the bit that I'm doing at the moment, the middle third of the book, reads more like a children's story, but a very adult children's story. It's mainly because it's primarily about children, a gang of dead children running round through the afterlife, a sort of fourth dimensional afterlife for the entire middle third of the book. The writing is quite adult and grown up but the fact that it's about children and from their perspective tends to give it that children's book feel. Meanwhile it's talking about fourth dimensional mathematics and morality and the persistence of events. I'm having a lot of fun with it. It'll be another couple of years before it's done.

In terms of your writing, is this the major project that's consuming you?

At the moment, yes, it's the only project that's consuming me with my writing with the exception of the continuation of The League of Extraordinary Gentlemen that me and Kevin [Smith] will be working on. Kevin at the moment is just finishing The Black Dossier which is a big League of Extraordinary Gentlemen document, it's not the third volume, but it's a big self contained League of Extraordinary Gentlemen book that is a lot of fun. It's got almost everything that you could ever hope for in it including a free vinyl seven inch single. That'll be coming out hopefully towards the end of the year. Kevin's just finishing the final 3D section of the narrative which should be pretty spectacular, and it's got everything in it, like I say. There's a sequel to Fanny Hill in it. There's a mock Beat generation novel called "The Crazy Wide Forever" that is written by Sal Paradise who was the Jack Kerouac surrogate character in On The Road. There's a Bertie Wooster novel which pits him against the entities of HP Lovecraft. There's a life of Orlando that gives an entire timeline for this fictional world from about 1190BC to the Second World War. There's an unbelievable amount of stuff in it, and that will be coming out sometime before the end of the year hopefully. Then me and Kevin will be getting on with volume three of The League of Extraordinary Gentlemen, which will be published by Top Shelf. I've not started writing it yet because I want to give Kevin a chance to get this out the way, but I've got the story pretty well thought through. So that will be something I'll be getting on with at the same time as Jerusalem but other than that at the moment those are the only two. Jerusalem is the only thing I'm working on at the moment but I'll be picking up The League of Extraordinary Gentlemen again in a couple of months.

Is magickal exploration something you would like to make more public or is it more of a private activity?

After I've finished with Jerusalem, then me and Steve Moore have got a book planned out which would be the Mother and Serpent Bumper Book of Magic that would actually be a straightforward, lucid, detailed explanation of what magick is, how it works, ways to deal with it. Hopefully there would also be a lot of quite funny stuff in there and some quite pretty and psychedelic stuff in there. We've been thinking of including perhaps a set of Tarot cards as part of the packaging. So, yeah, once I've got Jerusalem out of the way in a couple of years then the next [indecipherable] that I should like to actually launch upon is a grimoire, a book of practical instruction about magick that has also got a history of magick as part of it, and probably got an awful lot of the artists that I know contributing to it as well to pretty it up. So that's what's shaping.

Well, I won't keep you any more, Alan.

I think you've missed your chance with Melinda. I think that she's into the heavy passing out jetlag stage by now. Sorry about that but it's just the luck of the draw, I'm afraid.

If you can just pass my congratulations to her —

I will do, I'm sure she would love to hear that. And let me pass on my congratulations about Headpress. The few issues that I've seen were fascinating. I saw one piece — I'm sure it was something to do with Headpress — that was talking about a famous pornographer of the late nineteenth century who was… he was in a kind of a cabal of progressive thinkers with a number of others including, I think Swinburne, and our local MP Charles Bradlaw. I've got that somewhere; that was fantastic. A lot of the pieces I've seen from Headpress have looked really good.

That might be quite an early issue, not sure I've got that.

Might be. It was some sort of special paper, it wasn't perhaps an actual issue of Headpress but something that was a special little publication put out as a peripheral thing, something like that. I've got that around here somewhere; it'll probably be worked into Jerusalem at some point. But I will certainly pass on your comments to Melinda, I'm sure she'll love to hear them ☺☺☺

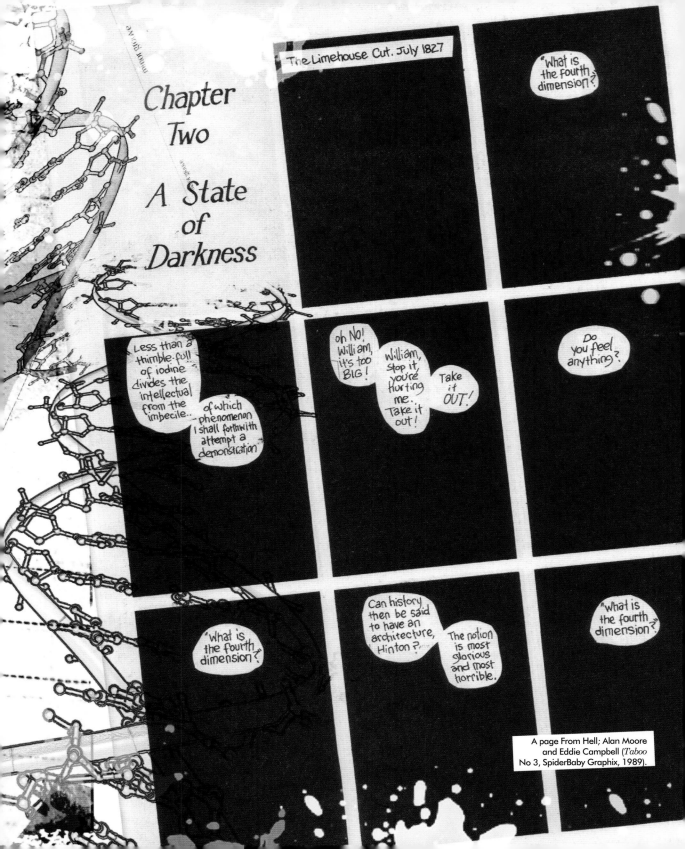

A page From Hell; Alan Moore and Eddie Campbell (*Taboo* No 3, SpiderBaby Graphix, 1989).

'Til you find a land where ~~all~~ is black...
A British dark side psych primer

Compared to its harder nosed American blues based counterpart, British psychedelia of the 1960s is seen as whimsical and obsessed with Victoriana, magic toyshops and teapots. To tar a whole wave of Brit psych one-offs as foppish daydreamers, however, is unjust and misses a profound sentiment of terrifying oddness. MATTHEW COLEGATE investigates in his purple finery. LORD SAVAGE provides the illustration on the left.

Kaleidoscope: Flight From Ashiya

If J G Ballard's *Unlimited Dream Company* had been a song it would be Kaleidoscope's glassily unsettling Flight From Ashiya. Its splintered, chiming guitar and monotone bass suggest a clockwork automaton playing something off PiL's *Metal Box*, but it's the lyrics that conjure up a dense fog of unease. Its setting is a psychedelically skewed plane disaster. "Captain Simpson seems to be in a daze…" sighs the vocalist, "One minute high, the next minute low," before adding in hushed, frightened tones "Nobody knows where we are." Brrrrr. It ends with the assertion that "Nobody will ever know why," as warped, choir like backing vocals add chill to the air. Where Ashiya (a name that could be straight out of David Lindsay's masterpiece *Voyage to Arcturus*) is located we never find out. Probably for the best.

Glass Menagerie: Frederik Jordan

The pacing on this song is unsettling enough, the Hammond organ striking with the ferocity of Jack the Ripper, while the guitars tear an orange haze into the ozone, but again it's the lyrics that do the most to unsettle. Three characters are evoked, Frederik Jordan, his wife and the unnamed singer, "Mr Jordan's best friend," no less. There's a love triangle of sorts going on, the wife is pregnant after making a "scene" with our crowing narrator, who seems to be encouraging poor Frederik toward suicide; "get me a gun I know you can." The song ends with Frederik blowing his own head off. "Frederik Jordan's going to blow his mind," bellow the vocals, inverting the period cliché with a snarl. A gloating, sadistic record, that equals Pulp's masterpiece of class-hatred I Spy in terms of misanthropic energy.

variety (Elvis, Dylan, Beatles, forever and ever into infinity, amen), British sixties psychedelia is seen as something of a joke, an idiot brother to the more blues based (read "authentic") sounds emerging from America's West Coast. Compared to the fried jams of bands such as Moby Grape or the Grateful Dead, British psych is characterised as whimsical and sickly, it's obsession with Lewis Carroll style doggerel, Victoriana and magic toy-shop fantasia an affront to the sensibilities of some music critics.

While this perception is partly correct (there is a strong vein of indolent fantasy in British psych, best demonstrated by some of the band names; The Floribunda Rose, Velvett Fogg, Tinkerbell's Fairy-dust and, my personal favourite, Boing Duveen and the Beautiful Soup) to tar the wave of Brit psych one-offs as foppish daydreamers, ineptly Xerox-ing the innovations of The Beatles, is unjust and blinkered. On a par with thinking that all comics are for kids, or that science fiction is incapable of "literary" merit.

Excepting the bigger, earlier acts (Pink Floyd, Soft Machine etc, all of whom went on to progres-sive rock success throughout the seventies), Brit psych was generally the product of musicians who would jump on a plague cart if it had "bandwagon" written on it. Most of the players on the hundreds of seven inch, one-off records released during the period were ex-R&B musos looking to capitalise on

the next big thing (or who had been pushed toward doing so by eager record labels). The results of this genre leaping were two-fold. Firstly, as is immediately obvious when listening to the tunes, the bands were *hot*. Six nights a week playing James Brown covers in working men's clubs will tighten any band up, and the best Brit psych records have a solid groove, no matter how much the lyrics rattle on about teapots. Secondly, this sudden displace-ment resulted in a lot of people getting it desper-ately, brilliantly wrong. Witness bricklayers from Salford committing embarrassing music hall parody! Gasp as a Brummie accented fey-boy lisps his way through Lewis Carroll's *Jabberwocky*, complete with backing vocalists burble burble-ing! Laugh your mind loose as the world's worst Bob Dylan impres-sion competes with mind numbing falsetto trills on Turquoise's Woodstock!

It was an era of hilarious band photos. There they stand; dressed in foppish finery — scarves, kaftans, King's Road militaria — all with a dead look in the eyes that seems to be saying, "Get me back into my fucking mohair, I look like a poof." A lot of the time the music was equally awkward, but amongst all the no-hit blunders and dunder-headed rip-offs lurk some of the strangest, most unsettling records of their era. Visionary music shrouded in purple smoke, that reminds us these bands are a product of the same imaginative landscape and heritage as Blake and Michael Moorcock, Angela Carter and Alan Moore. [*continued over page*]

Factory:
Path Through The Forest

One of the strangest trips ever committed to wax. A woodland orgy of billowing feedback and proto Krautrock drumming. Lyrically we're in Arthur Machen territory here. A forest ruled by spirits older than man. A trip into the land of Fairie. But what gives this song its power is its highlighting of the dangers of these territories. These aren't enchanted glades for skipping and prancing in, they are the forbidden places that "can drive you insane," as our hidden narrator points out, in a voice that's a cross between Oberon and a Station announcer. Glades where "Shadows confuse you/and silence is loud." The loss of control inherent in the psychedelic trip is magni-fied and revealed to have extra-dimensional elements. There are plenty of people wandering the streets today, talking to belisha beacons and wearing tin foil hats who should've paid

more attention to this one. Although of course no-one bought it at the time, unlike...

Pink Floyd: See Emily Play

Okay, so they're hardly a bunch of unknowns, but no discussion on the darker side of British Psych would be complete with-out a reference to this majestic single from the grey havens of Syd Barrett. A startling evocation of adolescent sexuality, flowing with images of rivers, lost minds and games amid the trees, coupled with one of the late Syd's most detached and ghostly vocal performances. The song's music box like arrangement heightens the feeling of a melancholic loss of innocence, while the lyrics conjure up a strange ritual, completed when Emily puts on a "gown that touches the ground/float on a river forever and ever." One of the most startling images of sexual awakening since Max Ernst's *The Robing of the Bride*.

When compared to the American bands of the period it is worth remembering that there was no war shovelling legions of British kids toward their deaths, no Kent state or Detroit riots, comparatively little to politicise the young enjoying their first taste of freedom. The results are a move back toward the decadence of the fin de siecle. Foppish experimentation, dandyism and a languid breaking of taboos for their own sake. A brattish, colourful revolt into style. But this is not to say that the movement was toothless. Far from it. The best Brit psych carries an overwhelming sense of disturbance and unease. The effects of acid on the previously mod-uptight musicians of the time can be felt in the perilous, woozy atmosphere of records like Caleb's Baby Your Phrasing Is Bad or The Poets' In Your Tower, while the spirit of psychedelically enhanced violence, a spiked skinhead crunching faces at the 14 Hour Technicolour Dream, is summoned by The Hush's Grey or The Flies vicious battering of the Monkees' Stepping Stone.

Studio experimentation was also at a premium. Whereas the American bands tended to record straight and loud and live (with some exceptions: Joe Byrd's musique concrete obsessed United States of America being the most obvious), the Brits, who have always loved their backroom boffins, were the first to start recognising the possibilities of the studio. Production geniuses such as Joe Meek and George Martin set a precedent for the degrees of experimentation allowed in the previously stuffy confines of the recording booth and the new breed

of psychedelic heads took to it straight away. Effects such as phasing started creeping onto productions, and songs went from straight three minute numbers to mini epics, often with several distinct sections. The Sands' Listen To The Sky, about the Nazi bombing of London, remains an unsettling experience, as it slides from it's jaunty beginning, through a barrage of sound effects and finally into a glowering, electrified version of Holst's Mars: God Of War from the *Planets Suite*!

Thematically the songs were all over the shop. From striking evocations of war through musique concrete, to the lurking spirit of Ballardian techno terror. From shattered minds, broken through love, drugs or a combination of the two, to power fantasies fuelled by misogynist hatred. Brit psych took on some big issues, and when the correct balance was struck (or in some cases totally ignored) music of rare power was conjured. Immediate, disorientating and quite unlike anything else before or since. The following records are examples of this short lived movement of accidental visionaries, which have lost none of their power to beguile and disturb. Music that shows you fear in a grain of sand and pulls you into the stygian depths of a drugged mania. Real one-offs, whose power can still be felt all these years later. And not a teapot in sight.

The Voice: Train To Disaster

A bone-shaking evocation of imminent apocalypse from the house band of black-robed sixties cult the Process Church of the Final Judgement.* "You know the end is near/and you're laughing out of fear." The band does it's best to imitate a train plunging headlong into a furnace while the overheated vocal delivery cries of "destruction, fire and searing pain." No solutions are offered — presumably you needed to read a leaflet or two from Mr and Mrs De Grimston (and offer them a not inconsiderable sum, I'll be bound) before you were allowed to know whether there were any escape routes from the coming Armageddon. "The world is on its way/every passenger must pay," they scream as a

Hammond organ imitates the screeching of train brakes on a track. Total overdriven doom mongering with all the subtlety of a nail bomb at a Brian Blessed convention.

The Accent: Red Sky At Night

An apocalypse of a different stripe, coming on, as it does, like a medieval beggar's prophecy. "Skies glowing," moan the out of tune vocals as the guitars clang like bells in red rain, "I can see dawn breaking/what's that strange glow? This boy's shakin'" they quiver. Taking the old wives' tale "Red sky at night, shepherd's delight/Red in the morning Shepherds warning" for its basis, this masterpiece of mood and suggestion twists into

* The Process Church of the Final Judgement (often referred to as simply "The Process"), an offshoot of Scientology, started in the early sixties by the charismatic Robert and Mary Ann De Grimston. This popular swinging London cult eventually left the shadow of Scientology behind to become more religious and metaphysical in nature and gained notoriety when various (somewhat tenuous) speculations were made regarding their connections to Charles Manson. For more information on The Process see Stephen Sennitt's A Game Of The Gods: An Introduction To The Process in *Rapid Eye 3*. Ed. Simon Dwyer, Creation books 1995.

GUITAR AMPLIFIER MAX TWATT *Spitfire*

OVERDRIVE

10 10 10

CLEAN

INPUT **MASSE** **LANGHOSE** **PLATZ** **HIMMELKANG** **POWER**

TWATT

a space of Blakean visions, swallows flying too low and a crimson sky filled with nightmarish portent.

The Creation: How Does It Feel To Feel?

A sludged out evocation of drug paranoia from the great should-have-beens of sixties Brit pop. A violin bow scrapes across guitar strings and the sound sits like a massive spider in a web of thundering malevolence. The lyrics speak to some unspecified victim of a bad trip. "How does it feel?" they repeat, "to never sleep again?" Before mockingly continuing, "When your room is black as sin/how does it feel to be scared of the dark?" Musically it's clangourous and dissonant with a droned out, repetitive urgency that would go on to influence the Spacemen 3 and Loop. Dark, unsettling and ear splitting.

The Family Gas: Mind The Flowers

Tinkling music box intro, vocals ooh-ing and aah-ing and an ultra fey delivery place us firmly in the domain of fairytale psych. The camp lead vocals deliver a description of a garden "covered in bloom/red, white, green and yellow in tune." Nothing to worry us there then, everything's fine. Well nearly: "Look to the rose in the bush by the shed/growing tall in the soil rich from my beloved." Ah, right. Start backing away. "In a clearing in my garden…" he continues, "you can hear the blackbirds sing/in that clearing if you look hard you may find a wedding ring." Yeah, I've changed my mind about staying for tea and cakes.

The Flies: I'm Not Your Steppin' Stone

This version turns the jaunty Monkees original into a fuzzed howl of wounded pride. What was, in the prefab four's hands, a spirited putdown of an upwardly mobile society girl, becomes a slug-slow rant. The singer's feelings of affection toward the girl who's jilted him have curdled and festered. His vocal delivery is pure malice. "When I first met you girl you didn't have no shoes/now you're walking round like you were front page news." This chap fully expects to see his intended again on her way back down the social ladder, where he'll probably have a good laugh into her crying face. Nice chap. Musically it's proto grunge; a lidless thousand yard stare slowed to a crawl. Heavy and foul.

Downliner's Sect: Glendora

What seems on the surface a simple story of love for a girl who "works in the window of a big department store" takes a Stenbockian spin when it's revealed that our narrator has fallen in love with a shop window dummy.* "She's never been young/and she'll never be old," he dribbles inanely. The tale ends tragically when Romeo sees that the window display has been changed. "Seems to me she lost her charms/they took off her legs and pulled off her arms," he weeps, while sarcastic female backing vocals coo his lost love's name. An utterly hopeless tale, with dark overtones of autoeroticism and fetishism.

Britain's love of dark side psyche didn't stop there, however. There were many more strange records made in the late sixties and all the way into the mid seventies by bands informed by the heavier weirdness. As an aesthetic it grew and grew, the dark current finding its way into the sound of bands such as Throbbing Gristle (whose Genesis P-Orridge has never been shy about declaring himself a psych head) and Clinic, and even stretching across the pond, to raise its ugly head in the work of Pere Ubu and, more recently, Olivia Tremor Control and the Elephant Six movement [w] www.elephant6. com.

Whether the above bands were heavy trippers or not is irrelevant. By attempting to make music dealing with altered states you open yourself up to all kinds of manifestations, feelings and confusions. Some will be pleasant, some painful, but all of them will be deeply Other. These records are glimpses into the blackest moments of that confusion and guides to worlds that, though occasionally untouchable, are never far away. Long may the current remain active. To the psychedelic traveller maps of Hell are just as important as maps of Heaven, if not more so. ◆

* Count Eric Stenbock. Notorious fin de siecle writer, alcoholic and decadent. Ate his meals off a coffin, kept pet monkeys and would notoriously be seen round Brighton with a life sized male doll on his arm. You'd've liked him.

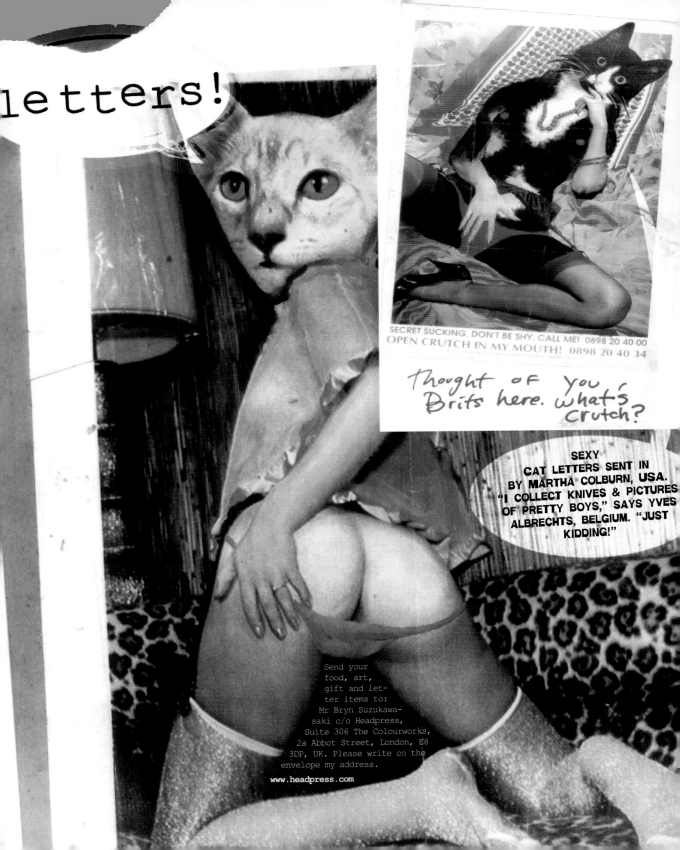

letters!

SECRET SUCKING, DON'T BE SHY, CALL ME! 0898 20 40 00
OPEN CRUTCH IN MY MOUTH! 0898 20 40 34

Thought of your Brits here. What's crutch?

SEXY CAT LETTERS SENT IN BY MARTHA COLBURN, USA. "I COLLECT KNIVES & PICTURES OF PRETTY BOYS," SAYS YVES ALBRECHTS, BELGIUM. "JUST KIDDING!"

Send your food, art, gift and letter items to: Mr Bryn Suzukawa-saki c/o Headpress, Suite 306 The Colourworks, 2a Abbot Street, London, E8 3DP, UK. Please write on the envelope my address.

www.headpress.com

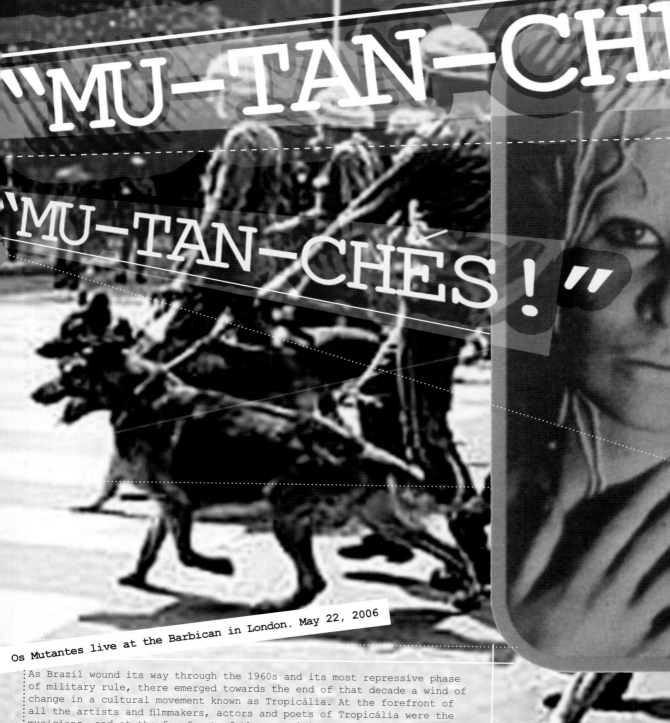

"MU-TAN-CHI

"MU-TAN-CHES!"

Os Mutantes live at the Barbican in London. May 22, 2006

As Brazil wound its way through the 1960s and its most repressive phase of military rule, there emerged towards the end of that decade a wind of change in a cultural movement known as Tropicália. At the forefront of all the artists and filmmakers, actors and poets of Tropicália were the musicians, and at the forefront of these musicians was a band called Os Mutantes, who sounded nothing at all like the music of Brazil and soon enough nothing at all like Tropicália. Os Mutantes split in 1978, leaving behind a legacy of music that continues to enthral and inspire. After almost thirty years, in May 2006, the band re-emerged to play a sell out show at London's Barbican centre. Attending was BILL BARTEL.

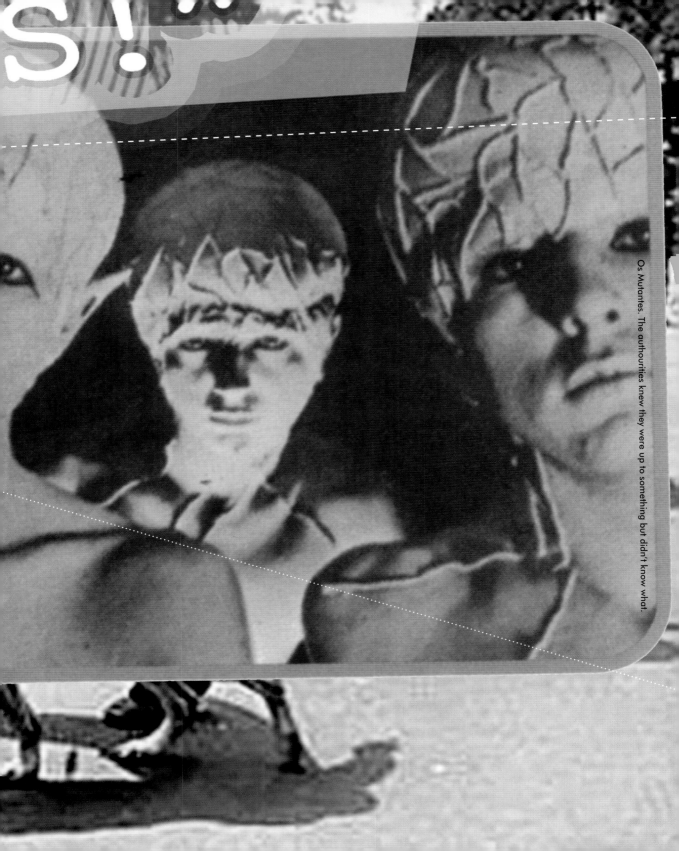

Os Mutantes. The authourities knew they were up to something but didn't know what.

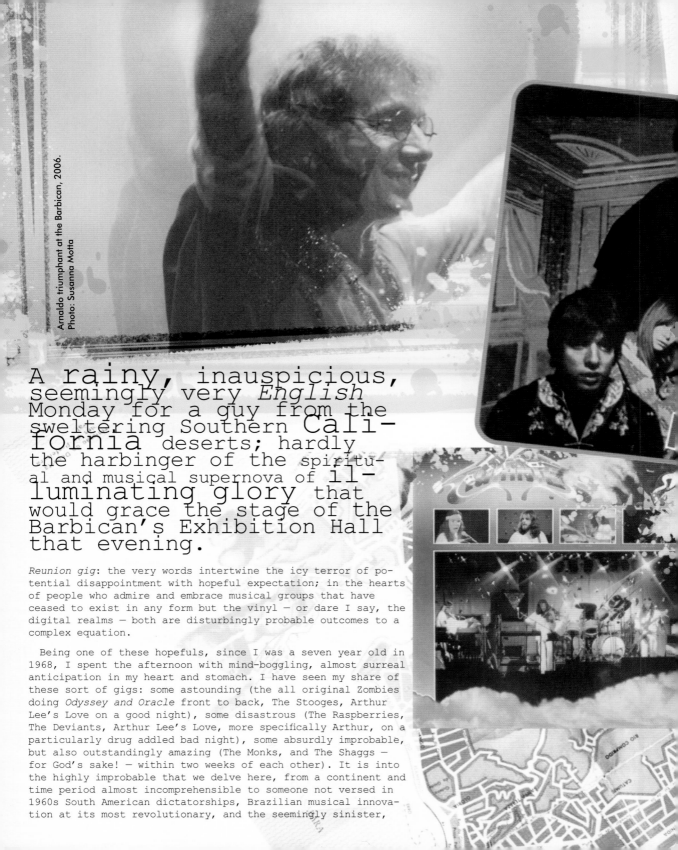

A rainy, inauspicious, seemingly very *English* Monday for a guy from the sweltering Southern California deserts; hardly the harbinger of the spiritual and musical supernova of illuminating glory that would grace the stage of the Barbican's Exhibition Hall that evening.

Reunion gig: the very words intertwine the icy terror of potential disappointment with hopeful expectation; in the hearts of people who admire and embrace musical groups that have ceased to exist in any form but the vinyl — or dare I say, the digital realms — both are disturbingly probable outcomes to a complex equation.

Being one of these hopefuls, since I was a seven year old in 1968, I spent the afternoon with mind-boggling, almost surreal anticipation in my heart and stomach. I have seen my share of these sort of gigs: some astounding (the all original Zombies doing *Odyssey and Oracle* front to back, The Stooges, Arthur Lee's Love on a good night), some disastrous (The Raspberries, The Deviants, Arthur Lee's Love, more specifically Arthur, on a particularly drug addled bad night), some absurdly improbable, but also outstandingly amazing (The Monks, and The Shaggs — for God's sake! — within two weeks of each other). It is into the highly improbable that we delve here, from a continent and time period almost incomprehensible to someone not versed in 1960s South American dictatorships, Brazilian musical innovation at its most revolutionary, and the seemingly sinister,

yet intriguing Voodooesque, religion of Os Mutantes. Legendary flagship band of Brazil, whose final incarnation, featuring only founding guitarist Sérgio Dias (né Baptista), called it quits uninitiated as to the history and music of this band, there here to enlighten you. Revolutionary in every definition of the word assessment; brilliant is merely a handy understatement. (Advice: go get recently issued in the UK for the first time, and be astounded.) Onward... CDs, Capping the Barbican's month long series of performances celebrating past stars and political activism, Os Mutantes (The Mutants, the Brazilian take on sixties psychedelic adherents to the passions of Tropicália, for you non Portuguese speakers) return, hitting London for the first time in their career.

With founding brothers Sérgio and Arnaldo Baptista (lead guitar and keyboards respectively), along with original drummer Ronaldo "Dinho" Leme, fronting the seven highly talented and absolutely diverse solo projects have kept this unit from functioning for thirty-three years. Tragedy, animosity and "Liminha" Filho, and somewhat more importantly, with fans (including myself) flying in from ber, Rita, the air is heavy with anticipation. Tonight the interstellar overdrive is in full throttle mode. A sold out performance, bassist Arnolpho all over the world, in spite of the band performing sans their mid-career addition, the band's third vocal cornerstone and founding member.

Rita, who arguably became the biggest pop star in Brazilian history after going solo in 1972, apparently declined the invitation to join the reunion; her integral vocal stylings are to be emulated guest vocalist, the sultry and very reverent Zélia Duncan, a current star in her own right in Brazil's pop music world. Arnolpho, long a well-respected producer, apparently had other commitments. I knew what the live show would Having been privileged enough to attend the private rehearsal the evening before, I knew what the live show would comprise. The band had picked not only the best material from their first five albums (eschewing any of the post Rita and post Arnaldo material that comes dangerously close to sounding like Yes or E.L.P.), but also the most improbable and musically complex selections. If they felt they needed to prove something musically, to the few guests who were invited to watch them rehearse most of the set list, they performed these intricate song suites so effortlessly it seemed almost surreal.

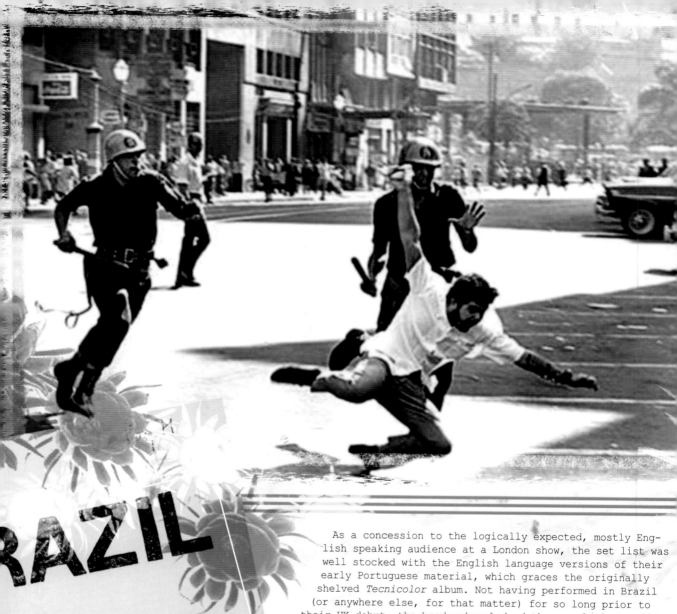

RAZIL

NIFESTO OF THE 70
REVOLUTIONARIES

ASINATIONS & EXECUTIONS
THE REPRESSIVE FORCES

As a concession to the logically expected, mostly English speaking audience at a London show, the set list was well stocked with the English language versions of their early Portuguese material, which graces the originally shelved *Tecnicolor* album. Not having performed in Brazil (or anywhere else, for that matter) for so long prior to their UK debut, the band acknowledged they *would* do an all Portuguese set when they finally decide to perform in their native country.

The group had abandoned the *Tecnicolor* album after completion in 1970, due to dissatisfaction with the production. Four of the English language songs did surface on the group's startling fourth album, 1970's *Jardim Electrico* (Electric Garden).

Tecnicolor in its entirety was finally issued in 1999 in Brazil (on Universal/Mercury Brazil), to much applause, featuring calligraphy and artwork by a huge American fan, a certain Sean Ono Lennon.

(An aside: In 2000 Sean coaxed the reclusive Arnaldo out of stage retirement, when his band Cibo Matto played a festival gig in São Palo. Covering Os Mutantes' classic Panis Et Circensis in front of a stunned Brazilian audience, Arnaldo's

shy but charming and joyous performance literally brought tears to the eyes of the reverent crowd.)

The evening of the show at the beautiful Barbican Centre was rife with rumour, excitement, international fandom and star turns: David Bowie had inquired about the guest list (he didn't show); Beck (whose album *Mutations* was itself a homage to Mutantes and Tropicália) was rumoured to have flown in from Los Angeles (he didn't); Pretender Chrissie Hynde gave dignified but brief interviews to the flurry of Brazilian and British television crews covering the event, expounding on her love of the band, without hinting at when she had actually first heard of them; Devendra Banhart, a noted Tropicália enthusiast, billed as a "special guest" that evening, held court in the lobby, resplendent in crushed velvet. Travel weary fans could be overheard speaking exuberantly in their assorted native tongues of American English, Portuguese, Brazilian dialect Portuguese, German, French, Italian, Czech and Japanese. Expectations and excitement were building in the lobby as the sounds of support act Nação Zumbi seeped through the closed doors and onto video screens from the auditorium.

Twenty minutes past the expected show time, the audience was ushered into the seated auditorium by the dimming of lights, and the maximum capacity crowd was charged with its own electric expectation. To my left were seated a Roman and Parisian who had made the sojourn to see the legends; behind me, young teenagers from Tokyo and São Palo, who couldn't have been born when the band broke up in 1978. Portuguese aside, this cross-cultural international pilgrimage to London succinctly illustrates the depth and clarity with which true genius speaks, irrespective of the language it uses.

Forty minutes past the announced show time, the restless crowd became palpably more anxious, visibly agitated. When the compere appeared on the curtainless stage, the crowd welled with enthusiastic applause, only to be silenced with "We've waited thirty-three years for this, if you don't mind waiting another twenty minutes, there are some problems with some of the vintage

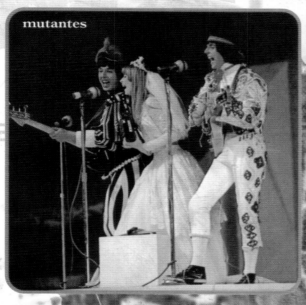

equipment."

Horror; muted, muttered concern from the crowd; fear that the show may not go on at all. Then a respite as the announcer continued: "So Sérgio is going to come out here for a moment and take a look at it, then the band will be on in a few minutes."

Cheering from the audience, upgraded to a standing ovation when a nattily costumed Sérgio, looking somewhat embarrassed, humbly graced the stage clutching *the* guitar: the instrument responsible for the group's otherworldly guitar sounds. Hand-constructed in the early sixties by his older brother, electronics genius Claudio Baptista, the famous instrument has fans of its *own* among musicians. Moments later, a string of signature Mutantes fuzzed notes blazed through the air, eliciting another round of relieved applause, and

a humble wave from a smiling Sérgio; exit, stage right. Time
was nigh.

As the introduction to Dom Quixote welled through the sound
system (by fellow Tropicálist pioneer and Os Mutantes' origi-
nal orchestral arranger, Rogério Duprat), furtive glances and
comments were exchanged between audience members. Incredulous
that that band would attempt Dom Quixote, possibly their most
musically and vocally intricate number, the crowd stood and
cheered as Os Mutantes, dressed in elegant capes and jodhpurs,
boots and black taffeta gowns, took the stage for the first
time in thirty-three years. And then proceeded to sonically
pummel any misconception that this particular reunion might have
been ill conceived.

Indeed, breaking directly into Dom Quixote ("Dom" being Portuguese
for the more familiar Spanish honorific "Don"), showcased the band's
intricate, baroque-syncopated *a capella* harmonies, melding them seamless-
ly with orchestral drumming and crazed feedback guitar, concocting an astound-
ing live rendition of a piece of recorded art. On the record (1968's *Mutantes*),
with all the safety nets and trappings of a recording studio, the track is a
remarkable work in itself; how they accomplished this feat live, without the assist-
ance of samples, synchronized pre-recorded tracks or computers, attests to their bravery, artistry
and incredible talents. And it was only the first song of the evening.

With more aggressive trumpet peals, the band then launched directly into another track from their
second album, its closing number, the ethereal Caminhante Noturno (Night Walker) — another complex
piece showcasing four part vocal harmonies and again, drummer Dinho's alternating rock and roll beats and
timpani malletted symphonic drums. Percussionist Simoné Soul excelled at alternating between scream-
ing through coiled plastic tubing, Brazilian percussive devices, and just plain odd noisemakers,
markably recreating every complex nuance of the studio recording. Simoné's job would remain the
most manic of the stage band throughout the evening, dutifully keeping up with the requisite sound
effects while alternating between intricate Latin percussion and unrecognisable instruments, seem-
ingly within split seconds of each other. Sérgio's theatrical guitar-mounted switch flicking led the
band through the various time signature changes (4/4 to 3/4/ to 6/8 to bossa-nova-in-outer-space/4)
and crescendos, with each knob turning arm movement acting as a conductor's baton. Onward and upward.

Reverting to their origins, the band next presented Ave Ghengis Kahn (Hail Ghengis Kahn) from their
first, eponymous album *Os Mutantes* (not be confused with the aforementioned, similarly titled *Mutantes*). A
subtle blend of samba, bossa nova and feedback, it features keyboardist Arnaldo out Jon Lord-ing the Deep
Purple keyboardist at his own game. It eventually devolves (like so many Mutantes songs…) into a terrify-
ing slow death march, with gang chanting and draconian spoken vocals from Sérgio, evoking a feeling of having
left a church of *some* sort for the trek to war across a blood stained plain. Three words, those of the title,
are chanted like a mantra; that's all it needs to terrify and mesmerize, which it does to great effect.

Next we heard English, for the first time this evening, as the keyboards swirled beautifully into Tecnicolor
(from both the once shunned album of the same name and their fourth album, *Jardim Electrico*). Sérgio's vocals al-
ternated with Zélia's, escalating to trademark syncopated harmonies, beautifully utilizing the other musicians a
backing vocalists to perform the first song of the evening that doesn't have a dark, threatening edge to it. Stil
weighty, but more uplifting than the previous selections, it was a magnificent ending for the set's introductory
four song medley. With the first words spoken to the audience, a pleased and friendly sounding Sérgio intoned,
"Thank you very much, it's great to be here; we're Os Mutantes." The song was five minutes long, and it seemed to
have flown by.

English again followed, with another track from the fourth album, the beautiful ballad Virginia. Softer, yet
still uncomfortably compelling, it is *almost* a country song, with Sergio playing almost flamenco style acoustic
guitar. It is "light" in the vein of The Velvets' Who Loves The Sun or Love's Red Telephone, i.e. heavy without
being obtuse.

Touching for the first time on the band's fifth album, the perplexingly entitled *Mutantes and His Comets in the
Country* (or "on the Planet" in some translations) *of Baurets*, and Arnaldo's first lead vocal, next came Cantar De
Mambo (or in English, simply Mambo Singer). With what could *possibly* have been a sarcastic "explanation" of the
premise of the song, the quest by Brazil's Sergio Mendes (of Brazil '66 fame) for an international platform for
his music, the group launched into, expectedly, a rocked up *mambo*. (Mambo itself being a Cu- bar
music, it is also a Haitian Voodoo and Spanish "contradanza" derivative style, fitting
nicely into the Brazilian version of Voodoo, the African influenced "Macumba" religion.)
Arnaldo's enthusiastic presentation, and again Simoné's pulsating percussion, had
every audience member on their feet, rollicking and looking for floor space to mambo
along with what may well have been an indictment of that *other* Sergio's commercial
success. Strange images of Santana's interpretation of The Zombies' She's Not There
came to mind during Sérgio's lengthy, hero worthy guitar solo, and not for the last

time in the evening.

Continuing with his gut string classical guitar, the third language of the evening, Spanish (as well as a few words in mock Italian, and some imaginary nonsense words that "sound like Portu-glish," according to Sérgio) makes it's sole appearance in the flamengo (the Portuguese word for the more familiar Spanish "flamenco") tinged El Justiciero, from album number four. With its original dramatic spoken English introduction embellished to sarcastically include "Jorgé Bush and also Tony Blair, el gran justiciero," Sérgio excelled at true flamengo playing, while singing the somewhat surreal adventures of a gun-toting hero of the peasants, now globally repositioned to "the United Kingdom." Time will tell if this mythical lover of tequila, chocolate, "Juanita Banana" and gun fuelled justice will end up protecting whichever city the band is performing in on their first ever U.S. tour beginning July 21, in New York City.

The following number turned out to be Zélia's first solo lead vocal, the *Tecnicolor* English translation of the first album's track, Baby. It is sultry, sexy with a Nico-esque cool, blended with a fiery lilt. A distinctly different vocal timbre than Rita Lee, the audience was still enthralled, partly because for those of Brazilian origin, Zélia is a major star with her own solo career. Reverently performed in the less garage rock *Tecnicolor* arrangement, its deceptively simple beauty accompanies bizarre lyrics about reading handwritten slogans on shirts and trying new flavours of ice cream. As with many Mutantes songs, the cliché rock and roll use of the term "Baby" has almost nothing to do with the song's subject matter.

The band then gently started upon I'm Sorry Baby, from *Tecnicolor* and their alarming third album *A Divina Comédia Ou Ando Meio Desligado* (Divine Comedy Or I Walk Disconnected). A soaring ballad, the English rewrite of the lyrics seems to be much more overtly about the boy in the relationship (telling his girlfriend he's about to commit suicide) than the Portuguese version. Ending with a rave up worthy of a Southern Baptist church service, the "glory glory of my life" chorus is hypnotic, and probably the most joyous celebration of self inflicted demise on record, or in this case, in concert.

The second lead performance by Zélia, which followed, was an entirely different from her previous delicate rendition of Baby. Top Top, the most popular track and single from *Jardim Electrico*, is presented as if Big Brother and the Holding Company were fronted not only by Janis Joplin, but also a tougher Grace Slick and the in-attendance Chrissie Hynde at the same time… if they were all at their peaks, and if, of course, they were all from Brazil. She levelled the audience with her gutsy stage presence and powerful vocals, and Rita Lee's phantom *conspicuous in absentia* is all but exorcised.

Perhaps the most unsettling song of the night is the disturbing and highly unexpected performance of Arnaldo's Dia 36 (Day 36), from the second album. Perhaps one of their strangest in-studio productions (and that is saying *quite a lot*…), Arnaldo sings through a "Leslie," a rotating speaker generally used to generate the swirling chorus effect of a Hammond organ; John Lennon used it to lesser effect on Tomorrow Never Knows. With bowed sliding bass guitar notes, droning wah wah from Sérgio, and nightmare inducing percussive dynamics from Dinho and Simoné, the song is a highlight of the evening. A disturbing, provocative highlight at that, with lyrics about scarves, bedspreads and, perhaps, hope. Really.

Following Arnaldo's standing ovation is Fuga No II (Escape Number II), again from the second album.

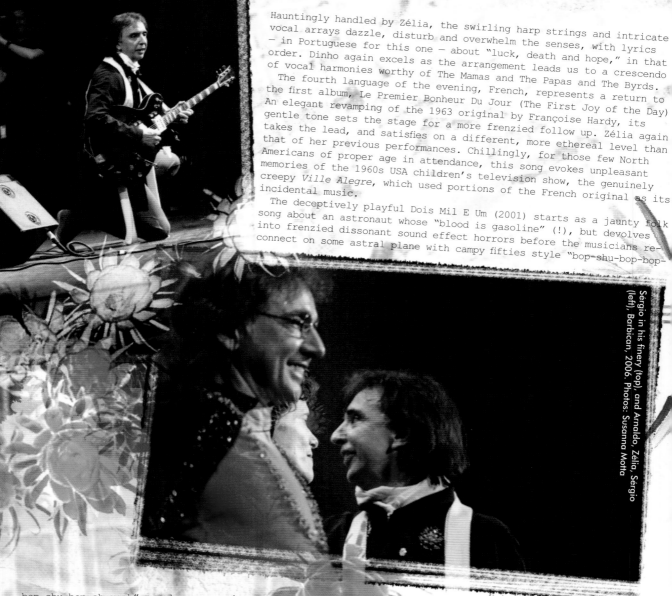

Hauntingly handled by Zélia, the swirling harp strings and intricate vocal arrays dazzle, disturb and overwhelm the senses, with lyrics — in Portuguese for this one — about "luck, death and hope," in that order. Dinho again excels as the arrangement leads us to a crescendo of vocal harmonies worthy of The Mamas and The Papas and The Byrds.

The fourth language of the evening, French, represents a return to the first album, Le Premier Bonheur Du Jour (The First Joy of the Day) An elegant revamping of the 1963 original by Françoise Hardy, its gentle tone sets the stage for a more frenzied follow up. Zélia again takes the lead, and satisfies on a different, more ethereal level than that of her previous performances. Chillingly, for those few North Americans of proper age in attendance, this song evokes unpleasant memories of the 1960s USA children's television show, the genuinely creepy Ville Alegre, which used portions of the French original as its incidental music.

The deceptively playful Dois Mil E Um (2001) starts as a jaunty folk song about an astronaut whose "blood is gasoline" (!), but devolves into frenzied dissonant sound effect horrors before the musicians re-connect on some astral plane with campy fifties style "bop-shu-bop-bop-

bop-shu-bop-oh-yeah" vocals — or perhaps more accurately, their Portuguese equivalent — to rousing effect.

Round two of the Hail theme is invoked next, with the complex and incredibly boldly titled Ave, Lucifer, which needs no translation but possibly an aside as to how radical this song's title was for a group of angelic young musicians living in a fiercely Catholic country run by a military dictator in 1970. Although their subtle political comments in other songs were cause for censorship and sometimes aggression from the police state, singing about such a subject in this manner was equally radical, if not more so, in 1968 Brazil.

Sérgio is again handed the spotlight for a song penned by brother Arnaldo and Rita Lee, with the beautiful piano driven Balada Do Louco (Crazy One's Ballad) from the fifth album. He has the entire audience singing along from the first note, through the Hey Jude style chanting outro. Perhaps the most emotionally moving moment of the evening, the band already sound like a full choir with their own vocals, but the audience makes it seem like it's The World Cup, and Brazil is in the finals.

One of the group's most incendiary tunes Ando Meio Desligado (I Walk Disconnected) follows — again courtesy of the Tecnicolor version, rewritten by the band into poetic English as I Feel A Little Spaced Out. With a distinctly Latin feel, it again brings to mind Santana's version of The Zombies, and then goes into a whole different world, melding Cream and Deep Purple's most furious moments with a Clapton-esque nod to the guitar solo of While My Guitar Gently Weeps — humorously including one line of Harrison's original in

the lengthy outro. Sérgio flawlessly elevates himself to his well-earned guitar hero status, with panache not often seen in today's musicians. The band stokes the fire of the song like driven maniacs, while never digressing into excess or self-indulgence.

As the song's vocal coda reverberates throughout the room, the band goes one step further into what can only be termed as kicking ass, launching into the closing number, the once banned Cabaluda Patriota (Long Haired Patriot), from the fifth album. Without question their hardest rocking song, the released version was forcibly retitled Time To Grow Your Hair — although instead of actually changing the offending lyric, the band, on record, simply put noise over the words.

There was a not so subtle statement being made in the originally banned title being boldly printed in twenty point type on the set lists: Os Mutantes had outlived their oppressors — both political *and* musical — and are all the stronger for it. The crazed keyboards and guitars ply for dominance, without overshadowing the all important (but seemingly innocent in this era) lyrics, on how hard it was to simply have long hair in a society that endeavoured to control almost every aspect of your life. A fitting vindication if there ever was one.

Launching directly into a first album favourite, the jaunty A Minha Minina (My Girl), Sérgio, for the first and only time of the evening, combined the *Tecnicolor* English translation of She's My Shoo Shoo with the original Portuguese, as written by fellow Tropicálist, Jorge Ben. With a fuzz guitar line worthy of Psychotic Reaction, the crowd was dancing in the aisles, clapping along in complex syncopated rhythms, and basically having the time of their lives, as were, apparently, Os Mutantes.

Glowing with the appreciation of the audience and without the pretence of actually leaving the stage, Os Mutantes returned to their respective posts for an encore of another popular number from their first album, Bat Macumba. The band, in 1968, was given this controversial Gilberto Gil/Caetano Veloso composi-

tion (the lyrics of which consist of barely three words that get shorter as the song progresses); controversial in that it basically emulates the frenzied trance like dancing and chanting of practitioners of Brazil's Macumba religion. It is hypnotic Top Forty Voodoo, with brother Claudio's built in "Green Devil" fuzz creation gloriously turning Sérgio's guitar solos into something akin to an acid drenched swarm of killer bees. Of all the original and retro 1960s garage bands in the world, none have come close to this primitive, dentist-drill-into-your-soul sound. Piercing, ear shattering and laced with the South American equivalent of an American Southern Baptist revival (fittingly, as the fervour of those church services and Macumba's intensity both stem from African rhythms), it is exhausting and invigorating at the same time. The band ends on an *a capella* refrain, after playfully interspersing a bit of the theme from the sixties television show *Batman*.

Crazed crowd recognition then greets the opening trumpet obligatos of Panis Et Circensis, Os Mutantes' first recorded introduction to the record buying public as a stand alone group. Again specifically written for the group by their patrons and progenitors of Tropicália, Veloso and Gil, Bread And Circuses (as translated from the original Latin) is a landmark song of the Tropicália movement, and could well be regarded as the band's signature song; placing it as the final encore illustrates that they know their own place in history. With the English language lyrics again clearly audible, from the *Tecnicolor* rewrite, this is an odd tale of lions roaming freely in the back yard, unnoticed by "people having dinner inside," and public execution of a lover. The words are almost superficial compared to the actual *sounds* of the song, which — both on record and here, live on stage — encompass intricate and unusual instrumentation and vocal arrangements, before it actually *falls apart completely*… only to be gently beckoned back to life by the melodic recorder playing of multi instrumentalist Vitor Trida, faithfully emulating the stylings of the band's original multi instrumentalist, Rita Lee.

The mantra like ending of Panis Et Circensis in the original version of the song translates into the tongue twisting "those people in the dining room"; for *Tecnicolor*, the band's English lyric is the charmingly awkward but more melodically phrased "the music lighted with heat of the sun." The vintage psychedelic confusing of tenses and transitive verb placement at this point had seemingly *no effect* on the absolute euphoria of the highly vocal audience, who followed the band's increasingly manic tempo like whirling dervishes, until there was simply nowhere left to go. For anyone.

And then the band was gone. Their final exit from the stage was accompanied by a full seven minutes of applause and chants of "MU-TAN-CHÉS!" (the Anglophilic denotation of the Brazilian Portuguese pronunciation) from the gleeful audience, before the house lights came on. Undeterred, the entire crowd remained in their seats, futilely chanting and pounding on their seats for an additional five minutes; but there would be no more that night: the band that had given so much of their daring youth to Os Mutantes and to the sixties and seventies cultural upheaval, had given these fortunate witnesses their all. Finally, the resigned crowd relented, knowing, as they talked amongst themselves whilst exiting the venue, that they had just experienced something magical, something personal, and most certainly, and without question, the absolute best of Tropicália. FIN

Alan Partridge... Steve Coogan... Could the real Tony Wilson please show himself...?

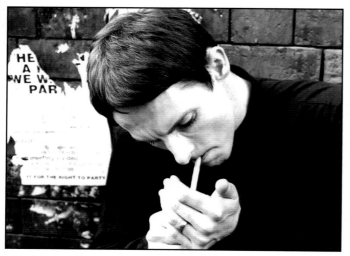

Manchester Punk and Manchester punks on film. By CHRIS BARBER.

Steve Coogan is renowned for his many comic personas on television, in particular regular slots alongside Chris Morris, and his own BBC series, playing bungling radio DJ, Alan Partridge. Coogan personifies dry, sardonic wit, with deadpan delivery and post-modernist ambiguity for the post-ironic age. His star casting as Tony Wilson in *24 Hour Party People* received wide critical acclaim. Many of Wilson's closest associates stated Coogan's portrayal perfectly captured the real Tony Wilson.

The real Tony Wilson was born in Manchester. In the early 1970s he got a job as a journalist for Granada Television, who shifted him around over the years as a presenter on various programmes, including the station's weekly rock music slot, *So It Goes*, which in 1976 happened to coincide with the emergence of punk rock in London. Wilson was one of the many in Britain at that time who was bored and dissatisfied with what was going down and was waiting for punk, or something like it, to happen. And when it did, he seized the opportunity to expose a bigger audience to what was happening on music's cutting edge. He was also helping the bands get wider exposure, when most of the media was closing ranks and denying airtime.

With Wilson, it was also personal. He was well informed and kept up to date with what was going on in politics, the arts and music. He had a good education and was aware of obscure, alternative and underground subcultures (like Situationism, comprising an exclusive group of revolutionary artists and intellectuals, whose complex philosophy had a significant impact on the Paris student riots in 1968).

He went to the first Sex Pistols gig in Manchester, claiming what he saw was "nothing short of an epiphany," and realised he was in a position to promote this exciting phenomenon. Over the next few months, *So It Goes* televised live performances by the Sex Pistols, Siouxsie and the Banshees, The Stranglers, The Clash, The Jam and more. This wasn't enough for Wilson; he wanted to be more involved and set out to open a punk venue. At Manchester's Paradise Lounge, the landlord was prepared to hire out the venue one night per week, on Fridays; Wilson called it Factory Club Night. New punk bands were forming all over Manchester, and this was the venue they needed to perform.

From that first wave of new punk bands, Wilson recognised the potential of Joy Division (who actually hassled him for gigs). He wanted to do all he could to help them develop and became a sort of surrogate manager, a role he would undertake for varying periods with many bands over the next fifteen years, in particular New Order and the Happy Mondays. But he also wanted a band he could mould from scratch and take on a fully committed management role; A Certain Ratio fulfilled this function.

The Factory name and idea would endure and expand, becoming an umbrella organisation that would facilitate a variety of associated functions. It appealed to Wilson because of its denotations with Andy Warhol's Factory in New York, a source of inspiration for him.

It was the Buzzcocks who really set the agenda for Manchester's first wave of punk bands. Howard Devoto recalls the release of their *Spiral Scratch* EP (early 1977):

There were no record labels up in Manchester then… A lot of people in our situation would have realised… But we had some other sort of wherewithal, which made us borrow money from Pete's dad, book a recording studio and have records made.

The Buzzcocks did it themselves, inventing their own record label, New Hormones. Boon recollects "There was a feeling… that the record could illustrate part of the 'do it yourself' Xerox/cultural polemic that had been generated." Even the picture sleeve, of the band mounting some statue, was snapped on a Polaroid camera. Musically, "it took about three hours, with another two for mixing"; sleeve notes give it to you straight, how it was done, literally listing the production process.

Now we can cut back to Tony Wilson, the importance of Manchester's early punk scene, and Winterbottom's sensitive direction (pertaining to both form and content) of *24 Hour Party People*; there was nothing new about independent record labels (Virgin, for example) when Factory suddenly gained status as the radical chic vanguard of punk rock production. To believe that is just crude snobbery. But the Buzzcocks had achieved something far more radical and useful; Wilson and some of his contemporaries like Joy Division were among the first people to fully understand this and recognise its further potential. This was the truly innovative dynamic that Wilson was looking for and would enable him to play a significant part in Manchester's punk and post-industrial renaissance.

Thankfully, the history and significance of punk rock, in all its diverse expressions, has found its perfect commentator and spokesperson in author Jon Savage. Savage summarises the full importance of the Buzzcocks' DIY record production and distribution process in ten words:

"*Its aesthetics were perfectly combined with the means of production.*"

Thus Tony Wilson (and Alan Erasmus) embarked on creating Factory Records: a new and independent record label, recording studio (selecting the finest music/sound producer, Martin Hannett), in-house niche marketing, design and packaging facilities, and a uniquely alternative internal working/management structure (whose faults could sometimes be as disastrous as its achievements could be inspirational). The Factory process would also lead to The Hacienda venue.

Don't give up the day job! Whatever parallels can, but probably shouldn't, be drawn between Wilson's and Warhol's Factorys, at least Wilson, unlike Warhol, didn't end up

[This page] Steve Coogan as Tony Wilson. [That page] Sean Harris as Ian Curtis. *24 Hour Party People* (2002).

on the Factory floor with his body bleeding and torn by seven bullets (although he sometimes came close!). Now Wilson's back, working at Granada TV, which is cool because whatever mistakes were made handling other people's cash, he didn't siphon off a private stash for his personal comfort. What worth the cultural legacy — *24 Hour Party People* says it all — and a fuckin' good time was had by all!

24 Hour Party People was a brash and audacious project from its inception, especially in British cinema. The task of realising relatively recent historical events, in a feature length movie, is usually only attempted to exploit the immediate aftermath of a media deluge still fresh in the minds of the mainstream British public — like Sheila Payne's prostitution scandal in *Personal Services* (1987) or the Nick Leeson merchant banking fiasco in *Rogue Trader* (1999). Or where public interest in recent history has been sustained or revived by later events (*The Battle Of Britain* [1969] covering events continuously revived in memorials etc, or *The Krays* [1990], gangsters whose prison sentences were effectively served, entitling them to seek release). One major hurdle is that many of the people/characters involved are still alive. No movie will please everyone concerned and some related persons might be upset by depictions, publicly contradicting and protesting against the screening of such a film, or even seeking legal injunctions or financial compensation. So when dealing with living histories likely to attract only minority or specialised interest, the risk is just too great. The best you can expect is a rigorous documentary, relying on original archive material and corroborated testimonials, to override objections and provide cost-effective material resources.

24 Hour Party People managed to involve all the real, living characters portrayed and, unusually, win universal favour for the end product, attracting only minor, well-meaning criticisms. For example, Peter Hook (the real one) of Joy Division/New Order, commented on the film's humour, saying the musicians took themselves more seriously at the time than depicted.

Any attempt to recreate living history in a feature film is bound to require creative compromise and innovation — mythologising — that presents the spectator with a cut-down, elliptical and enjoyable representation of actual events, ideally conveying the authentic intensity and spirit of their actuality, and exciting broader or renewed interest by creating mythology. In other words, transforming social history into cultural mythology. Even Hollywood movie corporations are reluctant to produce living mythologies. Oliver Stone's *The Doors* (1991) is an excellent and pertinent example of mythologising living history with only obscure cult appeal and turning it into a successful blockbuster; however, this was only possible thanks to the determined efforts of its already commercially successful director.

Chris Barber & Jack Sargeant

"Pissing in the Kitchen Sink" by Chris Barber, extract from the book **No Focus: Punk on Film** edited by Chris Barber & Jack Sargeant. Published by Headpress
UK £13.99 / US $19.95
ISBN13 9781900486590
www.headpress.com

So it's remarkable that *24 Hour Party People* was made at all, being reliant on Winterbottom's determination and the economic advantages of filming with the latest digital technology — there is a tradition among great film directors of mastering cutting edge cine technology to realise new visual potential, like John Ford's use of deep focus. Technology aside, another notable achievement of *24 Hour Party People* is the innovative diversity of techniques employed to embellish its mythology. One notable example is the inclusion of cameo appearances by real people historically associated with the story. These appearances include Mark E. Smith, the vocalist and songwriter of The Fall (originally associated with Manchester's punk scene, The Fall have subsequently remained one of the most obscure and innovative music acts for over a quarter-century), and Howard Devoto (original singer and songwriter in the Buzzcocks, who left to form Magazine).

24 Hour Party People is shot on digital video and remains a cutting edge example of how this technology can be used in cinema — only one other digital video feature comes to mind as its technical equal: Jean-Luc Godard's *Eloge de l'amour* (2001). Everything about it is slick: contrast of colour, fast editing and montage, smooth, often hand-held, camerawork, depth of field, seamless special effects, shot variety, audio quality, occasional use of split screen and monochrome photography, title sequence, use of overlays, transfer of material filmed on other mediums, and so on… Technically it's a tour de force — the shape of things to come? The cutting edge of British cinematic social realism has ditched the old sink and refurbished the whole fuckin' kitchen!

IN CONCERT TONIGHT MOTORHEAD

♪♪ FORTH DAY FIVE DAY MARATHON...

"THE FIRST BAND I EVER SAW WAS *BLACK SABBATH*. THE SECOND WAS *MOTORHEAD* AT THE *MANCHESTER APOLLO* IN 1978. *LEMMY* WAS ON VOCALS, *PHILTHY ANIMAL* WAS ON DRUMS AND *FAST EDDIE* WAS ON GUITAR."

"I WAS STILL AT *SCHOOL*. THIS WAS IN THE DAY WHEN EVERY BAND ON TOUR HAD A *SOUVENIR PROGRAMME*. MOTORHEAD'S PROGRAMME WAS CALLED *ALL ABOUT BEING LOUD*. MOTORHEAD WERE *LOUD*."

This next number is an oldie

some of you older people might remember.

Is it loud enough for you?

"*LEMMY* ASKED THE CROWD IF THE SOUND WAS *LOUD ENOUGH*. THE AUDIENCE GAVE A COLLECTIVE CRY: '*NO!*' THEY SAID. I WAS NEAR THE BACK. '*YES!*' I SHOUTED."

"*LEMMY* INTRODUCED ONE NUMBER WITH A LINE OFF *THE BEATLES AT THE HOLLYWOOD BOWL* ALBUM. THIS PLEASED ME."

ALL ABOUT BEING LOUD BY DAVID KEREKES ANTONIO GHURA

Motorpsycho Night-mare meets The Me-thedrine Monster

The Deviants were foremost among London's anti social communal rock bands of the 1960s and 1970s. Having recorded their debut album Ptooff! in the autumn of 1967, the Deviants spent most of the ensuing year on the road. The pressure of constant gigging and the attendant increase in drug consumption soon began to show. RICH DEAKIN provides a snapshot.

The Deviants, like any band, were not immune to the monotony that the road inevitably afforded, and devised ways to counter the boredom when not too stoned or drunk. Mimicking the hippies that attended shows was one way. "Various of us would imitate the individual in question," recalls Mick Farren, "but, after a hundred miles Russell and Sandy would be doing a whole 'raised on The Goon Show', pre Python dialogue."

The stoned dialogue between a bunch of hippies at UFO in Deviation Street on the album Ptooff! developed out of one of these conversations.

Another way of alleviating boredom on the road would be to recite favourite songs. Boss has recalled how he and Mick used to sing Bob Dylan's Motorpsycho Nitemare, "… it used to completely blow Russell and Sandy's brain out, 'How comes you two wankers know all that?' but we used to sing it anyway, and we'd be driving along drunk, or whatever, singing all this nonsense just to keep ourselves amused in this horrible van, you know?"

It is from a slightly later period in the Deviants career that Boss began to entertain the rest of the band on the road with a song called Why Does A Red Cow? Boss first heard the song as a child in a park off Camberwell High Street, where a clown used to entertain children during the school holidays, "…and he sang this stupid song about 'Why does a red cow give white milk when it only eats green grass, that's the burning question, let's have your suggestion, I don't know, you don't know, don't you feel an ass, why does a red cow… blah blah blah blah' and for some unknown fucking reason it stuck in my stupid addled brain."
He goes on to say, "Miles and miles, and hours and hours of motorway, and one day I probably came out with Why Does A Red

Cow and they all thought it was highly amusing."

It was funny enough for Boss to sometimes be called up onto the stage during the later, Pink Fairies years and made to perform it, much to his embarrassment.

Boss also bore the brunt of another game the band devised to counteract tedium. Mick says, "We developed an entire parody of Tommy designed to insult Boss that started 'It's a pig, Mrs Goodman, it's a pig! A pig! A pig!' You get very bored travelling the roads…"

The endless cycle of gig after gig, night after night, can soon take its toll, and although Sid Bishop can recite a list of some of the places the Deviants played, he says, "very little stands out, just a lot of scrambled memories, many of which now blend together." He does remember one gig at Aberystwyth University, however, or rather the aftermath, which he recalls thus, "We were invited back to some hippy's flat for an after gig party. We were often invited, or perhaps tempted might be a better word, into such situations post gig, as there was always plenty of free dope on offer, and often plenty of other free things as well! Russell, as I recall, had given me some Seconal on this occasion. I went into the kitchen to take it with some water, started to walk back into the living room and collapsed on the living room floor after covering about five yards. It was like being hit on the back of the head with a large rubber mallet."

Although drugs had always figured quite highly as recreational pastimes for the Deviants, the nature of the drug use on the scene in general had begun to change. Drug use was largely restricted to amphetamine pills, and the psychedelic staples of cannabis and LSD, but by 1968 other drugs like barbiturates

— the previously mentioned Seconal, for example — and the particularly strong hypnotic sedative mandrax, or "mandies," as street slang of the day had it, were becoming popular. Heroin was also beginning to creep onto the scene. But, perhaps more common was an explosion in the use of a particularly potent form of amphetamine called Methedrine.

Methylamphetamine chloride, or Methedrine, was first prepared in 1919 by Ogata in Japan, and, right up until its eventual withdrawal from the UK market altogether, its main legitimate use had been for resuscitation in surgical emergencies. This was a very different beast altogether from the type of speed favoured by mods in the early 1960s, but by the late 1960s, as Boss points out, "People reverted back to drinking and taking speed. Methedrine came along, and it was like… Ow! If Methedrine had been there as a problem thing with all the mods I think a lot of us would be dead probably."

Although the ampoules were designed for intravenous clinical use, it was more convenient, not to mention preferable to recreational users, to snap open an ampoule of Methedrine and pour its contents into a can of Coca-Cola and then drink it. For those who were more adventurous, and wanted to experience the full impact of the Methedrine rush there was always the option to inject. A generic form of disposable needle and syringe that could be used to inject the drug would be the inspiration for the title of the band's second LP, *Disposable* (as opposed to waggish detractors who claim the title to be an apt description of the LP itself). It was not unknown for certain members of the Deviants entourage to favour the injectable method of taking Methedrine. Whatever method one used, the long term affects of prolonged use could still often be detrimental to physical and mental health.

By 1968, Mick says, "The band was divided into two factions: those who injected their meth, sometimes chased by a shot of vitamin B12 for the sake of their health, and the ones who popped the glass top off the ampoule and poured it into a Pepsi-Cola…" Mick and Steve Sparks fell into the latter category, both declaring an aversion to needles. Despite the heavy duty nature of Methedrine, Steve Sparkes certainly favoured it over the more acceptable choice of hippy drug: LSD. Talking to Jonathon Green in 1987, Sparkes said, "I was taking acid, and the wonderful, glorious methedrine. I have to admit that I always thought that acid was pretty boring. I was essentially a speed freak and acid was just like a different sort of speed as far as I was concerned.

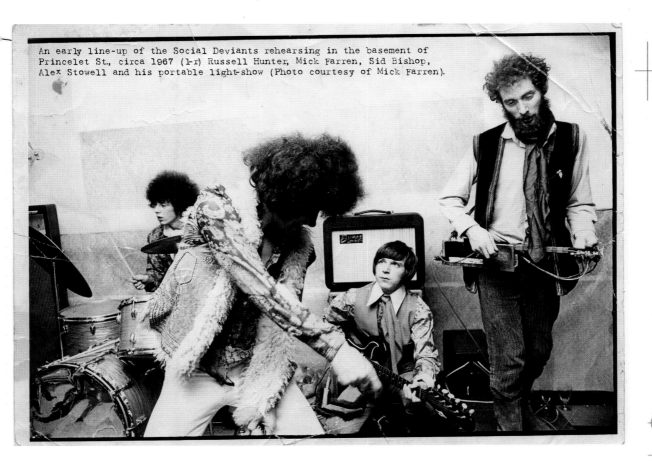

An early line-up of the Social Deviants rehearsing in the basement of Princelet St., circa 1967 (l-r) Russell Hunter, Mick Farren, Sid Bishop, Alex Stowell and his portable light-show (Photo courtesy of Mick Farren).

I never got the glorious hallucinations that I read about. I was always greatly disappointed in acid… I don't know where the Methedrine came from but it came in its little medical boxes and it was cheap and plentiful."

Methedrine had become relatively easy to get hold of, its source in no small part being the "junkie doctors," a group of doctors of which Lady Isabella Frankau and Dr John Petro were two of the most notorious. The Deviants had their own "junkie

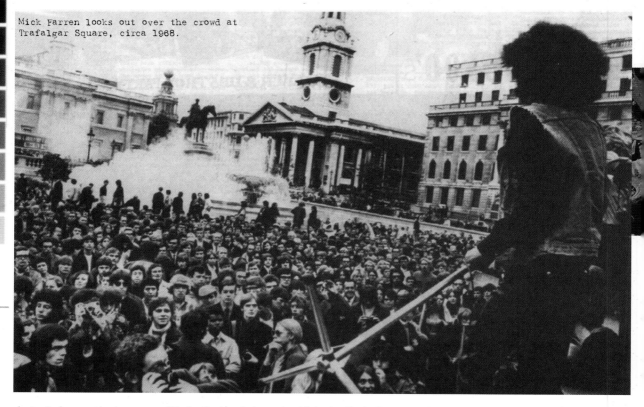

Mick Farren looks out over the crowd at Trafalgar Square, circa 1968.

doctor," who went by the name of Dr Brody. After being evicted from his Shaftesbury Avenue consulting rooms, Dr Brody, according to Mick, was "reduced to sitting in Boots, the all-night chemist in Piccadilly, writing prescriptions for anyone who could pay."

In a previously unpublished 1987 interview for Jonathon Green's book *Days In The Life*, Russell Hunter has said of this period, "I took drugs to find out really — you had to see what happened. I was also heavily into Methedrine, which I used to get from Dr Brody in Shaftesbury Avenue — 'You are mad. You will kill yourself! Give me the money. Thank you.' — I also met Dr Petro, the junkie doctor. He was completely mad and he was sampling his own wares. I remember him sitting in Micky's flat in Shaftesbury Avenue just writing methedrine scripts on an old Smith's notepad, giving them out to anybody who'd give him a tenner. I don't think Micky was actually there… he was very down on Petro and wouldn't have liked it. He took a lot of speed but not much else. Micky had quite a moral thing about those guys."

Jenny Ashworth, Russell's girlfriend and sometime Deviants backing singer describes the insidious nature and proliferation of methedrine thus, "Ah yes… methedrine. The reason my teeth all fell out! And yes, *Disposable* happened when all that was at its peak… We were all at it, myself included, and yes, it was excessive. I don't think we realised how serious it was. We were young and thought we would live forever. We were all pretty strung out. It's ultimately a horrible drug. Messes with your brain leading to massive paranoia and a kind of weird spaced out madness, which you got so used to, it felt normal."

By 1968 it was evident that methedrine was getting out of control, and by October of that year the Ministry of Health reached an agreement with the manufacturers of the drug to restrict supplies of injectable methedrine to just hospitals for a year. This they implemented fairly rapidly, leaving a potentially dangerous void in its place. Russell Hunter has said, "the government stepped in and stopped all that over night, literally. They just said 'That's it. After six o'clock tonight, no more methedrine.' It was very lucky really."

In suddenly imposing these restrictions in one fell swoop, the government shifted the parameters to unwittingly open up a wider

field of potential abuse, and possibly exacerbated the perceived drug problem to a greater degree. On the one hand, because of the act, many casual methedrine users, like the majority of the Deviants, were spared their physical health as well as their sanity. But on the other hand others with more serious needle fixations, who were more deeply immersed in the drug sub culture, subsequently switched to injecting other drugs, such as heroin, or barbiturates.

band recorded the LP, they were out on the road again to promote both the still fairly recently released *Ptooff!*, and to showcase some of the new songs on *Disposable*. Because of the escalating drug use, and the band's increasingly frenetic schedule of recording and touring, the circumstances surrounding the creation of *Disposable* are almost as legendary as those surrounding the making of *Ptooff!*, but for completely different reasons.

Methedrine was being used almost daily by nearly everyone

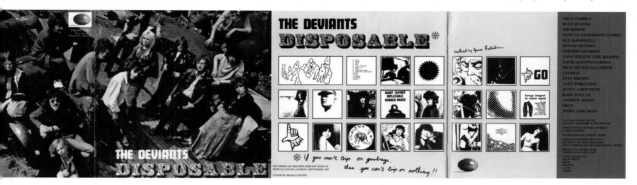

Having gigged extensively throughout the spring and summer of 1968 to promote *Ptooff!*, the band entered Morgan Studios in September to record their second LP, *Disposable*. By now Farren and Sparkes, under the guise of Mean and Filthy, had secured the Deviants a record deal with newly established independent record label, Stable, supposedly owned by Simon Stable. Today, Mick implies that, in hindsight, the Stable deal was something of a mistake, and without going into too much detail says, "I was stupidly simple. Simon Stable was a club DJ, mainly at the Country Club in Belsize Park, and worked in the record store Musicland on Portobello. He was fronting a psychedelic record label for the guys that ran the Trojan blue beat label. They also owned the Flamingo nightclub of Georgie Fame fame. A Combo of West End and JA mobsters. Heavy!"

Disposable was knocked together in little over three weeks, and is nowhere near as experimental as its earlier counterpart. It could have been produced by a different group altogether, and in some respects it was: Sandy and Mac had replaced Cord Rees on bass, and Tony Ferguson and Dennis Hughes shared keyboard duties. Although the compositions were largely much more straightforward than the more experimental numbers on *Ptooff!* they certainly had much more of a scuzzy edge than a great deal of what else was around at that time, and could hardly be classified as mainstream rock. Indeed, in November 1968, *Record Mirror* journalist Derek Boltwood commented, "Like garbage the sound of the Deviants is rough and raw and not the sort of thing you serve for tea in the front room on Sunday afternoon."

The recording of *Disposable* may have given the band a brief respite from the rigours of the road, but its production time from the start of recording in September to its release in December was considerably shorter than that of *Ptooff!* No sooner had the

involved, and with a constant cycle of uppers, counteracted by downers, it was not long before amphetamine psychosis and the side effects of other drugs began to affect certain members of the band and its entourage. For some members injecting had become the norm when taking drugs, and not just methedrine either. Heroin had started to creep onto the scene in a bigger way than before, and even at this early stage the Deviants were not without its own dabblers.

Steve Sparkes arranged for a photo shoot to take place in an old car breaker's yard that he had discovered near Littlehampton on the south coast of England. All of the band, and a number of their friends and other acquaintances made the trip to the coast in the group's legendary black transit van early one Sunday morning. Before they had made it out of London they were stopped and questioned by the police. Steve Sparkes remembers it like this: "It was 6.30 in the morning, and we all meet up in Ladbroke Grove, and jump into the back of the van, and we had a jukebox… So there's a van with a jukebox, and the Deviants and Boss, and everybody's girlfriend… and every drug known to mankind in the back of this van… So we pull out into Ladbroke Grove and the police stop us, and one guy goes up to Tony Wigens to get his licence or whatever, and the other copper goes round the back and opens the back door to the van. He looked in, and looked at everybody in the back of the van, then he closed the back of the van, and said to his mate, 'Come on let's go. I don't want to do this!'" On this occasion, the bizarre sight of so many freaks in one confined place freaked the poor copper out.

By the time they reached the coast and parked up it was apparent that the increasingly erratic keyboard player Dennis Hughes had taken a heroin overdose, and all attempts to

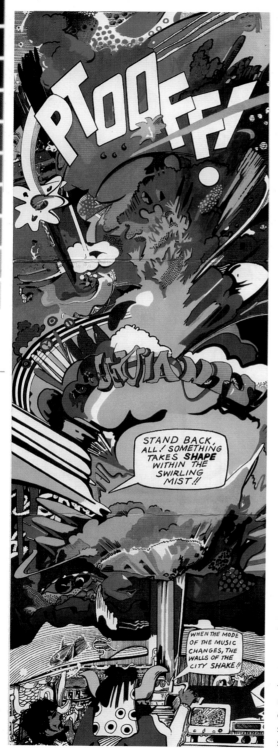

resuscitate him proved futile. Sid now says, "We thought he was dead. He certainly appeared to be, and checks on his pulse, heartbeat and breathing all proved negative. Even the old mirror under the nose trick failed to find any sign of life." It was at this point they assumed Hughes to be dead. Not wanting to waste their photo opportunity, however, having crawled out of bed at some ungodly time on a Sunday morning and made the journey down to the south coast, the rest of the entourage went and had their photos taken. They would worry about what to do with the hapless Hughes afterwards. It was even mooted that they carry the body down to a remote beach, where they hoped he would be found and his death would be attributed to the accidental overdose that it was, thus deflecting any unwanted police attention from the rest of the band.

Having completed the photo shoot, the band trudged back to the van only to be greeted with a volley of abuse from the supposedly dead Hughes, who had come round in a somewhat confused state of mind. The entourage then had to re-adjourn in order to shoot the photo session all over again, this time with Hughes! The final result was used on the gatefold cover of *Disposable* and shows the Deviants and their retinue in all their freaky glory.

In hindsight, the story is darkly humorous, but the reality was that Hughes had become a very troubled individual, a situation exacerbated by the huge amounts of drugs he was taking, such as LSD, STP, methedrine, and heroin, not to mention heavy drinking. He would leave the band soon after the release of *Disposable*, and apparently committed suicide by jumping from a castle in Wales. The Deviants' other keyboard player, and Sandy's old friend from school, Tony Ferguson, would meet a similar fate in that he also took his own life. After leaving the Deviants, Ferguson suffered periodic bouts of depression, and became a Hari Krishna for some time before drowning in a bizarre attempt to swim between the two piers on Brighton seafront, having been hospitalised following an attempt to kill himself.

Disposable was a conscious stab at producing a more commercial effort. Today Steve Sparkes says about the album, "We were trying to make some money… we were trying to move towards competence and less anger." In came a more hard edged straightforward rock sound, which was favoured over the experimentation that the band indulged themselves in on *Ptooff!* Sid Bishop is given more of a free reign, and his trademark fuzz guitar comes more prominently to the fore and impressive throughout (although the throwaway guitar instrumental Sidney B. Goode is best left alone).

Steve Sparkes had booked the band into Morgan Studios in Neasden, London, where one of the resident engineers was Andy Johns, brother of the more famous producer and engineer Glyn Johns. On one memorable occasion, someone snapped an ampoule of methedrine and spiked Andy Johns with it. In an interview with Trevor Jones (reprinted on the sleeve for the Deviants *Disposable* CD re-release in 1998), Russell recalls: "I remember one evening, Andy Johns was feeling tired and wanted to go home and we said 'What! Here we go Andy, try some of this… you'll feel better!' I cracked an amp of it and poured it into a glass of milk… and I think we were there for about two days on the trot after that…" This was not the only time Johns fell prey to the amphetamine fuelled Deviants. His coffee was subjected to the methedrine treatment every time he showed signs of flagging, according to Mick. Not only did this put Johns on the same wavelength as the band to some degree, it also had the desired effect

of obtaining extra studio time. Steve Sparkes has said, "He didn't know what week it was, let alone what hour it was!"

On another occasion when the band were due to record a song called Let's Loot The Supermarket (perhaps owing more than a nod to Boss's previous existence as a supermarket manager, a position from which he was sacked for redistribution of food amongst local hippies), the band were about five days into what amounted to a marathon methedrine binge, and Boss called up his dealer friend Gerry 'The Man' Burroughs to enhance the day's proceedings with whatever herbs he had to offer at the time. Come the time to record the track, all involved had smoked themselves into a near senseless stupor and were hardly in any state to rehearse the song, let alone record a competent final version.

Let's Loot The Supermarket, discordant shambles that it is, indicates where Farren was coming from at the time. Fire In The City was a much more serious proposition, both musically and in terms of the political content of its lyrics. For the song, Mick recruited veteran jazz saxophonist Dick Heckstall-Smith, and Pete Brown of Battered Ornaments, also a respected trumpeter and Jack Bruce's early song writing partner for Cream.

With its funky jazz rock vibe, and lyrics like *The world's gone insane, and the wind has changed, and who's to blame?*," Fire In The City mirrors the social and political foment prevalent throughout Europe in 1968, as it does the continuing unrest in black ghettoes throughout a number of cities in the United States. Champions of the Civil Rights movement, Martin Luther King Jr and Senator Robert Kennedy had both been assassinated that year, and the radical black power movement was really now entering its ascendant, spearheaded by the militant Black Panther Party. Districts such as Watts in Los Angeles and Detroit, went up in flames to the war cry of "burn baby burn." Richard Nixon was elected President, and the anti-war movement began to pick up momentum as the war in Vietnam escalated. Turbulent times indeed!

Contemporary interviews with Mick Farren certainly highlight his own political awareness at that time, and he stresses that the Deviants were a political band. *Disc and Music Echo* ran an "Underground" special in its November 2 issue from 1968, and in an article called 'Revolution — with guitars, not bullets,' Mick is quoted as saying, "The underground is what it literally means — a resistance movement against the establishment. Like in France during the war, but today it's sneakier and less direct… The present underground uses widely different media to earlier ones — that's if you can call sub-machine guns a media. Violent revolution is not the answer because, basically, revolution means a change in people's attitudes and violence doesn't do that — it just gets rid of those with different attitudes to your own."

The common thread throughout the article was revolution by means of music, "with electric guitars and harmonicas rather than bullets and bombs." Mick emphasised that, "Pop music is the only large medium the underground has. And it's the only thing which this generation has grown up with and can totally identify with."

If Mick was eager to stress that the Deviants were a political band, others were not necessarily so inclined.

The musical side of being in a band was always more important to Sid Bishop than the politics. He enjoyed the spirit of communal rehearsal sessions in the early days in the East End, but he was never all that keen on the idea of living the communal life with the rest of the band when it was mooted at one stage. Besides, he was married with a baby daughter, and his wife was even less than enamoured with the communal idea than Sid. Since the early days of the Social Deviants certain members of the band had always lived with one another, or in close proximity to each other, and now did so at Shaftesbury Avenue. "Truth be told," Sid has said, "most of us didn't really get on that well on a personal level, and even musically, people were often pulling in different directions. The whole thing inevitably would have been a disaster, and certainly would have resulted in the band's early demise. The community thing is a bit of a myth I'm afraid. Just because we all assembled for a few photos, and looked like a load of hippies, and gave out a vibe of community spirit doesn't mean to say there actually was one."

Whatever the relationship was, the exact circumstances surrounding Sid's departure are not entirely clear. Sensing his impending ejection, Sid himself says that he went before he was pushed, but Mick has suggested that he became a victim of the next round of Stalinist purges within the band, probably precipitated by new Canadian friend Jamie Mandelkau's tales of an amazing Jimi Hendrix style guitar player called Paul Rudolph…

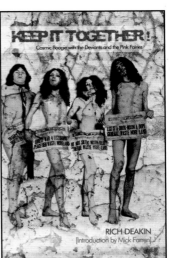

Extracts from the chapter "Motorpsycho Madness and The Methedrine Monster," taken from the book *Keep It Together: Cosmic Boogie with The Deviants & Pink Fairies* by Rich Deakin. Published by Headpress
UK £13.99 / US $19.95
ISBN 9781900486613
www.headpress.com

THE FIRMAMENTS OF WRATH

A detour through the wastelands of West Yorkshire by RIK RAWLING

"I reign over you, sayeth the God of Justice, in power exalt above the firmaments of wrath; in whose hands the sun is a sword, and the moon as a through-thrusting fire." Enochi 'Invocation of the Mystery,' the Ritual Opening of the V

PROLOGUE

"It is a secret place, the land of tears" Antoine de Saint Exupery

It is a photograph, specific details unknown, except that it was taken in Morley, West Yorkshire, in the first decade of the twentieth century. An unnamed number of people are stood in a field, mostly men but notably including a woman and what can be presumed to be her daughter, holding a small dog on a leash. Judging by the clothes and faces, a broad variety of age and social status is represented, but the setting doesn't appear staged in the manner of civic portraiture, so what has brought these people together, on this day, in this field, to stand in front of a thirty foot tall bonfire? The pyrrhic woodpile is made from planks, poles, tree branches and, at its crown, a beer barrel upended atop the tallest pole jutting out from the twisted mass of kindling. Is it just another Guy Fawkes cluster of chumped wood, to be torched and cheered at as sparks drift up into the black sky?

Or does it, as suggested by the stark tones of the picture, represent a more sinister ritualistic intent on the part of the townsfolk? Wicker Man vibes, but kept in check by a stoic Yorkshire intolerance for nonsense — so no masks or dancing or pagan pigtails, just some unfortunate unbeliever tossed into the inferno, screams lost amidst the crackling of the tinder. The stench of cooking pork and, on the faces of the children, the shimmering incandescent glow of the consuming fires.

This is my home, the place that I geographically came from, and where, spiritually, we are all headed.

I awake in the dark and don't recognise where I am. My eyes adjust to what light is available, revealing brick walls, a corrugated tin roof, wooden slats across the windows. Its cold, breath misting. Outside, I can hear rain drip and, getting closer, voices.

I sit up and find I've been sleeping on a pile of straw. Next to me is a girl's body, fully dressed but unmoving, her face covered by her jacket. Suddenly, I'm shivering. The voices get closer, louder. Gruff, male voices. Boots stomp through the undergrowth.

By my hand is a milk bottle, now empty. A memory surfaces… stealing the bottle a few hours earlier, from a doorstep. Taking it to an off licence where no questions would be asked by the rheumy eyed old wanker behind the counter, with hair growing out of his ears and gravy stains on his shirt. He filled the bottle from a plastic barrel with a tap, to the brim with a foul treacly mess sold as sherry. With not enough for a bottle of Olde English, it would have to do. We'd sat in the barn and taken swigs, gagging at the melted liqueurs and petrol taste, swallowing it anyway. Feeling the burn on an empty stomach. Dizzy in the dark, hushed whispers when someone walking the dog passed by. Then we'd done it.

There were at least two men outside now, torch beams flickering through the gaping crack in the doorframe. Then they were in, the door opening with a Hammer Horror creak. Police. They told me to get up. One of them pointed his torch at my face; the other gently shook the girl, unsure if she was alive or dead. Others came into the barn behind them, raindrops glistening on their shoulders. A torch beam was aimed at the crotch of my jeans, unfastened, earning me a look that suddenly woke me to the stark reality of my circumstances.

Outside, the rain hissed as it fell on the weeds and nettles.

"A small town is a kind of hell" Argentinean proverb

Like Rome, Morley was built on seven hills. And that's where the comparisons end. *La Dolce Vita* never reached this forgotten stain on the map of Northern England. It's only ruins, never destined for tourist photo opportunities, are the same rat infested abandoned mills that have since been converted into Manhattan style loft apartments in some of the more invigorated towns of the post industrial valleys of West Yorkshire. Not so in Morley. Though less than five miles from the alleged "Barcelona of the North" — Leeds, a New Labour success story if the brochures are to be believed — the town has yet to benefit from any overspill of affluence from the burgeoning metropolis to its North. The imposing Victorian edifice that is the clock tower of Morley Town Hall looks out across a decaying municipal borough devoid of hope, ambition or any sensible reason to stay. It exerts its own drab inertia on those born there and if you don't get out during your wanderlust years then you will never leave. The horizon draws in around you, the roads turn back on themselves and the world beyond the fringes of Bradford and Wakefield, its closest neighbours, exists only as backdrops for soap operas and "gritty" crime dramas. Occasional excursions to Manchester airport, for stag dos in Amsterdam or Dublin, are a reminder that a significant portion of life's options have been casually dismissed, in favour of the same faces you went to school with, stumbling into the same pub every Friday night, discussing the same stale memories. A ritual of denial, performed unconsciously every weekend — kebab grease and broken bottles in place of black candles and sacrificial daggers.

A shithole, the town is slowly collapsing in on itself. Property prices have shot up now that everyone wants an LS postcode, but you simply pay more for the same soot stained terraces, car parts and wheelie bins in the weed encrusted yards. Some try to express a sense of mortgaged pride via B&Q cosmetic surgery — stone cladding and decking and hanging baskets — but you can't polish a turd. Queen Street, the main shopping conduit through the town, has been pedestrianised too late, with most stores going to the wall in the nineties when the White Rose Shopping Centre, a mini-me version of Meadowhall or the Metro Centre, was erected on the site of a former sewage works on the fringes of the town. As a result, all that remains are hollowed shells, the Retail Outlet To Let signs fading now, with only the ubiquitous Cancer Shops offering somewhere for pensioners and teen mothers to shelter from the rain in. Faces hang grey and sallow from skulls full of fag ash and misery. From the generations of deprivation and ennui, the town has produced two names deemed worthy of historical record: liberalist Prime Minister Herbert Asquith and flash in the pan novelist Helen Fielding, author of the fatuous *Bridget Jones' Diary*, spawn of thousands of column inches by paid pifflers, London latte quaffers who would last about five minutes in the Market Café, a black lung full of carcinogens and lard that's as far removed from Islington that it might as well be on the moon.

Beneath the litter and graffiti of Morley are remnants of a once attractive Victorian town, where prosperous Aldermen and the proud, hard working serfs could stroll of a weekend in the well tended parks of Scatcherd and Scarth, Lewisham and Dartmouth, or take a train out through the acres of greenery that once surrounded the place, isolating it from the neighbouring towns. The train stations have all

but gone now and the greenery has been gradually concreted over, replaced by industrial parks, leisure complexes and the roads needed to feed these zones of compulsory commerce. Fine old buildings now host Mike's Carpets or Asian Cash & Carry. The war memorials have been ruined by successive generations of bored teenagers, a hormonal blitzkrieg triggered by contempt for a place where nothing ever happens, never has and never will.

That's the surface story, nothing new and nothing unusual, repeated dozens of times over throughout the towns that lurk either side if the Pennines. But for those who know it, and have seen its inner workings, there is a whole other back story to consider.

Illustration by Louis Price

One rarely discussed in the open, just overheard whispers in the shadows and the taprooms of backstreet pubs, many of the pertinent details now lost to senile memories collapsing into the grave, soon to be apocryphal notions, ghost stories.

I was born in Morley, August 25, 1968. Family legend implies that when they brought me home they found that the kitchen clock has stopped at the exact minute of my birth, a spooky detail that helped fuel my Damien fantasies. The building I was born in was the same maternity hospital that saw my elder siblings — brother and sister — emerge into the world, and was known as Morley Hall, reputedly haunted. For many years afterwards, the building remained abandoned, derelict, another piece of nineteenth century architecture left to the vines and the pigeons. It sat atop a hill overlooking Scarth Park, a dank hillside of rhododendron bushes and discarded crisp packets, the overgrown foliage providing discreet cover for homosexual encounters and after school cider

binges. Once, a cat was found hung by its neck from a tree there, maggots feasting on its eyes.

Whilst Morley was my hometown, my family lived in Churwell, a village some two miles to the North, which had gradually been absorbed into the town's sprawl during the 1960s. If Morley was a place where no one went without good reason, Churwell was simply off the map. Self contained in many respects, it was surrounded on all sides by farmland, much of it still tended, the produce used to stock the village shops.

Many of the families in the village had lived there for generations, often in the same house, with children moving away often no further than the next street. My mother's family had lived there as long as she could remember, her Grandparents shoring up from County Kildare after the spud famine, and apart from her brother in the army, all her sisters also lived within a doorstep's shout of one another. It was the archetypal close knit community, upholding the clichés of everyone knowing one another and never having to lock their doors. Children played safely in the park at the centre of the village and there was nothing to distinguish it from anywhere else. Normality, or so it seemed. But from a child's perspective, the truth is sometimes more plainly seen.

And it's the little details that adults inadvertently let slip that would allow a more instructive portrait of a place to be collaged.

Two doors down from our house lived the village idiot, Lloyd Jennings. His mother, Dot, was a four foot tall hunchback who shambled about in her rags and unwashed hair like one of the Sea Devils I saw in Doctor Who on a Saturday teatime. Eddie, Lloyd's father, had been the sole restraining influence on his peculiar son, and when he died in the early seventies, Lloyd's true spirit was unleashed. He looked like a fool, a Deliverance reject, with a bluntly tooled Halloween turnip face and an asymmetrical haircut that predated Phil Oakey's Human League flick by several years. Lloyd was beyond fashion, though. He was beyond anything I had yet come across, and I lived in breathless expectation of his next stunt. Pyromania was one of his favourites, but lacking incendiaries, he would resort to good old fashioned blunt instrument destruction. Starting out quietly and unexpectedly, he set fire to the fields behind our estate; old mine workings now overgrown with scrub grass, known locally as The Pit Hills. Dry grass on a summer afternoon soon caught ablaze and the street was soon full of fire engines and standpoints were cranked open so the hoses could be brought nearer to the source of the blaze. In amongst the crowd watching the flames lick ever closer to the houses, was Lloyd with his Peter Kurten smirk of glee doing little to dispel the commonly held belief that it was he and not "some kids" that had started it.

Afterwards, the fields were reduced to charred black stubble for months afterwards, the grass growing back just in time for him to do it again.

He also smashed windows. House windows, car windows, any pane of glass he took an aversion to. Starting out with eggs he soon progressed to half bricks and breeze blocks. He did my aunt's kitchen window, our kitchen window, our living room window and even some of the windows in his own home. The final straw came when he put through the windscreen of dad's Mini, which, despite the lack of evidence, earned him a leather gloved

beating that would be unthinkable in today's society but at least stopped any more windows getting smashed. From there, Lloyd moved on to explosion, starting with his moped. He had always started fires in their metal bin in the garden, but setting a torch to his scooter (a leak in the petrol tank was the reason for its mechanical failure) was a considerable step forward, with the inevitable result of a thunderous blast as the petrol ignited, instantly torching the overgrown hedges and sending shards of plastic and metal flying all down the street. One Saturday morning I was awoken by a similar detonation when he burnt a faulty fridge that blasted shrapnel against my bedroom window and left their garden a smouldering crater.

There are many more stories about Lloyd — the two smashed television sets, bricks put through the screen "because there was nothing on," the stray cats they started to take in, until they numbered into the dozens, the awesome squalor inside their house, including an old sofa that the cats had been using as a communal toilet, and the unholy stench therein — and it's safe to say that Lloyd was a significant character in my formative years, opening up my mind to the potential applications of eccentricity.

Another such character was Stanley Yarrah, the bogeyman of my youth, who lived alone in a house at the end of the street. He dressed only in black and had a permanently unwashed caste to his flesh, that suggested nocturnal activities in graveyards and the disposal of body parts, though in reality he was nothing more than a gyppoe with a postcode, a lurker on the fringes of the same lifestyle as Fred West: allotments hoarding stolen goods, lead nicked from church roofs and stacked in a bath never used for ablutions, dried under the fingernails, pockets full of greasy the palm prior a hand- horseshit and rags. Yarrah children and would chase them away from outside his house, though once they were old enough to be "of use," he became their Fagin, sending them scuttling off up drainpipes or in their skylights, to purloin for his benefit. He would then load the loot into the back of his Reliant Supervan III, a turquoise Del Trotter mobile known to us kids as "The Electric Chicken" that was once famously blown up with a paint tin full of gunpowder, on yet another memorable Mischievous Night. He was pissed off for a long time after

chicken blood and coal dust hobnail boots, sweat, tenners, spitting in shake deal, hated

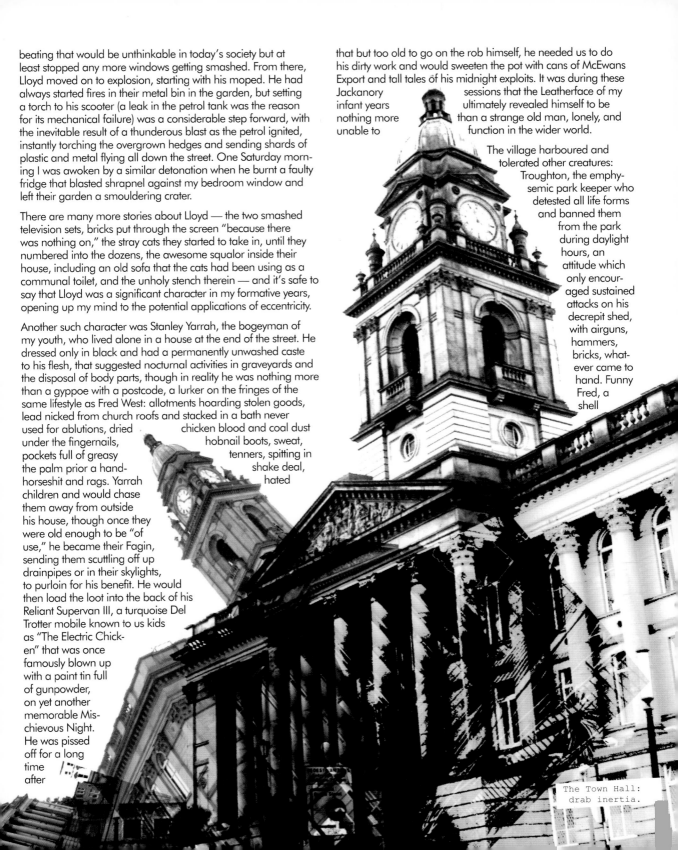

The Town Hall: drab inertia.

that but too old to go on the rob himself, he needed us to do his dirty work and would sweeten the pot with cans of McEwans Export and tall tales of his midnight exploits. It was during these

Jackanory infant years nothing more unable to

sessions that the Leatherface of my ultimately revealed himself to be than a strange old man, lonely, and function in the wider world.

The village harboured and tolerated other creatures: Troughton, the emphysemic park keeper who detested all life forms and banned them from the park during daylight hours, an attitude which only encouraged sustained attacks on his decrepit shed, with airguns, hammers, bricks, whatever came to hand. Funny Fred, a shell

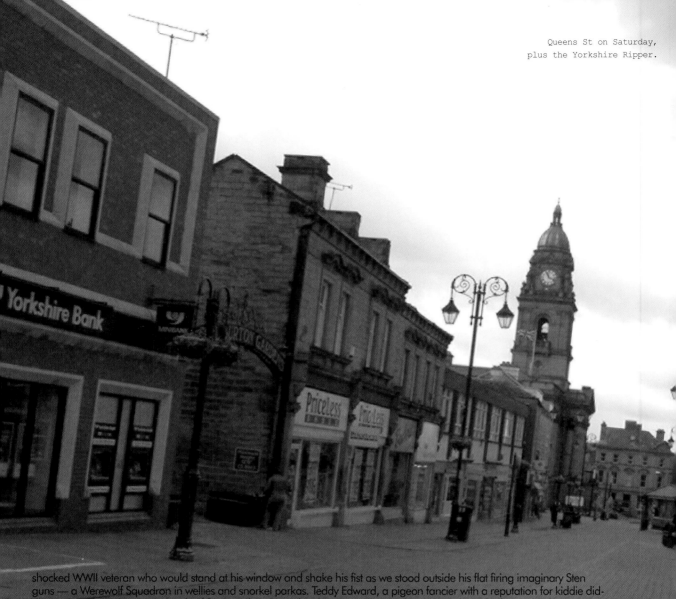

shocked WWII veteran who would stand at his window and shake his fist as we stood outside his flat firing imaginary Sten guns — a Werewolf Squadron in wellies and snorkel parkas. Teddy Edward, a pigeon fancier with a reputation for kiddie diddling, who received annual parcels of flaming dog shit on his doorstep every Mischievous Night. Harmless enough, just casual spite and childish energies channelled in the wrong directions. Nobody got hurt, not yet.

One bright morning in 1974 my cousin Marcus was doing his morning paper round, which took him the length of William Street, a row of post war housing that faced onto Churwell Park. He had just passed the house where a lad we knew only as Kipper lived, when there was a thunderous eruption that was heard miles away. At home, I was eating breakfast when the Krakatoan detonation went off. My mother, assuming my brother had been pissing about in the bedroom and had pulled the wardrobe over on himself, ran upstairs to assess the damage but the phone was soon ringing as relatives and neighbours began to spread word of what had happened. It seems that Kipper's dad, aggrieved, depressed, possibly suicidal, had risen early that morning, turned on the gas taps, and sat awaiting the inevitable spark of a flicked light switch. The resultant explosion totally destroyed their house, along with those of their neighbours to either side, and imploded most of the windows along the street, though my cousin came away completely unscathed. The park was strewn with debris, glass shards and chunks of brick and the tattered remnants of household detritus. Mattresses and charred cushions hung from the treetops like strange new birds. The event made the local and national news and for a few Warholian minutes our village was on the media map, though because no one had actually died (amazing when you consider the awesome scale of destruction wrought), it was

soon forgotten. But there would be other tragedies not so easily erased from the public consciousness.

"They give birth astride of a grave, the light gleams an instant, then it's night once more" Samuel Beckett, *Waiting For Godot*

Doomed to be a bastard, his mother's indecision made him too late for the abortion bucket. Within days of his squalling emergence into the world, her options were clear. As a low wage factory worker and the impregnator long gone into the beer-fogged night, she had no means of supporting this parcel of flesh and regret, and so shortly after his birth date of April 21, 1947, Robert Black was given up for adoption. His mother Jessie was to later marry and emigrate to Australia, where she raised a family of four children and never openly discussed the other child she had borne. Sometimes she would think of him, what became of the child she abandoned to fate, and it's perhaps fortunate that she died several years before the awful truth was ever known.

Jack and Margaret Tulip lived in the Highlands of Scotland, in the town of Kinochleven. They adopted Robert at the age of six months and raised him at their home for the next few years. Jack Tulip died when the boy was just five years old and the parenting chores became the sole responsibility of his wife, who applied a stern Presbyterian discipline to Robert's childhood misdemeanours. He would turn up at school covered with bruises but claimed no parental abuse as such, though his mother was known to lock him in the house or lash his bare arse with a leather belt whenever he fell foul of her commandments. He was a habitual bed wetter and a nose picker, called "Smelly Robert Tulip" by the other boys and regarded as a bully. He would lash out at those he knew he could physically dominate — younger and smaller boys and, on one occasion, a lad with an artificial leg who was stomped mercilessly for no apparent reason. He would not, could not, mix with boys his own age and cobbled together gangs of smaller children to lord it over, administering the kind of stern justice he had learnt at home. Whilst he cultivated a reputation as a hooligan — a "wild wee laddie" — he never got caught doing anything the other boys weren't all capable of in some way, the usual playground power rituals, dishing out black eyes and bloody noses, kicking shins and pulling hair. A daily battlefield for all, at that age.

Privately, he played his own games. Prematurely aware of his own body he began to fumblingly experiment with its potential for sensation, which started out as a kind of *Why Don't You?* experiment to see what kind of things he could insert up his anus. This started out as small household items, before progressing in later life to the kind of Channel Five shockumentary items that police found Polaroids of: table legs, wine bottles, fists. It was the culmination of an obsession with bodily orifices, a lifelong descent into the Freudian abyss from which he never emerged. In his own misguided way it was a way of exploring his sexual identity, a chance to be the girl he had always grown up wishing he were. He had learnt to hate his male body, especially the vile attachment of his penis, and would have preferred to be a girl, thus offering up two holes for further enquiry. Was this some vain attempt to reconnect post umbilically with the mother that had discarded him, excreted and flushed him away like so much waste? Did his probing of holes ritually allow him access to the mystery

of his existence, back to the amniotic source of his being?

Despite the indiscriminate anal antics, he was not homosexual and from an early age evinced a fascination with girls. It was just the usual Doctors and Nurses games, harmless comparing of mysterious genitalia, fleshy outgrowths that seemed to serve no function beyond differentiating between whether or not you could stand up to piss.

Innocent games turned nasty though after his foster mother died, when Robert was aged eleven. He was sent to a Children's home near Falkirk and it was here, on the cusp of puberty, that a more violent and aberrant aspect of his sexuality came into fruition.

He took part in an attempted gang rape when he was just twelve, though neither he nor the other two boys could raise a sufficient erection to consummate the act. The matter was hushed up and it was decided it would be best for a boy with Robert's proclivities to be raised in a home with a stricter regime. The Red House in Musselburgh was an all boys environment, where he was repeatedly abused by a male member of staff. The loss of his mother had unhinged him just as he was entering a critical phase of his development, where the sexual urge stains the once unsullied bed sheets of youth, and demands expression. Through the beatings about his person at his old home, to the rectal bedroom games, to his latest experience of physical intimacy, Robert learnt to regard the world as a hostile environment from which desires must be satisfied via force. The feelings and even basic humanity of the victim didn't matter — they were nothing more than a fleshy anvil upon which he beat out his rage.

By sixteen years of age, Robert was engaging with the world as an adult. He had left the boys home in Musselburgh and was now renting a room

The Zionist chapel graveyard behind the supermarket, plus porn mags and *Violation of the Bitch*.

in Greenock, near Glasgow. Working as a delivery boy gave this now damaged-beyond-repair individual access to the homes of hundreds of people, and it was during this period that he admitted to molesting anywhere between thirty to forty young girls. The molestation was a variation on the kinds of bodily assaults he'd made on his own person, the difference here being that he was forcing his will, his aberrant urges upon these girls. Given the number of victims it's hard to accept that his behaviour wasn't noticed by any of the parents but this seems to be the case, and it wasn't until a year later that he received his first conviction for lewd and libidinous behaviour, a legalese euphemism for what was basically attempted murder. Using the standard ruse of having some kittens to show her, he took a seven year old girl to a derelict building and made his assault, by first pinning her down on the ground and throttling her

and then, once inert, stripping her and fingering her body, before kneeling over her and masturbating which, without all the hammers and bloodshed, was practically the same ritual Peter Sutcliffe would perform on his victims. Once spent, her left her for dead, oblivious to the repercussions of when she would inevitably be found. As it turns out, the girl had been unconscious and woke up confused and bleeding. She was found later walking the streets in a state of distress, and her attacker was soon named and brought before the courts. Despite a record that included attempted rape, numerous molestations and now an obvious attempt at murder, Black was given nothing more severe than a telling off, what's known under Scottish law as an 'admonishment'. The Judge's decision was based, in part, on a psychiatric report on the boy, which implied that this incident was a 'one off' and that it was unlikely he would commit any such similar offence again. It was just youthful high jinks gone awry, obviously.

Scot free, so to speak, Black moved to Grangemouth in 1964 where he rented a room from a couple who needed the extra income from a tenant. He had a job with a builder's supply merchants and when he began seeing local girl Pamela Hodgson on a regular basis, he felt some sense of stability come into his life for the first time. He fell in love with Pamela and, after the relationship had developed a sexual aspect, he proposed marriage to her, which she accepted. The engagement didn't last long though and a Dear John letter from her left him distraught, his fragile new world crumbling around him, causing him to revert to his former patterns of behaviour. Maybe he never really curtailed his molestations but having a girlfriend would have certainly prevented him from the kind of indiscriminate activity he soon embarked upon once she'd told him it was over. He was caught molesting the nine year old granddaughter of his landlady and once again the matter was hushed up, with Black being asked quietly to leave the premises. He moved on to Kinochleven, the town where he had been raised, and soon performed to type once more, this time with the young daughter of the couple he rented a room from, only this time the police were called.

He was twenty years old, guilty of indecent assault and banged up in Borstal. On his release he knew that he had developed a certain notoriety throughout the areas of Scotland he was familiar with, and with his welcome outstayed it was time to seek out a new locus, a place where someone of his inclinations could perhaps be more easily absorbed without attracting too much attention. A place already rife with every type of human scum.

London became his new home. He lived in bed-sits and paid his rent with casual labour, drifting through his days and nights. He hung around pubs, swigging pints of lager shandy and taking the piss out of strangers. A match of darts he sometimes joined in on but he wouldn't allow himself to be drawn into any kind of social circle. He stayed distant, remote, a moon with nothing but dark side, orbiting around a metropolis that didn't seem to care, least of all about a child molester in its midst. He wasn't alone in his perversion, as he discovered when exploring some of the more obscure and rarely trodden alleyways of Soho. Child porn magazines from Amsterdam could be purchased, brown paper wrap ers under the counter, tenners palmed in a handshake, and Black acquired a large collection throughout the 1970s, progressing onto videos when the technology became more widespread. One of his casual jobs had been swimming pool attendant, clearly a post filled with no enquiry into his past, where he would watch the little girls doing lanes. At a loose end of an evening he would break into his workplace and enjoy the facilities for himself, casually breast-stroking up and down the pool with a broom handle stuck up his arse, an activity that could only have been undertaken in the days before blanket CCTV, otherwise the resultant footage would have made for a bizarre late night edition of *You've Been Framed!*

Black became interested in photography and recording video. His favourite subject matter was, of course, young children, especially little girls down on the beach, running around in their bathing costumes. These images acted as aids to refine his fantasies down to specifics, allowing him to strip away all the extraneous details and get down to what really mattered. And what really mattered was getting into the back of a van, dressing up in girls' swimming costumes, stuffing who knows what up his arse and then wanking himself silly. He was at the point where simply fulfilling his fantasies within his own mind could not sustain him for long and he would have to act out in the physical realm his desires, in order to feel some sense of "release." It's been suggested that he may well have already murdered by this time, and whilst the first incident directly attributed to him didn't occur until 1982, there remains compelling reason to suggest that he killed several times during the 1970s. His job as driver for PDS (Poster Dispatch and Storage), delivering posters all over the country, gave him ample opportunity to spread his predations far and wide, and due to his willingness to handle the longer haul routes that would have kept his colleagues away from their families, he was often on the motorways between England and Scotland. On the 30th July 1982, a delivery job brought him close to the town of Coldstream, just across the border in Scotland where eleven year old Susan Maxwell had cycled over to her friend's house to play tennis. Several witnesses remembered a girl matching her description, seen crossing the Tweed Bridge at about the same time as her mother was expecting her home. After that,

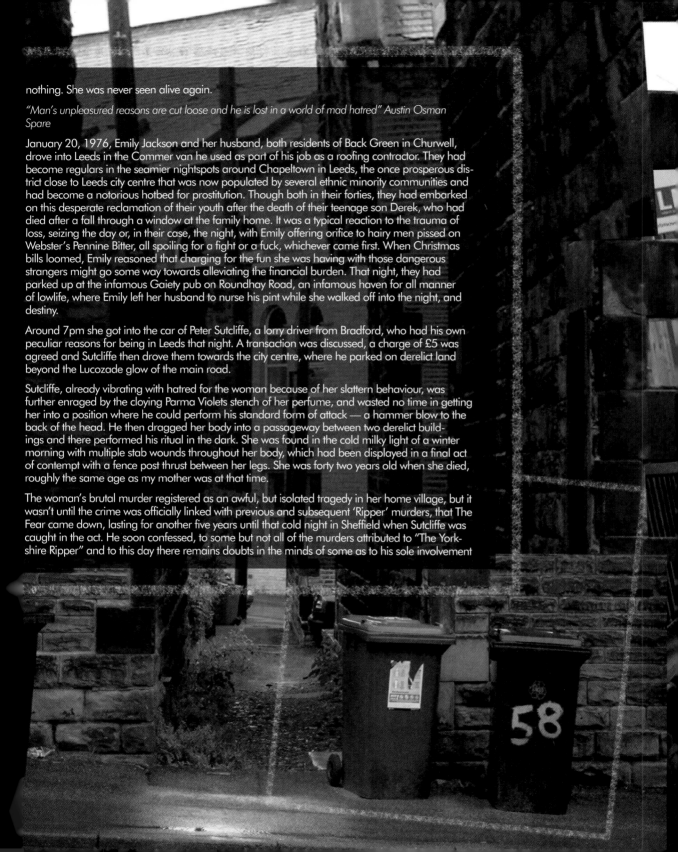

nothing. She was never seen alive again.

"Man's unpleasured reasons are cut loose and he is lost in a world of mad hatred" Austin Osman Spare

January 20, 1976, Emily Jackson and her husband, both residents of Back Green in Churwell, drove into Leeds in the Commer van he used as part of his job as a roofing contractor. They had become regulars in the seamier nightspots around Chapeltown in Leeds, the once prosperous district close to Leeds city centre that was now populated by several ethnic minority communities and had become a notorious hotbed for prostitution. Though both in their forties, they had embarked on this desperate reclamation of their youth after the death of their teenage son Derek, who had died after a fall through a window at the family home. It was a typical reaction to the trauma of loss, seizing the day or, in their case, the night, with Emily offering orifice to hairy men pissed on Webster's Pennine Bitter, all spoiling for a fight or a fuck, whichever came first. When Christmas bills loomed, Emily reasoned that charging for the fun she was having with those dangerous strangers might go some way towards alleviating the financial burden. That night, they had parked up at the infamous Gaiety pub on Roundhay Road, an infamous haven for all manner of lowlife, where Emily left her husband to nurse his pint while she walked off into the night, and destiny.

Around 7pm she got into the car of Peter Sutcliffe, a lorry driver from Bradford, who had his own peculiar reasons for being in Leeds that night. A transaction was discussed, a charge of £5 was agreed and Sutcliffe then drove them towards the city centre, where he parked on derelict land beyond the Lucozade glow of the main road.

Sutcliffe, already vibrating with hatred for the woman because of her slattern behaviour, was further enraged by the cloying Parma Violets stench of her perfume, and wasted no time in getting her into a position where he could perform his standard form of attack — a hammer blow to the back of the head. He then dragged her body into a passageway between two derelict buildings and there performed his ritual in the dark. She was found in the cold milky light of a winter morning with multiple stab wounds throughout her body, which had been displayed in a final act of contempt with a fence post thrust between her legs. She was forty two years old when she died, roughly the same age as my mother was at that time.

The woman's brutal murder registered as an awful, but isolated tragedy in her home village, but it wasn't until the crime was officially linked with previous and subsequent 'Ripper' murders, that The Fear came down, lasting for another five years until that cold night in Sheffield when Sutcliffe was caught in the act. He soon confessed, to some but not all of the murders attributed to "The Yorkshire Ripper" and to this day there remains doubts in the minds of some as to his sole involvement

in the thirteen murders, with several conspiracy theories in circulation — from Irishman Bill Tracy proposed as the genuine culprit, with Sutcliffe only coming into the frame later as a "copycat" killer, to Sutcliffe's Wearside accomplice, seen accompanying him in the trucker's cafés and alleged maker of the "I'm Jack" tapes. For years, there was some loon who would hand out leaflets in Leeds city centre claiming 'shocking' details of who the "real" Ripper was, and it was perhaps this self same crank that was responsible for an intriguing piece of graffiti that, for several years — until the recent Docklandisation of Leeds — could be seen scrawled in black felt tip across the whitewashed wall at the back of a newsagents on Swinegate that was fondly recalled by teenaged boys of my generation as the only place in Leeds during the 1980s where you could buy hardcore porn mags with no questions asked. The graffiti read: SCOTTISH PETER BLACK, THE SECOND YORKSHIRE RIPPER.

"Damaged people are dangerous. They know they can survive"
Josephine Hart

Susan Maxwell's body was found in a ditch next to a lay by on the A518, near Uttoxeter in the West Midlands, on Friday, August 13, 1982. This was over 250 miles from where she was last seen alive and a common area for Robert Black to pass through on his long distance runs between Scotland and the capital. Due to the hot summer weather in the two weeks since her disappearance, her body had decomposed to the extent where it could only be identified through dental records. The police acted promptly and conducted the kind of sprawling enquiry you'd expect from such a crime, though it was soon in danger of being compromised by the overwhelming amount of leads and information coming in. Some two years on from the Yorkshire Ripper case there were significant lessons that had still to be learned about co-ordination and use of

the available information. In the days before computerisation the Staffordshire police had only a manual database of index cards to work with and after a year the inquiry began to lose momentum. With no promising leads and no prime suspects there was little else to be done, least of all the prevention of such a crime from happening again.

Portobello is a seaside resort, east of Edinburgh. It was from here on July 8, 1983, that Robert Black abducted five year old Caroline Hogg. She'd been allowed to play out late after a friend's party and was down at the children's playground just a short walk from her home when she vanished. Eyewitnesses claimed to have seen her holding hands with a "scruffy man," who seemingly took her through the park to the amusement arcade at Fun City and let her ride on the roundabout, before walking off with her hand in hand. She was never seen alive again.

Despite tearful press conference pleas by her parents for her to be brought

It starts in the heart of Morley:
Peel St and its snicket.

home, and the thousands of volunteers who joined in to search for the girl — the largest of it's kind in Scotland at that time — there was nothing, absolutely nothing, that could now be done to stop the inevitable. Ten days later, Caroline's body was found in a lay by in Leicestershire, just off the A444 and less than twenty-four miles from where Susan Maxwell's body had been found. And again, as with Susan, the summer heat had caused her remains to decompose so rapidly that identification could only be made by the locket she was still wearing. Other than that, she was naked.

The similarities between the two murders demanded a co-ordinated response from the four police forces now involved — Leicestershire, Staffordshire, Northumbria and Edinburgh. Computers were used for the first time in a major enquiry of this type, in order to collate all the data. This would involve the transcription of a massive number of manual files, a daunting and time consuming task that resulted in the decision to log only the Caroline Hogg enquiry into the computerised database, whilst the Susan Maxwell case, now over a year old, would remain manual. How impactful this decision was on the subsequent investigation it was too early to say.

By the summer of 1984, the Miners' Strike was well underway whilst the enquiry into the murder of Carline Hogg had stalled. The young girl's last journey had been reconstructed and every lead fed through to the police had been followed up, including the 600 names given in response to the artists impression of the "scruffy man," but it had amounted to nothing but a mass of information that was leading nowhere. Meanwhile, Robert Black was still at large, driving up and down the motorway network in his van, always slowing down when he passed a school or cluster of girls stood at a bus stop, dreaming his dreams.

"We are Leeds, and we are reasonable people" Headline from The Guardian, 2000

The 1970s, the Ripper's decade, was when Yorkshire enjoyed its recognition within the mass mind, sometimes for all the wrong reasons. Harvey Smith, equestrian hooligan, was loathed and revered in equal measure for his TV twos up, pissing off the toffs whilst making the participant in a puff's sport a folk hero amongst the Tetley Bittermen. *Kes*, the film was an honest depiction of my homeland, complete with genuine accents impenetrable to any Southern softie, and came loaded with the glowering Rottweiler presence of Brian Glover as the Games Teacher we all feared. The original book, by Barry Hines, was now a standard O-level text at our school, cherished for its bold cover of Billy flicking the V at anyone and everyone, a once defiant gesture eventually rendered empty by the media gooning of the pissed up Scallies in Oasis. LUFC still basked in the glow of their 1973 domination of English football (ignoring the FA cup embarrassment at the hands of Sunderland), though by the decade's end attendances were down, as were the team, condemned to the Second Division, while Elland Road itself became a cold and hostile place to be of a Saturday afternoon — Stanley knives and bicycle chains, steel toecaps to the shins and you daren't move if some bastard stood behind you in the Kop and unzipped to piss down your back. Scargill's sideburns became sentient as his Hitlerian hectoring and foghorn delivery grew ever more shrill, his face off with the

Harridan of Grantham still to come. Norman Collier and Compo from *Last of the Summer Wine* provided some light relief — flat caps, wellies, ferrets down the trousers — cathode ray cretins failing in their role as distractions from the grey horror of it all. What was the worst part of it? The casual beatings from older kids, often for nothing? The daily bullying by schoolteachers whose sole form of recreation and physical exercise was kicking boys up the arse or shattering eardrums with a roundhouse sideswipe to the head for some imagined act of insubordination? The pervasive atmosphere of dread — of the rent man, the bailiff, the drunken stepfather? Standing at the bus stop every morning in the wind and rain, facing a rusty garage door onto which had been painted a swastika and the words MORLEY PIGS BENT? Dog shit smeared on your bike? Anthony Camm rubbing a piss snowball in your hair? Getting spat on by your sister's new boyfriend? The nightly news that brought nothing but stories of guerrilla war, Baader-Meinhoff, power cuts, strikes, death, despair and doom?

No, to be honest, what was worse than all of that was the boredom, the monumental, towering and unassailable cliffs of boredom that reared over our heads every single fucking day. Another Ripper victim was a break from the tedium, sending a *schadenfreude* frisson through the populace, already looking forward to the ITV dramatisation once they caught him. Stories of Leeds fans chanting "There's only one Yorkshire Ripper" at home games were, at that age, not shocking but funny. Everyone I knew was secretly thrilled at the idea of their dad getting stopped by the police, their car's searched, hauled down to the station if they had a toolkit or a beard. I was glad of the haunted houses, the death trap old relics held together with pigeon shit and lies. I loved the lush creepiness of the woods, dark and mysterious, like something out of *The Evil Dead*. I was smitten with the burnt out remains of the old train station, the soot blackened skeletal remains humming with the resonances of comic book horror stories. It was a harmless darkness, a benevolent horror that we indulged in but it was spawned by the presence of The Ripper, who had served as a gatekeeper to previously unexplored regions of our imaginations. Until his capture, The Ripper didn't seem mortal at all, more like Morbius the Living Vampire sprung wide eyed and bloodthirsty from the pages of *Spider-Man Weekly*, and when the police finally did cage him there was, beneath the relief expressed by the adults, a lingering sense that something had been lost, some vital energy, some charge of dark anticipation, had now dissipated. No more twilight dashes from my sister's house with a carrier bag full of piss reeking nappies, running through the park, careful to keep on the brightly lit path, not daring to even chance a quick sideways glance into the shadows beneath the trees. No more nights spent wondering if He had driven past our house, his headlights sending crazy shadows across my bedroom ceiling. No more of any of it. The obvious tedium and restrictions of adulthood were bearing down fast upon me and I simply was not ready for it. I didn't want to emerge from the hooligan dusk that engulfed me, and lose all those things I cherished, that I knew were vital and unique components of my right brain Neverwhere, the Dark Narnia I would rather wander in than face another load of pointless maths homework.

It was during that period of mourning for the night side of childhood that my mother told me that she had gone to school with Donald Neilson, the Black Panther, scourge of sub postmasters

everywhere in the early seventies. Whilst not on the same fiend scale as Sutcliffe, his crimes earned him his fifteen minutes in the months preceding punk, his shotgun blasts a harsh counterpoint to the sha-la-la bollocks of the Bay City Rollers. She remembered him as just another sullen lad with a pudding bowl haircut, running around the playground at Victoria Road School with his scabbed knees and his socks around his ankles. There was certainly no indication of what was to come — a failed squaddie turned burglar; the bizarre games of Soldiers conducted in his living room, his wife and daughter dressed in camo, playing dead; the gradual escalation of his crimes, until, inevitably, murder. Lesley Whittle was the final victim of his pathetic attempts at playing Dick Turpin, her naked body found dangling in a drainage shaft, the kidnapping botched by both abductor and his pursuers. As with The Ripper, it took a couple of sharp eyed bobbies, acting on their suspicions, who brought the man to justice and he resides to this day at Her Majesty's pleasure, knowing full well that he will never be released.

Shortly after my mother's revelation about Neilson, my dad came home one day with a photograph, taken in the canteen at work. His job as a crane driver at the containerbase in Leeds brought him into contact with truckers from all over the country, including a certain gap toothed DLT look-alike. In the photo I could see my father and his familiar work colleagues sat around a table loaded with the detritus of several fry ups and an ashtray overspilling with tab ends. And there, in the foreground, sat close to my old man, was the shyly smiling face of Peter Sutcliffe.

"I don't know! I don't know why I did it, I don't know why I enjoyed it and I don't know why I'll do it again" Bart Simpson

Peel Street, Morley. It starts in the heart of town, adjoining Queens Street at right angles and leads downhill, past the Maid Marion Café and Ackroyd Street Working Men's Club, for about a quarter of a mile or so until it joins Albert Road in one of the older residential parts of the town, where back to back terraces huddle closely next to Lewisham Park. It's not an affluent part of the town. New estates that blossomed nearby in the nineties — the houses now valued at nearly twice that for a typical back to back — attract commuters drawn by the booming financial sector in Leeds, who live a world apart from their neighbours less than hundred yards away, their modest properties tarted up with forlorn hanging baskets. Satellite dishes are barnacled to every wall whilst a racially diverse mix of kids runs around the tight street corners and alleyways (known as "snickets"), making up games with empty pop cans left in the gutter. It's a defiantly working class enclave, the kind Thatcher wanted to see eradicated during the 1980s, where you rely on the corner shop for everything and always stop to chat with Mrs Champaneri, occasionally forgetting yourself in front of the kids and calling it the "paki shop." Bread, milk, fags — you're always running out of something, so you send the kids on an errand. Get them to earn their pocket money.

March 26, 1986, the Harper family were indoors at their home in Brunswick Place, just off Peel Street, watching television. Outside it was cold and raining, but they were nearly out of Sunblest and there'd be nowt for the kids' breakfast, so Jacki asked if anyone was willing to go down the shop for her. Her ten year old daughter Sarah said she would and pocketed the £1 coin her mother gave her to buy a loaf of bread. She took two empty pop bottles with her, to claim the deposit, and set off up the road to K&M Stores on Peel Street, just a short walk that she had undertaken many times before.

Sarah arrived at the shop, returned the empties, and bought some bread and crisps. She set off back home, taking a short cut down a narrow unlit snicket, a route that would have been familiar only to locals. At about the same time, there'd been sightings of a "strange man" walking around the streets, and an unfamiliar white van parked close to Brunswick Place. This man was seen going into K&M Stores shortly before Sarah arrived but after that, he seems to have vanished.

So, it seems, had Sarah. When she hadn't arrived back home within a few minutes, Jacki began to fret as all mothers do, but assumed that Sarah was just talking to friends or had stopped off somewhere to munch her crisps so she wouldn't have to share them with her siblings. But after an hour, and searches made the family both on foot and in the car, the police were called. Immediately, the worst was feared.

Two weeks later, on April 19, a man was walking his dog along a pathway that ran parallel to the River Trent in Nottingham. A dumping ground for all manner of material, it wasn't unusual to see something floating in the river. What he initially thought was a bundle of old sacking made him curious enough to go down the riverbank for a closer look. The current was turning the bundle around as he moved closer and that's when he saw that it was actually a body. Using a stick, he managed to drag the body to the riverbank, where he could now see that it was a young girl, dead. It was Sarah Harper.

A postmortem later determined that she had still been alive when dropped into the river, and had suffered violent injuries, especially to her bodily orifices. It was clearly the handiwork of a sexual sadist, who had treated the girl like a doll for his own personal amusement and satisfaction. She had been abducted, tortured and killed by Robert Black, who had kept her in his van for days, before dropping her into a river as he drove through Nottinghamshire, down the M1 on his way back to London.

The Ripper's "reign of terror" understandably had the most immediate and obvious effect on the women in my life, but in some unusual ways it had a positive effect. For too long they had been made to feel like the *untermensch*, especially in a Cro-Magnon wasteland like Yorkshire where a couple off for a night out at the local could be recognised by the wife dutifully walking three feet behind her glowering husband. Reactions in this Fear Zone ranged from the sensible precaution of wives, sisters and mothers carrying sharpened nail files in their handbags, wariness of Geordies with beards and insistence on lifts home from family and friends to hysterical banshee howls of the feminists, attacking WH Smith's to remove copies of *Mayfair* and *Titbits* from the shelves and famously storming into the Plaza in Leeds, last outpost of XXX spunk cinema, when it dared to screen a curious example of Euro art wank called *Violation of the Bitch*. Rotten fruit was pelted at the screen whilst terrified onanists were berated as rapists and, obviously, wankers. A misguided soul, trying to cash in on the mood with t-shirts bearing the famous photofit and "I'm Not Jack" slogan had his market stall trashed.

Meanwhile, for young mind's teetering on the brink of puberty, women were to be regarded in a whole new light. "Nuddy books" had become powerful talismans, the keys to a new kingdom of wonder. Found in the charred embers of bonfires or rain soaked and stained under hedgerows, each tattered remnant was infused with totemic power by those who had found them. Torn pages, sometimes complete issues, were kept in boxes under the bed, carefully slotted in amongst comic collections or hidden inside gatefold album covers inherited from older brothers who'd flown the coop. My friends and I had a den inside the old tennis courts in Churwell Park, which, due to the nailed up doors and windows, was accessible only via a narrow passageway where the toilet pipes used to run. No caver ever had to negotiate such a dank and narrow passageway but once inside the strain and claustrophobia was worth it. Armed with Gloy glue and Sellotape nicked from school, we had plastered the walls inside with images collected from *Mayfair, Park Lane, Rustler, Raider, Playbirds XXX* and even a few from full on hardcore Euro porn titles like the

hallowed *Color Climax*.
A makeshift cathedral of porn, it helped fuel a prurient interest long before masturbatory indulgences were physically possible. All those coy smiles, the garish lipstick, tarantula eyelashes, Slush Puppie coloured suspender belts and airbrushed arseholes, swirling together in minds not ready to handle such an overload. A maelstrom of muff and mammaries, a miasma of wet pink, who knows what lasting damage was done in that place, long since flattened by bulldozers, the frazzled energies now sunk into a grassy knoll where many a teenaged finger has followed its first cider emboldened pathway to glory. An experience we often discussed but had yet to realise, though for some of us, it would happen sooner than we had ever anticipated…

I sat in the police station with my mother, waiting. A friendly bobby was sat with us, trying to keep the atmosphere relaxed. My mother sat glowering, chain smoking, pissed off at being woken at 4am in the morn-

…past the Maid Marion ca and Ackroyd St Working Men's Club, overlooked b the Man Who Laughs…

ing and dragged to the cop shop to hear her son's confession. The bobby advised me not to crack my knuckles, that I would regret it in later life when arthritis set in. I was nervous though, and needed to do something, anything with my hands.

Two proper coppers came in, wearing Sweeney suits and Brut aftershave. They had come to take my statement. It didn't occur to me that I could have said nothing. I felt I had nothing to hide, so I told them what had happened. They wrote down what I said, every single word, and asked their questions. What had started for them as the search for a missing fourteen year old girl, fearing some sick bastard had got her, was now nothing more than a confirmation of whether or not a sexual assault had taken place. They told me they'd spoken to the girl and she'd been looked over by a female PC, and they'd found no signs of rape — no scratch marks, no bruises. So if what I had to say corroborated her story then I was free to go. So I told them what had happened.

Sometimes, their questions seemed un-

necessary. "Did you penetrate?" "Do you know what penetration is?" "Was she crying?" My story seemed so plain and boring, something that I knew happened in houses and caravans and in the back seat of cars every night of the week. I'd just had the bad luck of being caught by the pigs with my pants down, literally, and now I was having to explain how far I'd penetrated while my mother mashed another Regal No.5 into the tin ashtray.

Just before dawn, they let me go home. Mum and I got a lift in a Panda car and I went straight upstairs to bed, where I collapsed fully dressed onto my bed. I slept the rest of the day.

"Do not wait for the last judgement. It takes place every day" Albert Camus

1984, the year of the Miners' Strike, was when I turned sixteen and could, if I'd wanted to, have left school. Utterly clueless as to what to do with my life I drifted through the summer until I had no choice but to go back to school and endure another two years in the sixth form. The adult world beckoned and I simply wasn't interested. Day after day doing the same shit, seeing the same people, saying the same things. A slow death.

For others of my generation, the end came much sooner than was expected. Within a year of leaving school, we heard of drug overdoses, suicides, car crashes. One lad we knew ran his motorbike into the back of the thirty-eight tonner and had his head ripped clean off. He'd been a little cunt at school, bullying others by threatening to get his big brother to beat them up, so there were some who were glad that he was dead. Only seventeen though, it was suddenly shocking that we could be mortal after all. Another lad who'd grown up in my village rolled his car over a roundabout and died in the wreckage. I remembered playing football with him, throwing snowballs. Dead now. One girl jumped off a motorway bridge, into the fast lane, dying instantly on impact. Another boy we all knew well wrote a goodbye note and took an overdose, claimed he couldn't take 'it' anymore and apologised for hurting anyone. So many, in such a short space of time. It was a tragedy, our mothers said. We ourselves didn't know what to make of it.

"For murder, though it have no tongue will speak with most miraculous organ" William Shakespeare, Hamlet

Robert Black was finally captured in July 1990. The investigations into the murders of Susan Maxwell, Caroline Hogg and Sarah Harper had ground on and since 1986 the three inquiries had been painstakingly brought together in one database, the work completed at around the same time that Black was driving his van up the M1, towards Stow, a village in the Scottish borders about five miles north of Galashiels. July 14 was a high summer day, bright and sunny, and six year old Mandy Wilson was walking to her friend's house. One of her neighbours saw her walking down the road when a van pulled into a driveway beside her. The door opened and a man got out, stooping to speak with her. Then, suddenly, the man was bundling the girl into the cab of the van, climbing in after her and then driving away at high speed towards Edinburgh. The neighbour took note of the van's

registration number and called the police. Squad cars were quickly on the scene, with the van's description and registration radioed around the area. The neighbour was stood in the driveway from where the girl was snatched, explaining what he saw to the police and the child's father when he saw the van coming back down the road. A copper ran into the road to bar the vehicles way, causing the driver to swerve and lose control. Policemen descended on the vehicle, pulling the driver, Robert Black, out of the cab and handcuffing him. The child's father was screaming expletives at Black, demanding to know what the bastard had done with his daughter. He climbed into the back of the van and found a pile of rags behind the driver's seat. Under the rags was a sleeping bag inside of which he could feel a small human body inside. Tearing open the bag, he saw his daughter's face, bright red from lack of oxygen, a strip of sticking plaster across her mouth. He removed the Elastoplast, untied her hands and cradled his girl, who had been shocked into silence by what had just happened to her.

"The pains of the past need to be appeased — or they will come back" Iain Sinclair

As a child I had many powerful and frightening dreams, some of which still linger with me to this day. One powerful night ride through the nether regions of my right hand lobe saw me sat in a US army jeep with a busty blonde in khakis riding shotgun. We were driving along a winding mountain road, sheer drops beneath us and when we rounded a tight corner we could look out across a wide expanse of desert, above which hung a bank of white clouds, that had been shaped by strange winds to resemble a gigantic skeleton laid on its back. I woke from that one with a scream.

There were also the "grinning man" dreams that I had when I was about three years old, which featured a non descript looking man, dressed in skin tight black, who would push his smirking face up close to mine, whilst behind him the room would begin to spin and swirl. I've since read that John Keel — ufologist and student of odd phenomena — had, in his studies, discovered numerous accounts of this entity haunting the dreams of other small children across the world.

However, by far the most disturbing nocturnal illusion was the recurring visits I made to an abandoned old house in some unspecified but vaguely familiar scratch of land somewhere in Morley. The roof was gone, but it retained many of its rooms and seemed to have a seemingly endless number of nooks and crannies, but my dreams always took me via the same route — through a narrow and filthy passageway, full of cobwebs and mould, until I reached a small windowless room. The floor was strewn with old rags, sheets of greasy tarpaulin and rusty nails, and in amongst the detritus there laid a girl's body. She was naked but apparently unharmed physically, but I knew with a

Lovecraftian lurch that she was dead, and I was responsible.

These murder dreams started shortly after the incident in the barn, and continued for some time thereafter. My layman's understanding of Freud and Jung gives me no insight as to what this was supposed to represent and over the years I've wondered if it was part of some latent Catholic guilt reaction to my sexual waywardness, but in more recent years I've considered a more idiosyncratic interpretation. Before I was born, my mother gave birth to a stillborn baby, a girl who would have been called Victoria and, had she lived, would have meant that I wouldn't have even been conceived. I don't know at what age I was told of this but it seems I have been aware of it all my life and many's the time I would find myself wondering what he might have been like? Would she have looked like me? Would she have done some of the thing I did? Liked the same books and telly programmes that I did? This ghost sister went on to haunt me for a long time, half glimpsed in the peeling silver backing on old mirrors or reflected in the convex bowl of old spoons found at the back of a drawer. Her name was written in the lint under my bed, her faerie stories etched in the wood grain on my wardrobe door. She was the spirit that hid my lost toys and stole chips from my plate when I wasn't looking. Hers was the cold hand that sometimes brushed my face and woke me in the middle of the night, gently shattering my idea that the world made sense.

As I got older, and supposedly wiser, her phantom became more indistinct, her voice harder to hear over the increasingly shrill howl of the adult world. Eventually, I gave up thinking about her at all… the faint ghost of her only surfacing whenever some random tragedy involving a young girl would appear on the news. When I saw the school photo of Billie Jo Jenkins, bludgeoned to death at her foster home in February 1997, I briefly felt that old familiar rush, of recognition, of loss. Her face, the hope in her eyes, that honest unforced smile, became the photofit for my lost sister, a sad map to an abandoned country, passport to Croatoa.

I kept a picture of Billie Jo, clipped from a newspaper, in my sketchbook and often looked at it, wondering why anyone would want to take her life? What awesome injury they did feel that required a murderous redress, a sacrifice of innocence?

The murder was soon pinned on her father, circumstantial blood spatters that saw him eventually released on appeal. The usual legal tennis match then ensued, with the ball of guilt bouncing in and out of the courts, but Billie Jo was still dead. What if she'd grown to adulthood? Could I have met her, known her? This urge to protect, where did it come from?

I know now it was my future — self preparing me for what was to come. Against type, against everything I'd previously said about children and parenthood, on February 9, 2004 I became a father to Aimee Louise Rawling. Life changed completely from that day onwards and previously long held assumptions and attitudes were cast to the wind as I finally had to jettison the last vestiges of youth and grow the fuck up, once and for all. Once

of the most significant changes was the immediate and, to be honest, welcome obliteration of all liberal notions pertaining to capital punishment. A debate fraught with moral difficulties, suddenly one thing became as clear as the blinding light at the heart of a sun going supernova. Anyone who intentionally injures a child, especially for their own sexual gratification, should be killed. Extinguished. Vaporized. Their atoms removed from space-time, the black stain of their name erased from the Akashic record. It really is that simple. I'd read similar hard line arguments before Aimee was born and couldn't quite understand the Old Testament mentality behind them, but now I could see things clearly for the first time. Why should some genetic accident like Robert Black be allowed to sit on his fat arse, munching Hob Nobs in his cell and wanking off over *Hollyoaks* while the bones of someone's child lie mouldering in the ground? Picturing his doughy mongoloid face, his beard full of crumbs and spittle, I could suddenly feel the rage of all the fathers of all the murdered daughters and knew that I would, in their position, never sleep again until the cause of all the misery in the world died by *my* hands. There would be no other kind of justice that could suffice.

"The world is a dangerous place, not because of those who do evil, but because of those who look and do nothing" Albert Einstein

Robert Black has never confessed to his crimes, except for the abduction of Mandy Wilson, which would have been fairly hard to plausibly deny seeing as she was found bound and gagged in the back of his van. In later discussions with psychologists, Black gave details of the sexual assault he had intended for Mandy, a crime he claimed was an isolated one, a "rush of blood," where he would have kept her with him until his next delivery and then simply let her go after "spending some time with her" and if she had died during his predations it would have been unintentional, "a pure accident." He seemed happy to talk about this subject, open and candid about his sexual inclinations for little girls, and during six hours of questioning, gave intimate details of his prior offences for which he had been convicted — the molestations and rapes in Scotland — along with an insight into the abuse he suffered as a child, his masturbatory fantasies and his relationship with Pamela Hodgson. However, when the subject of his involvement in the abduction and murders of three little girls was ever broached, he refused to answer. There was no attempt at denial or the establishment of an alibi; he simply would not speak of these things.

The police stopped trying for a confession and resorted to building up a damning body of evidence against him. Using wage books and receipts from PDS' fuel credit cards they were able to place Black's movements to within spitting distance of each of the three abduction points in each of the three cases, on the significant dates in question. All circumstantial evidence but when taken as a whole, and tied in with the kid porn haul from his flat,

The Showcase cinema at the very top of the town, recently landed like a Lego mothership in the middle of a retail park.

it suggested that they had, at the very least, a strong suspect. There was no forensic evidence to support the case against him, but the Crown Prosecution Service decided there was enough to serve ten summonses against the man.

It took another two years of legal wrangling before the case finally came before a court and in May 1994 he was found guilty on all counts. Eligible for parole in 2029, by which time he would be eighty-two years old if he lived that long, Robert Black was jailed, no longer a threat to little girls anywhere. Beyond the three murders for which he was convicted — Susan Maxwell, Caroline Hogg and Sarah Harper — it's believed by police forces both in the UK and on the European mainland that Black is responsible for numerous other crimes in France, Amsterdam, and Germany, along with at least ten unsolved murder abductions that occurred during the years that he was at large. The girls who died were April Fabb, Christine Markham, Genette Tate, Suzanne Lawrence, Colette Aram, Patsy Morris, Marion Crofts, and Lisa Hession.

In some cases, where Black's involvement is suspected most strongly, the files have been re-opened. This may provide some "closure" for the families but it won't bring their daughters back. As James Ellroy, son of a murdered mother said, "Closure is bullshit." The pain doesn't end. The initial wound, raw and bleeding, may scab over in time but it remains infected with all the poisons of a world where the murder of a little girl is tabloid fodder, a three day wonder until the next cretin from Big Brother drops their trousers. We are all complicit in this relentless disaster if we continue to ignore what is going on in the world. A more evolved species would not allow these creatures the dubious cultural status they have achieved, that of "folk heroes," dark and alluring bogeymen to stir the jaded nerve endings of a mass lumpen audience who park their arses of an evening and watch *Midsomer Murders* as a distraction from the daily grind. Murder is not a game of Cluedo. It is not a video game. If art is going to discuss the subject, as it should, then it must be

Industrial Morley #1.

done honestly and uncompromisingly, with the focus at all times on the *victims*. They are the subject. Those who torture and kill them are almost incidental and must be studied with the correct eye, that of the surgeon looking for the diseased cells that need to be removed.

All the study and psychological profiles of these specimens has taught some basic but important lessons — put the wrong composition of genes into the wrong environment, give it all the worst examples a parent can offer, allow it to confuse its sexual impulses with

toilet training or torturing cats, beat it with a stick at regular intervals and offer it no human warmth or compassion whatsoever, and see what happens. Time after time the examples of these ruinous environments are paraded before us, usually as police mug shots, with the same bilge water eyes staring out at a world they are as removed from as the moons of Saturn. Humans such as the one currently attacking young women with a hammer around West London will undoubtedly turn out to be adherents to the now tiresome cliché of the unloved and misunderstood son whose heart went black as his mind caught fire. Books and articles will be written about him, and absolutely nothing will change.

My dad drove me to the police station. It was one of those clear winter evenings when you can sense that Spring is just around the corner and everything is going to be alright. We gave our names at the front desk and sat on uncomfortable orange plastic chairs, waiting to be summoned. Dad sat with his legs splayed, hands clasped between his thighs, continually clearing his throat with guttural grunts, nervous.

I was tempted to pick at the loose flap of rubber on the sole of my trainer but didn't, knowing that the circumstances demanded a more concerned and conciliatory posture.

Eventually, a young copper came through a side door and escorted us down a corridor. I was surprised at how quiet it was in my notorious local nick, no shouting, no hurled threats, no drunks trying to thrash their way out of their cuffs, no screams from the cells below. It was like a library, even smelt like one.

We were shown into a room where an older geezer — balding, grey sideburns — sat behind a desk in his uniform. Behind him was a window looking out on Corporation Street, taxis and buses rumbling faintly behind the double glazing. He asked us to sit down. Before his he had a thin brown file, the sum total of the paperwork generated by my case, which he never once referred to as he spoke. There wasn't much to say.

The girls' parent weren't going to file charges after all, and it was obvious to him, and all those concerned, that this was just one of those things that, for thousands and thousands of teenagers, never comes to the attention of the police. He tried to imply that I had nevertheless been lucky that matters had not gone any further and that I should keep my nose out of trouble from now on — the standard adult admonishment I was now tediously familiar with from school — but it was clear that he was juts going through the procedural motions and tying up the final loose end on a matter that had been a waste of police time and a bit of an embarrassment for everyone else involved.

His last words to me were: "Choose your girlfriends carefully in future."

Dad and I walked back to the car and he praised me for taking it like a man and advised that I heed by the top cop's words, though I could tell that he was still basking in the knowledge that, ever since the unfortunate incident had come to light, he at least knew that his nerdy book reading introverted son wasn't a puff after all.

A wind was blowing from the park, leaves and empty crisp bags skittering across the car park. Dad's Viva sat like a tired old tramp under a streetlight, before I got in I had one last look around, the Town Hall under-lit above us, looking like something majestic and proud, not the usual pile of old stone covered in pigeon shit. Life had, after years lost in the doldrums of childhood, suddenly got interesting again. What else might it have in store for me?

"I hate to think that all my current experiences will someday become stories with no point" Calvin & Hobbes

Is it just blind fate that brought Robert Black to Morley? His work brought him there, a delivery to make, but perhaps the place itself generates some malefic pulse that registers far beyond the visible spectrum, detectable only to a certain kind of nocturnal creature, some moon mutant that exists for no other reason save mayhem. On the surface it's just another depressed former mill town, a crust of industrial history caught in the armpit of Yorkshire that would be a ghost town in ten years time if it didn't act as a convenient satellite for Leeds commuters. Their influence may rub off and one day Queen Street will be thronged will beautiful specimens, sat outside street cafés sipping lattes and talking about art, but having intimate knowledge of the dominant gene pool that seems unlikely. Morley is scum, and they like it that way. They like going to JD's on a Friday night, high on the thought of the weekend ahead, pissed by 10pm, dancing, laughing, puking, fucking,

and they like going back there on a Saturday night, pissed off, hungover, struck dumb with the stark black and white photocopy of their lives pinned to a lamp post: Lost. That's when they come out to fight, to spit, to hurl abuse, to smash windows, to act as vessels for all the frazzled energies that must be earthed through the right conduit. Meanwhile, behind their gated windows and doors, the pensioners huddle, fearing nail bombs and a teenage rampage that will never, ever happen. But in a place where nothing else seems to happen, anything is possible and the most blatant media myths ring true somehow.

I moved away from there, finally, in 1999 and I will *never* return. Regard this as the final exorcism, the last remnants of the place expunged from my system. Family connections demand the occasional return and every time I do the ghosts are harder to see; the places they once haunted now flattened or converted into housing estates. Determined to see if there was anything else to know about my home town, I undertook a long walk around the place, late one night in January 2005, a crude psycho-geographic indulgence that might lead to nothing more than me freezing my bollocks off on the kind of night when you wouldn't put a dog out, even if it had shit on the rug. But the weather and season seemed appropriate; Morley wasn't a blue sky sunshine kind of place. Wordsworth, even on a good day, couldn't have waxed positive about the locale. If needed the cover of night to hide its drabbest features, and let the shadows fill the gaps where answers simply weren't available.

I started from Showcase cinema at the very top of the town, recently landed like a Lego mothership in the middle of a retail park that included the usual DIY warehouses and pizza outlets, all lit with neon intended to suggest that this might be some vaguely cool part of the USA, not a bland concrete maze of feeder roads and dead ends on a windy hillside in England. Cars and lorries thundered past, hissing spray as they negotiated the slipways and junctions

from the M62 and M1. This was a key convergence of transit, where a lot of caffeine headaches and adulterous yearnings leaked out into the ether. That couldn't be doing Morley any good, a place already overloaded with tedium and longing. Living in Morley was like the longest motorway journey you could ever dread to make, each day passing like another mile of litter strewn embankment.

Walking away from the Showcase, I crested the hill and could look down on the collapsed constellation of Leeds down in the valley below. The city basked in a lemonade glow that stained the night, numbing the shine of the stars down to a dull flicker, torches with the batteries running out. Walking down the road, the village of Gildersome to my left, I felt memories of my adolescent adventures there beaming into my head, but resisted and stuck to the mission — to see Morley for what it was. The one man security hut in the industrial park brought me back to the now, its lone bulb attracting no moths in the cheek burning chill. I couldn't see the guard slumped under its unshaded glow but it could well have been someone I once went to school with. Maybe he loved his job, the hours, the freedom, maybe even the sense of authority that comes with a navy blue sweater that has elbow patches and your name stitched on the front?

Like two black skid marks across the gusset of the night, the high rise blocks of Cottingley Towers loomed ever closer, a target destined to never be struck by anything more destructive than a half blind pigeon. A right turn at Branch End, traffic lights now installed after decades of auto fatalities on one of the most hair raising junctions ever made, and onwards, down Asquith Avenue, passed the woods and across the bridge that spanned the motorway where I stopped to look down at the traffic racing to and from Leeds. An amber streak of relentless noise that used to sound like the sea from behind my old bedroom window, the M621 had provided the background hiss to my childhood. From this vantage point I could see the once dark acres of farmland now lit in pockets as slowly, incessantly, the city encroached further and further into the last pathetic shreds of countryside left. Give it ten years and the whole place would look like Detroit, one huge monotonous concrete yawn, the grey desert dotted with the occasional oasis of a fun pub or a drive-through burger bar.

The place I'd grown up in was gone. Skeletal remains were occasionally visible behind the façades and billboards, but it was dead all the same. I walked through housing estates without seeing another single living soul. No cars passed by. A kind of exhausted silence kept the night in check, leaving the garage forecourts and telephone booths to bleed an existential ectoplasm into the dark, a forlorn yearning for something, anything, even an explosion, just to act as a reminder that this wasn't *it*, this wasn't how the world ends; not with a bang, but with a yawn.

I could have, at that point, detoured, gone to the narrow little ginnel just off Peel Street, where Sarah Harper met Robert Black, or

Industrial Morley #2.

walked another quarter mile to the hallowed ground where I lost my virginity, now buried under another hurriedly erected cluster of mortgaged cells where middle managers go to die. But it didn't seem worth the effort, somehow. There was nothing to be learnt, no insight to be gleaned. I could feel the vortex of despair swirling around me, an anti-cyclone of ennui, a collapsing lung, and I knew that to push it any further was to tempt the wrong kind of fate. Home, the only one worth having, was now some 200 miles to the South, far enough from Morley to be safe, where my daughter slept, destined to inherit a world of shit. A world where Robert Black, Peter Sutcliffe, Donald Neilson, Dennis Nilssen, Ian Brady and all the fucking rest of them still fester like spiders in their holes, sustained on a diet of black memories and the dried blood under their finger-nails. It would be some comfort if they represented nothing more than the last numbing vestiges of hangover from humanity's most terrible century, but it seems the forces they invoked still linger.

On Tuesday, May 31, 2005, a five year old boy named Anthony Hinchliffe was found in woodland close to his home, wandering alone and lost, crying and distraught. The woods, known locally as Devil's Ditch, are in Dews-bury, West Yorkshire, just down the road from Morley. Sometime between 5pm and 6pm that evening, Anthony had been led from his back garden to parkland where he claimed "some boys and girls tied a rope around my neck and tried to tie me to a tree." Injuries to his body supported his claims, including severe bruising to his neck, as if he had been hanged. Five children, all aged between eleven and twelve, were arrested and questioned, before charges of GBH were eventually placed upon a twelve year old girl, soon depicted in the tabloids as the spawn of the Antichrist himself.

Was it a kid's game that went too far? Or was there homi-cidal intent in place before he was even coaxed from the safety of his own garden? There are uncomfortable shades of Jamie Bulger and Mary Bell about this case, and when it hit the news I was not surprised in the slightest to see where it had happened. The tainted ground of my origins still hummed with the radioactive half life of past misdeeds. There are many such places across the country, across the planet; fault lines in the psycho tectonic mantle, negative intersections of leys. Dead Zones.

But I now realise that what makes it dangerous is not blood, but *boredom*. The typical grim post industrial Northern town boredom that is undiluted by any traces of hope or relief, condensing, requiring a violent over reaction to prevent total obliteration of the senses. Hence the beer glasses hurled across the dance floor at JD's, the games of slag tennis, the exploded dog shit bins smouldering in the pale morning light. Broken windows at the kebab shop, again. Swastikas sprayed on the door at the Maharaja takeaway. Used Johnnies stuffed through letterboxes. Garden sheds set on fire.

JG Ballard observes that people these days are *dangerous-ly* bored. Potential gone to rot, opportunities stillborn at the school gates, aborted in the job centre doorway, all hope dead before it has a chance. The real danger is the one we present to ourselves. Too hungover to riot, too tired from working two jobs to feed the kids and pay the mortgage to do anything except mong in front of the telly and let the usual parade of privileged twats piss you off even more, all that rage turns inwards, starts the rot of the soul. Morley is the *real* England, the one the media can't bring itself to depict. The country where foxes are free to roam but it's still blood sport for all. Where everyone has an A-level but not a fucking clue. Where nothing seems to matter anymore and no one seems to care.

◆ ◆ ◆ ◆ ◆ ◆ ◆ ◆ ◆ ◆

Just down the road from my house is a single track lane that cuts through the estate. It's a leafy lane, bordered by old hedgerows and brambles and about halfway along is a road sign, the familiar red bordered triangle you see near schools, featuring the silhouette of a man holding the hand of a small girl. It's intended as a simple warning that pedestrians use this lane and that drivers should take care, but across the bottom of the sign, written in black felt tip scrawl are the words: BEWARE PAEDOPHILES.

FEMALE IMPER-SONATORS

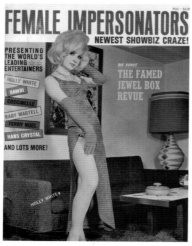

Summer 1965
Magnum
Publications,
Inc., 185
Madison Avenue,
New York,
NY $1.00 72pp

Published in 1965,
Female Impersona-
tors is just one of
the many hundreds
of "Bad Mags"
to have hit the
American news-
stands in the sixties
through to the
eighties. Often short lived (some never made it beyond one
issue), many of these mags catered to a rarefied market,
while others attempted to create their own markets. Female
Impersonators falls somewhere between. TOM BRINKMANN
tells the story.

Newest Showbiz Craze!" reads the cover of FEMALE IMPERSON-
ATORS, an obscure mag from the summer of 1965, published by
Magnum. The cover model is a very feminine looking Holli White in
drag, who also appears on the back cover, out of drag, but making
a good looking butch lesbian with serious "camel toe."

Two very similar pics of Holli were used before, on the cover
of FEMALE MIMICS #4 (Fall 64) published by Selbee Associates.
There was a rumour that Ed Wood Jr had written for FEMALE
MIMICS under the name Carlson Wade, but that was not the case.
Carlson Wade was a regular in the Selbee mags and wrote many
articles on fetishism and sexuality, but he was not Ed Wood.

Also listed on the cover of FEMALE IMPERSONATORS, and
featured inside, are Bambi, Coccinelle, Baby Martell, Terry Noel
and Hans Crystal. Most of the features have pics of the female im-
personators in the process of becoming their drag personas, putting
on make-up, wigs, dresses, and so on, backstage.

Clear As Crystal is a photo feature on Hans Crystal, who is
apparently "the toast of European capitals." Hans — or Crystal, his
stage name —lived in NYC in an apartment filled with "Oriental
antiques, and Renaissance and Nineteenth Century paintings."

Another article, *Grab the Brass Ring: Paris Style*, is devoted to
the Paris club, the Carousel, about which the author states:

"So many Frenchmen can't be wrong! The attendance at the Car-
ousel club soars every year — and no wonder. In a city of extreme
sophistication, even Parisians gasp, laugh, and cheer like country
cousins when they visit this fabulous place. The show, truly interna-
tional in scope, presents acts that span all eras and all nations. The
mecca of all serious transvestites, the Carousel very often plays host
to distinguished female impersonators from all over the world. The
audience is also made up of world famous stars, devoted French-
men, and tourists who find the Follies Bergere just too tame."

Swinger Singer is devoted to Holli White, the cover girl, who
was a headliner in the "world famous" Jewel Box Revue. Holli is
"a natural comedian as well as an accomplished singer," and is
compared to another famous blonde bombshell, Marilyn Monroe,
although to me s/he looks more like the character Honey West
(Anne Francis) of sixties TV fame.

The Craziest Crazy Horse spotlights the New York version of the
Paris strip club, the difference being that New York's Crazy Horse
featured female impersonators. Lew Manx, the manager of the club,
is quoted explaining, "Any woman can strip — there's no talent in just
showing off a body. But when a man can create the illusion that he's
a woman *even* when he's stripping, he really has talent."

Bonnie/Terry Noel was the leading singer at New York's Club
82, which in the early seventies was a favourite hangout of the New
York Dolls.

Coccinelle: World's Most Fabulous Fe-Male concerned Jacques
Charles Dufresnoy, who turned
himself into the transvestite Coc-
cinelle (which means "lady-bird"
in French), and then was surgi-
cally changed into a woman. In
1961, her native France granted
her legal status as a woman, and
the following year she married
photographer Francis Bonnet. To
his credit, Coccinelle is the most
feminine looking in the mag.

*The Famous Jewel Box Re-
vue* was a New York drag show
that had "international fame."
It had started after WWII and
was produced by Danny Brown,
who explained the show's appeal as
follows: "The revue appeals to the
sensitive intellectual who under-
stands that there is a bit of woman in
every man."

The only advertisement in the
mag is on the inside of the back
cover for "Paul Valentine & Princess
Flavine's Seduction Lingerie" in NYC.

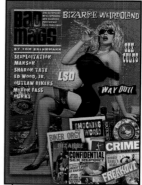

"Female Impersonators"
is an extract from the
book *Bad Mags: The
strangest, sleaziest
and most unusual
periodicals ever
published!* by Tom
Brinkmann. Published by
Headpress
UK £17.99 / US $29.95
ISBN 9781900486422
www.headpress.com

HANS CRYSTAL

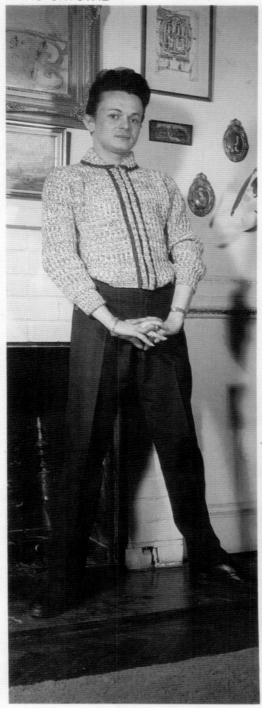

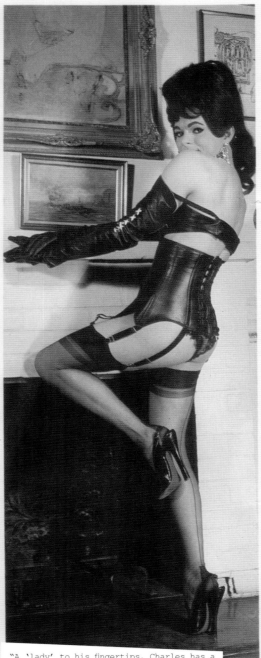

"A 'lady' to his fingertips, Charles has a weekly manicure while his wigs are being done up." *Female Impersonators*

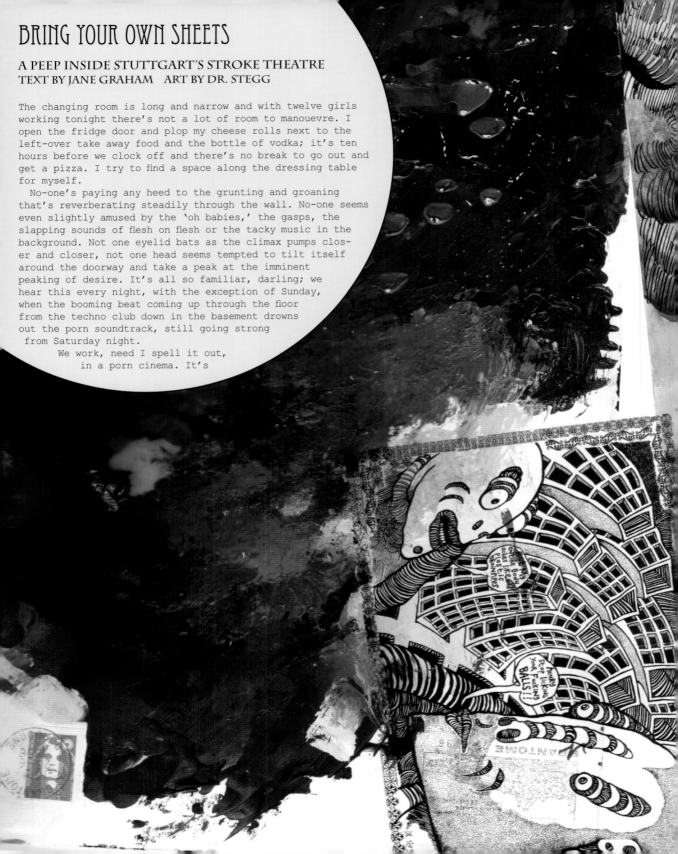

BRING YOUR OWN SHEETS

A PEEP INSIDE STUTTGART'S STROKE THEATRE
TEXT BY JANE GRAHAM ART BY DR. STEGG

The changing room is long and narrow and with twelve girls
working tonight there's not a lot of room to manouevre. I
open the fridge door and plop my cheese rolls next to the
left-over take away food and the bottle of vodka; it's ten
hours before we clock off and there's no break to go out and
get a pizza. I try to find a space along the dressing table
for myself.

 No-one's paying any heed to the grunting and groaning
that's reverberating steadily through the wall. No-one seems
even slightly amused by the 'oh babies,' the gasps, the
slapping sounds of flesh on flesh or the tacky music in the
background. Not one eyelid bats as the climax pumps clos-
er and closer, not one head seems tempted to tilt itself
around the doorway and take a peak at the imminent
peaking of desire. It's all so familiar, darling; we
hear this every night, with the exception of Sunday,
when the booming beat coming up through the floor
from the techno club down in the basement drowns
out the porn soundtrack, still going strong
from Saturday night.
 We work, need I spell it out,
 in a porn cinema. It's

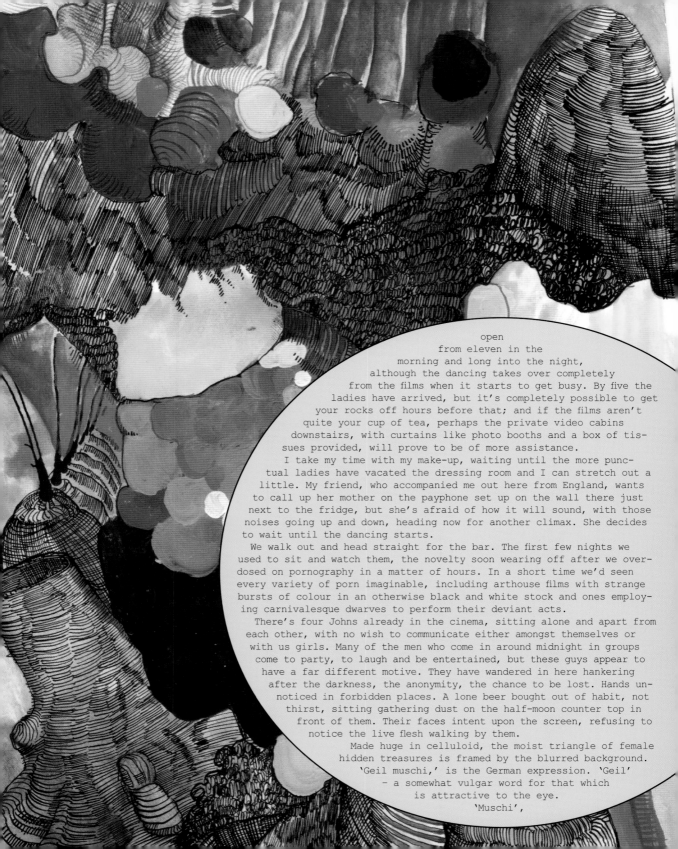

open
from eleven in the
morning and long into the night,
although the dancing takes over completely
from the films when it starts to get busy. By five the
ladies have arrived, but it's completely possible to get
your rocks off hours before that; and if the films aren't
quite your cup of tea, perhaps the private video cabins
downstairs, with curtains like photo booths and a box of tis-
sues provided, will prove to be of more assistance.
 I take my time with my make-up, waiting until the more punc-
tual ladies have vacated the dressing room and I can stretch out a
little. My friend, who accompanied me out here from England, wants
to call up her mother on the payphone set up on the wall there just
next to the fridge, but she's afraid of how it will sound, with those
noises going up and down, heading now for another climax. She decides
to wait until the dancing starts.
We walk out and head straight for the bar. The first few nights we
used to sit and watch them, the novelty soon wearing off after we over-
dosed on pornography in a matter of hours. In a short time we'd seen
every variety of porn imaginable, including arthouse films with strange
bursts of colour in an otherwise black and white stock and ones employ-
ing carnivalesque dwarves to perform their deviant acts.
 There's four Johns already in the cinema, sitting alone and apart from
each other, with no wish to communicate either amongst themselves or
with us girls. Many of the men who come in around midnight in groups
come to party, to laugh and be entertained, but these guys appear to
have a far different motive. They have wandered in here hankering
after the darkness, the anonymity, the chance to be lost. Hands un-
noticed in forbidden places. A lone beer bought out of habit, not
thirst, sitting gathering dust on the half-moon counter top in
front of them. Their faces intent upon the screen, refusing to
notice the live flesh walking by them.
 Made huge in celluloid, the moist triangle of female
hidden treasures is framed by the blurred background.
 'Geil muschi,' is the German expression. 'Geil'
 – a somewhat vulgar word for that which
 is attractive to the eye.
 'Muschi',

slang
for vagina, pussy,
what a richly onomatopoeic word
that is; one that seems to resonate with
moisture and dirtiness.
The young man is back in, a kid who can't be much
older than seventeen or eighteen, with his pimpled, ado-
lescent skin and mole-like eyes cowering behind spectacle
panes. I've tried communicating with him before; he doesn't want
to know. He'll leave as soon as the films are over, just like yester-
day and the day before.
Unless all the men leave before we get that far, the films should
stop in about ten minutes, and then the first girl will perform her
show. We each dance to one song only, ending nude with our g-strings
wrapped around our wrists. After every girl has danced there's a break,
in which the cinema starts up again for about a quarter of an hour. That
goes on until it gets later, busier and livelier, when the hustling for
drinks and table dances begins in earnest and the films just get in the
way of making money, so the projector gets rolled up and the curtain
closed.
We don't perform too many table dances. It's not really that kind of
club; men in Germany have grown so accustomed to the hostess clubs with
live shows and 'company' available courtesy of the champagne menu that
the lap dances have never really caught on. The residue of U.S. mili-
tary still stationed around Stuttgart, however, offer us a few chanc-
es.
Most of the girls have these voluminous, velour swathes of mate-
rial draped over their shoulders, as if they need something to keep
their backs warm over their tiny, negligee-like dresses. It's a
peculiarity of Germany, the sheet laid over the revolving
disc which dominates the stage to perform a show which
is more peepshow floorwork than it is high energy
pole dancing. Get rid of that stage light-
ing, turn on the naked bulbs of
the daytime cleaning

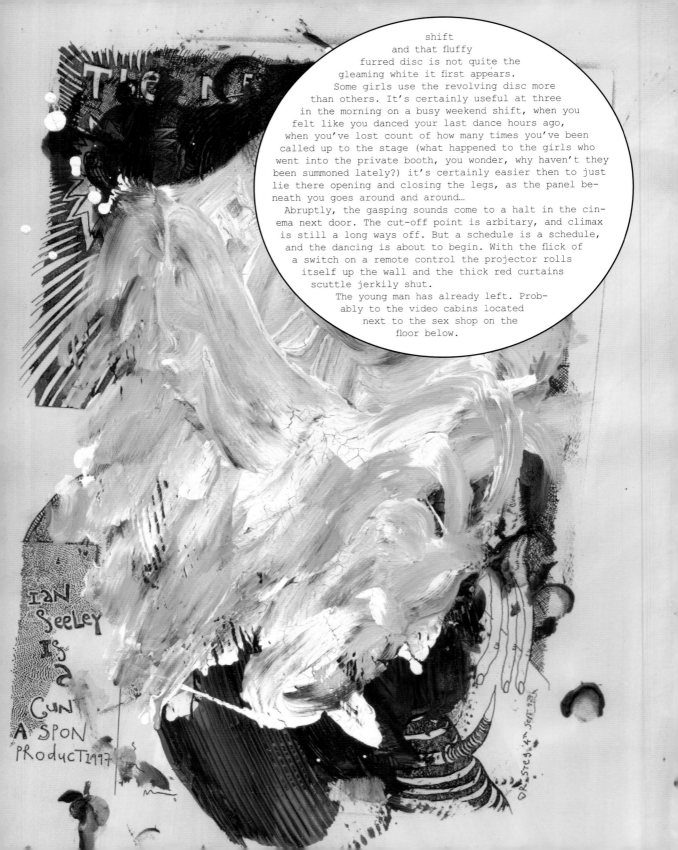

shift
and that fluffy
furred disc is not quite the
gleaming white it first appears.
Some girls use the revolving disc more
than others. It's certainly useful at three
in the morning on a busy weekend shift, when you
felt like you danced your last dance hours ago,
when you've lost count of how many times you've been
called up to the stage (what happened to the girls who
went into the private booth, you wonder, why haven't they
been summoned lately?) it's certainly easier then to just
lie there opening and closing the legs, as the panel be-
neath you goes around and around…

Abruptly, the gasping sounds come to a halt in the cin-
ema next door. The cut-off point is arbitary, and climax
is still a long ways off. But a schedule is a schedule,
and the dancing is about to begin. With the flick of
a switch on a remote control the projector rolls
itself up the wall and the thick red curtains
scuttle jerkily shut.

The young man has already left. Prob-
ably to the video cabins located
next to the sex shop on the
floor below.

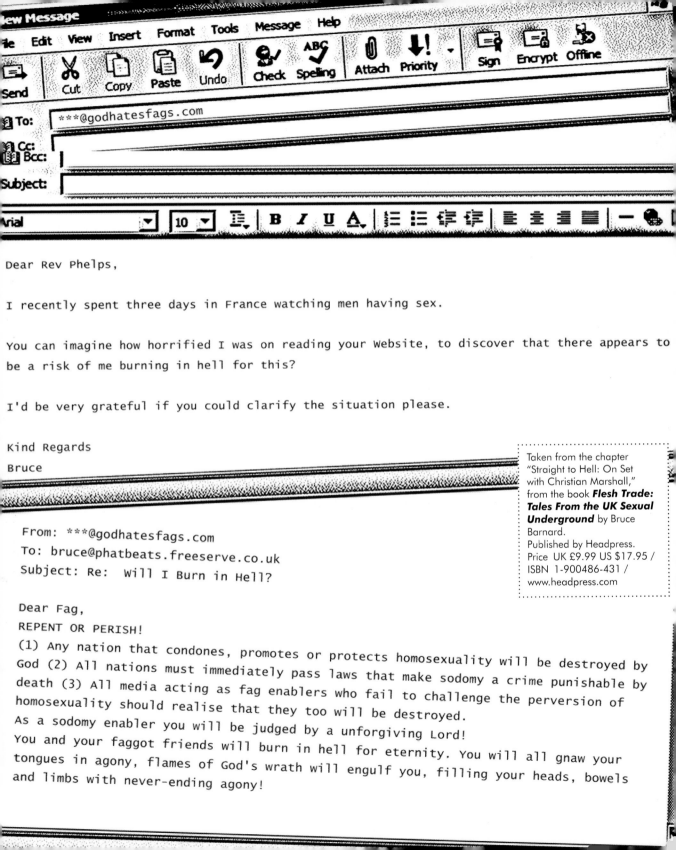

To: ***@godhatesfags.com

New Message

File Edit View Insert Format Tools Message Help

Send | Cut | Copy | Paste | Undo | Check | Spelling | Attach | Priority | Sign | Encrypt | Offline

To: ***@godhatesfags.com

Cc:
Bcc:

Subject:

Arial | 10 | B I U A | ... |

Dear Rev Phelps,

I recently spent three days in France watching men having sex.

You can imagine how horrified I was on reading your Website, to discover that there appears to be a risk of me burning in hell for this?

I'd be very grateful if you could clarify the situation please.

Kind Regards
Bruce

Taken from the chapter "Straight to Hell: On Set with Christian Marshall," from the book **Flesh Trade: Tales From the UK Sexual Underground** by Bruce Barnard.
Published by Headpress. Price UK £9.99 US $17.95 / ISBN 1-900486-431 / www.headpress.com

From: ***@godhatesfags.com
To: bruce@phatbeats.freeserve.co.uk
Subject: Re: Will I Burn in Hell?

Dear Fag,
REPENT OR PERISH!
(1) Any nation that condones, promotes or protects homosexuality will be destroyed by God (2) All nations must immediately pass laws that make sodomy a crime punishable by death (3) All media acting as fag enablers who fail to challenge the perversion of homosexuality should realise that they too will be destroyed.
As a sodomy enabler you will be judged by a unforgiving Lord!
You and your faggot friends will burn in hell for eternity. You will all gnaw your tongues in agony, flames of God's wrath will engulf you, filling your heads, bowels and limbs with never-ending agony!

~~The Career of Long Jean Silver~~

Dr. Spike

Long Jean Silver: A name that can strike fear into the hearts of those who patronised adult cinemas in the late 1970s. Strange effect for such an attractive young blonde, whom Josh Friedman in his book *Tales of Times Square* described as "frightfully gorgeous." A notorious porn performer, she shocked audiences with a bizarre spectacle, a speciality trick, the sight of which made some patrons run for the exit.

Jean Silver was born around 1956 with a missing fibula, so doctors amputated her lower leg several inches below the knee when she was two years of age. Growing up, aside from the usual challenges in a family with six siblings, Silver had to learn to walk and dance with an artificial leg attachment. Hailing from Tempe, Arizona, her father was a colonel in the armed forces who built missiles and she was raised on an airforce base and in small towns around the state. As if she did not have enough to contend with, aged twelve she was attacked and beaten by five youths in a park while coming home from her birthday party. Four of them raped her, but the fifth declined when he saw her leg.

Silver grew to become a proficient burglar, but at fifteen she was caught and sent to reform school for two years. She started working as a stripper at the Kit Kat private club in Phoenix, Arizona, before moving to the east coast where she supported herself by working as a prostitute. Moving into the porn business at the age of eighteen, she usually played dominant characters in S&M films and appeared in numerous lesbian scenes. According to Silver her first film appearance was a small role in the notorious *Waterpower* (1975); however, she had already made several porn loops. (Gerard Damiano acknowledges that he was supposed to direct *Waterpower*, and did begin the film, but quit before it was completed.)

Waterpower is about an enema bandit (Jamie Gillis) who attacks women in their

apartments. When he selects his first victim, a stewardess, he expounds his philosophy in saying, "She's dirty. Just a toilet. If I cleaned her out she would be clean again. She'd thank me. She'd be glad I cleaned her out." The theme of obsessive self righteous behaviour is similar to that explored in *Taxi Driver* (Martin Scorsese, 1976), and the story is based on the crimes of Michael Kenyon, whom Frank Zappa immortalised in a satirical song The Illinois Enema Bandit.

After *Waterpower* Silver made a few more loops, and appeared in *Cheri* magazine (Feb 77) where the interviewer inquired if she had anything to say to those who felt handicapped, to which she thoughtfully responded:

I'd tell them to be glad for what they have… that they're not so mangled [that] they're dead to everything. Everyone has something beautiful, either inside or outside. They shouldn't feel sorry for themselves; if you do, you're just going to make yourself ugly. If you don't feel sorry for yourself, nobody else is going to be either, and your beauty really comes out. Just show people who you are, and say I'm just as good as you.

This is an interesting statement of intent that reflects the diversity of the porn industry in that era, but one that would be frustrated in her subsequent career.

was an obvious pun on the peg-legged pirate Long John Silver in Robert Louis Stevenson's *Treasure Island*, and forewarned the audience that they were about to see something very unusual.

Advertisements tempted audiences with the enigmatic promise, "I've got a secret: I fooled Mother Nature!" The *Something Weird Bluebook 2* catalogue describes Long Jeanne Silver as de Renzy's "paean to paraplegic sexuality," the focus of which is evident in Silver's enticing monologue: "My name is Long Jeanne Silver and I'm handicapped and horny. Due to a quirk of mother nature, I was born with a bigger dick than John Holmes and, baby, you better believe, I know how to use it."

In keeping with the pseudo documentary approach Silver's narration precedes a series of scenes that are presented as re-enactments of her actual sexual experiences. In the first scene a woman (Amber Hunt) brings Silver home as a birthday present for her husband (Joey Silvera), who feigns surprise when his blindfold is removed and he sees Silver performing her speciality trick, 'stumping' his wife by using the sixteen inch deformed leg as an enormous penis. When Silver lubricates her stump with Vaseline before all of the insertions "it resembles a baseball player putting pine tar on his Louisville Slugger!" according to *Something Weird Bluebook 2*,

Silver was one of the first films he ever saw in a porn cinema, but he walked in half way through the scene where her leg is deep inside some man's asshole and said out loud, "How the hell am I going to jerk off to this?" When Silver pulled her leg out Butler was even more confused. Because he had missed the beginning of the film he thought she had left her foot inside the man's rectum. The film "fulfils all expectations for those seeking a 'freakshow' event," but in *Long Jeanne Silver* the surprise of the stumping soon loses its shock value and can be monotonous. This was to prove an ominous foreshadowing of the limitations Silver would face in her career.

Alex de Renzy showed *Long Jeanne Silver* in his own cinema, the Screening Room, in San Francisco's Tenderloin district, for several months and when he had made his money back plus some profit, he offered it to Mike Weldon to distribute. However every buyer, theatre owner or sub distributor who viewed the film left the cinema "screaming like a banshee," according to Johnny Legend, always exactly at the same point in the film — the stump scene with the gay man. Legend admits he could not watch the scene where the man is impaled on Silver's stump so he marked the start of the scene on the film stock and got the projectionist to tell him when it was over. Knowing where the scene began and

When she returned to New York Sprinkle, with the help of Bobby Hanson, Les Barany and Long Jean Silver, put together a new version of the *Love* issue, restaging the original photographs, which received national distribution under the title *Hot Shit*. Later in *Annie Sprinkle's ABC Study of Sexual Lust and Deviations* (1983) she immortalised Jean Silver with the lines

A is for amputee
We think amputees are hot.
And we fuck them a lot.
We don't need wine, we don't need pot.
Just stick a stump right up our slot.

Silver continued working in burlesque and appeared in a *Mr.* magazine (Mar 79) feature article entitled "I Was Born With A Handicap," but did not return to porn films until 1981 for a small role in *Debbie Does Dallas 2* (Jim Clark, 1981), followed by *Desire For Men* (Carol Connors, 1981) and *Prisoner of Pleasure* (Jack Hammer, 1981).

The script of *Desire For Men*, produced by the Mitchell Brothers, makes full use of Silver's stump. Directing her first film Carol Connors also stars as a sexually aggressive woman who preys on any men who come near her, and there is a ten minute long sequence, interspersed with close-ups, of Silver using her stump on Connors. Pro-porn

films were extreme. Their reputation spread by word of mouth and, by targeting a specific audience, Avon became permanently associated with violence. Shot on 16mm film and made for between $5,000 and $10,000, Avon films were primarily exhibited in a chain of theatres which the company leased in Times Square (Doll, Avon 7, Paris, Bryant, Avon 42nd, Avon Love, Park Miller and Avon Hudson). Later, their film performers would headline in live sex shows at the same theatres.

Prisoner of Pleasure tells the story of a hedonistic housewife who swings, gets kidnapped, and discovers the pleasures of rough sex and masochism including being penetrated by Long Jean Silver in an orgy scene. In discussing the social construction of pornography Laszlo Kurti notes that "the most shocking effect is created by using performers with bodily distortions in sexual contexts" and gives Long Jean Silver's appearance in *Prisoner of Pleasure* as an example.

The film also features Patrice Trudeau, advertised as a Penthouse Pet, in her first big role, but Silver got star billing because her stump was used.

Shortly after her return to porn films Jean Silver was featured in *Adult Cinema Review* (Dec 81), and a few months later *The World of Velvet* (Feb 82) published a photo feature and extensive interview, "Long Jeanne Silver: A Peg

Mistress Candice, a dominatrix, and David Christopher, a professional submissive. Silver never admitted to liking any of her films, saying "They all suck," but she did like *House of Sin* because all she did was watch other people having sex and get head from Honey Stevens.

Silver also worked with David Christopher in her own dominatrix performances at the sex clubs of Times Square, where she was the first major porn star to appear at the Avon. Of one twenty minute show Silver stripped off her black dress while teasing and tormenting Christopher. Then she took off her artificial leg and batted the stump against his penis, prompting an explosive response from the audience, following which she re-attached the leg and left the stage.

In her shows she liked to flash her leg on stage at the end of her performance, just to "freak people out," according to Friedman in *Tales of Times Square*. Jeremy Stone, of *Adam Film World*, also performed in live sex shows with Long Jean Silver, and the experience broadened his perspective on life. In one particularly memorable bachelor party show Stone was having sex with Silver whilst a member of the audience kept shouting "more" repeatedly as encouragement. Confused about what else was expected Stone tore off Silver's prosthetic leg and threw it into the audience. "After that, you could've heard a

erts, 1982) Silver plays a courier who carries drugs in her artificial leg, and in *Maneaters* (F J Lincoln, 1983) she plays a prostitute who is forced into anal sex by Joey Silvera. *Lady Lust* (Arthur Benn, 1983), *Piggy's* (Robert Houston, 1983), and *Intimate Action 2* (1983), where she teamed up again with Annie Sprinkle, were less memorable. *My Mistress Electra* (1983) was mainly notable because the soundtrack is lifted from *Taxi Driver*. Late in 1983 vice cops raided the Avon theatres, brought an end to them and the company's production of films, and made employment for Silver more difficult. After the police closed down the Avon theatres there was no outlet for the Avon produced films and Silver only appeared in a few more titles. She took small roles in *Brooke Does College* (Robert Garston, 1984), *Pleasure Channel* (Robert Houston, 1984) with Jerry Butler, who had been shocked when he saw Long Jeanne Silver, along with *Hypersexuals* (Robert Garston, 1984), the four episodes of *Taboo American Style* (Henri Pachard, 1985) and *Fashion Dolls* (David Christopher, 1986), before she quietly left the industry.

After 1977 and her initial notoriety Silver was not often picked up for magazine work. While she thought it was possible to work around her stump, photographers and publishers disagreed, and she warned, "Well sooner or later, they'll come to or I'll just quit." When porn moved from film to video it became a generic product. Porn star Vanessa Del Rio lamented to 42nd Street Pete the production line mentality that came to dominate the industry: "Everyone's from a cookie cutter. In my time, if you lined up fifteen of us, there would be fifteen different looks and personalities." Perhaps that was the reason why Silver did not feature in more films. She preferred burlesque for the opportunity it gave her to control her own performance. She stopped making films in the mid 1980s.

Silver did not like working in the porn industry. She did it for the money, and in the course of her work she got big tips from customers who thought she was a nice girl who should give up prostitution. Her ambition was simply to make some money, buy a ranch, settle down and raise a family. Prior to her departure she said in an interview that she was going to college to study child psychology and was working as a volunteer in physical therapy programmes, preparing for life after the porn business.

Silver's departure from the porn business coincided with the Meese Commission Report (1986), and amongst the films examined by the Commission in a study of "The Imagery Found Among Magazines, Books and Films in Adults Only Pornographic Outlets" were a number of Jean Silver's. Susie Bright, whose life had been changed by one of Silver's films, noted that the Meese Commission Report made bondage a household word across America. She remembered, "I masturbated to that report until I just about passed out — it's the filthiest thing around! And they know it!"

How could Silver compete with that?

In the 1970s you could look like whatever you are and be a porn star. Long Jeanne

"STAND AND WATCH THE TOWERS BURNING AT THE BREAK OF DAY"
AN ENCOUNTER WITH 9/11 BY DAVID KEREKES

[...there was a fireball in front of the building the world trade centre...]

A BLUE SKY CAN MEAN A LOT OF THINGS. IT IS THE WHOLESOMENESS ON WHICH CHILD-HOOD AND INNOCENCE CAN PLAY ON A DAY IN A CLOUDLESS SUMMER. AND ON ANOTHER DAY

IN SEPTEMBER IT IS A VIOLENT AND CRAZED MOMENT, THE DAWN FOR THE SPECTACLE OF A NEW AGE. THIS SKY IS A BLUE SKY. A SKY OF BLUE SKY.

IT WAS BLUE FOR THE CLIMAX OF *KING KONG*, THE 2006 REMAKE, WHEN DIRECTOR PETER JACKSON POSITED THE MIGHTY APE ATOP THE EMPIRE STATE BUILDING IN ORDER FOR IT TO SWAT BIPLANES, BEFORE FALLING LONG TO ITS END. FROM THE EMPIRE STATE BUILDING IN MERIAN C COOPER'S 1933 ORIGINAL, THE KING KONG APE FELL SIMILARLY TO ITS DEATH. IN 1976, PRODUCER DINO DE LAURENTIIS FINANCED ANOTHER VERSION OF THE STORY. IN DRESSING UP THIS *KING KONG* TO BE BIGGER AND MORE SPECTACULAR THAN THE ORIGINAL, THE BIPLANES FOR THE DE LAURENTIIS STANDOFF WERE REPLACED WITH JET FUELLED FIGHTERS AND THE LOCATION ELEVATED SOME 118 FEET, FROM THE EMPIRE STATE TO THE WORLD TRADE CENTER. THE POSTER CAMPAIGN FOR THE 1976 KING KONG FEATURED AN ENRAGED KONG STRADDLED ACROSS THE TWIN TOWERS, WITH BEAUTY IN THE ONE HAND AND THE CRUSHED HULK OF A PLANE IN THE OTHER, A PLUME OF BLACK SMOKE RISING INTO THE SKY, SOMETIMES DENSE SOMETIMES LESS SO.

[...this is a five sided building ... may god bless America...]

THE WORLD TRADE CENTER WASN'T THE TALLEST BUILDING IN THE WORLD AT THE TIME DE LAURENTIIS WENT INTO PRODUCTION WITH HIS FILM. THAT PRIZE BELONGED TO THE SEARS TOWER, THE TALLEST BUILDING SINCE 1974. BUT WTC WAS THE MOST RECOGNISABLE AND CARRIED WITH IT A COMMENT ON MAN THE CREATOR OF THINGS TWICE AS BIG AND MODERN. WHEN SAM RAIMI'S *SPIDER-MAN*, ANOTHER MAJOR FANTASY ADVENTURE, WAS PRIMED FOR THEATRES IN THE YEAR 2002, WTC HAD SLIPPED

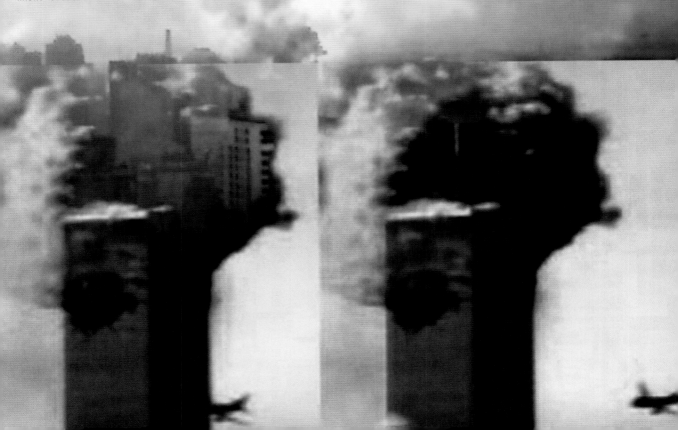

FURTHER DOWN THE RANK OF TALL BUILDINGS. YET AGAIN WTC WAS INTEGRAL TO THE MARKETING CAMPAIGN, THE TOWERS PROUD AND MEANINGFUL IN A TEASER TRAILER THAT FEATURED A HELICOPTER LOADED WITH CROOKS BEING SNAGGED IN A GIANT WEB SPUN BETWEEN THEM. MORE SUBTLE THAN THAT WAS THE POSTER ART, WHICH SHOWED THE TOWERS REFLECTED IN SPIDER-MAN'S EYE. A REFLECTION IN AN EYE CAN SYMBOLISE A THOUGHT PROCESS, THE MANIFESTATION OF A THOUGHT FOR ALL TO SEE. HERE THE TOWERS ARE THOUGHT TO BE A PORTENT OF SOMETHING DEEPLY SIGNIFICANT, A STANDOFF PERHAPS, IN THE DISTANCE, WAITING TO HAPPEN.

AND WHEN THE TOWERS WERE DESTROYED ON 9/11 (SEPTEMBER 11), THE TRAILER AND POSTER ART FOR SPIDER-MAN WERE RE-CALLED BY THE STUDIO, EFFECTIVELY REMOVING THE THOUGHT AND ITS MEANING ALONG WITH THE BRICKS, STEEL, LIVES AND REALITY OF THE WTC ITSELF.

[...trouble ... go now to washington ... scenes of washington...]

IT WAS FREEZING COLD BACK IN THE EARLY MONTHS OF 2001 WHEN I MADE MY FIRST TRIP TO THE UNITED STATES, SPECIFI-CALLY NEW YORK CITY, WHERE I MET TOM BRINKMANN FOR A LONG AFTERNOON IN AND AROUND WHAT WAS LEFT OF PORNO ON TIMES SQUARE, CLOSE TO THE PORNO OFFICE WHERE HE WORKED. LATER, OUTSIDE THE DAKOTA BUILDING, WHERE JOHN LEN-NON WAS ASSASSINATED, TOM ASKED IF I LIKED TO GET HIGH AND THEN WHETHER I CARED TO SEE THE WORD TRADE CENTER. I WANTED TO SEE ANOTHER BAR AND TOLD HIM, "NOT REALLY. THERE WILL ALWAYS BE A NEXT TIME." HOW WRONG I WAS. ON MY RETURN TO NEW YORK IN DECEMBER 2001, WTC HAD BEEN REDUCED TO GROUND ZERO AND THE CITY WAS RESONATING WITH JIT-TERY PATRIOTISM AND T-SHIRTS WITH SLOGANS THAT TRUMPETED, "NOW IT'S OUR TURN."

[...unbelievable unbelievable ... the federal reserve ... i see an incident like this is very difficult to plan for...]

THE BOOK, *102 MINUTES: THE UNTOLD STORY OF THE FIGHT TO SURVIVE INSIDE THE TWIN TOWERS*, A *NEW YORK TIMES* BEST-SELLER BY JIM DWYER AND KEVIN FLYNN, OPENS WITH A PAIR OF SHOES ON PAGE ONE: THE SHOES OF DIANNE DEFONTES, A FIFTY ONE YEAR OLD RECEPTIONIST ON THE EIGHTY NINTH FLOOR OF THE NORTH TOWER, SWAPPING COMFORTABLE WALKING SHOES FOR LESS COMFORTABLE WORK SHOES AT APPROXIMATELY 8:30AM. LESS THAN TWO HOURS LATER THE NORTH TOWER HAD COL-LAPSED.

[...it's not open ... i think right now the best thing to do is to walk to your destination ... the schools will remain open ... starting at around one or two o'clock...]

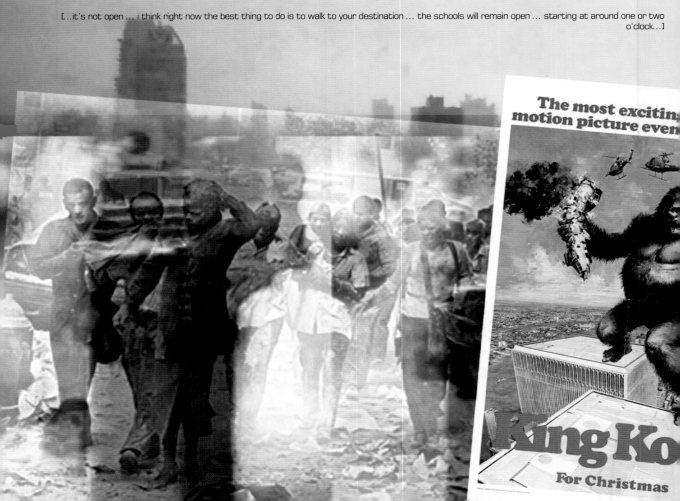

SHOES AS A BEGINNING: ACROSS THE SKY ON THE COVER OF *THIRTY SECONDS OVER NEW YORK*, A "FAST PACED" THRILLER BY ROBERT BUCHARD, PUBLISHED IN THE US IN 1970, A PLANE ZIPS BY ON A COLLISION COURSE WITH THE TWIN TOWERS. (FOR THE ORIGINAL FRENCH LANGUAGE EDITION OF THE NOVEL, PUBLISHED THE PREVIOUS YEAR, THE TARGET WAS THE EMPIRE STATE BUILDING.)

THE BOOK TELLS THE STORY OF A NUCLEAR ATTACK ON THE UNITED STATES FROM CHINA, THE WARHEAD DELIVERED ON BOARD A PLANE. IT IS A FICTION THAT PURPORTEDLY HAS A BASIS IN FACT, THAT IN 1966 CHAIRMAN MAO WAS SO FEARFUL OF A SURPRISE NUCLEAR OFFENSIVE FROM THE US THAT HE DEMANDED A COUNTERATTACK INITIATIVE PROGRAMME. FROM THE COVER OF BUCHARD'S BOOK A CHINESE PERSON LOOKS OUT AT THE READER WITH COLD DETERMINATION IN HIS EYES. HIS SHOES CANNOT BE SEEN.

THIRTY SECONDS OVER NEW YORK SOON DISAPPEARED FROM AIRPORTS AND NEWSSTANDS ACROSS AMERICA. FOR THE GOVERNMENT IT WAS A CONCERN THAT PALESTINIAN TERRORISTS WERE AMONGST ITS READERS, MORE SPECIFICALLY THE POPULAR FRONT FOR THE LIBERATION OF PALESTINE (PFLP), A MARXIST-ORIENTED GROUP THAT PIONEERED AIRLINE HIJACKINGS.

[... we cancelled it ... it made no sense to have an election day ... we'll find another day for the election ... given the magnitude to focus on what you have to do...]

THE PUB ROCK BAND DR FEELGOOD ALLUDED TO 9/11 IN ALL THROUGH THE CITY, A TRACK WRITTEN BY WILKO JOHNSON FOR THE ALBUM *DOWN BY THE JETTY*, WAY BACK IN 1975. THE OPENING LINE IS:

"STAND AND WATCH THE TOWERS BURNING AT THE BREAK OF DAY"

THERE'S LOTS OF CONFUSION, PROBABLY BECAUSE OF ALL THE SMOKE, ALTHOUGH SMOKE ISN'T MENTIONED OUTRIGHT IN THE SONG. LATER, SINGER LEE BRILLEAUX OBSERVES THAT THE

"STREETS ARE FULL OF SIGNS, ARROWS POINTING EVERYWHERE / PARKS ARE FULL OF PEOPLE TRYING TO GET A BREATH OF AIR"

THIS IS IN KEEPING WITH A LOVED ONE OR A COLLEAGUE THAT IS MISSING, LOST AMIDST ALL THE CONFUSION. BRILLEAUX RETURNS WITH THE REFRAIN:

"I'VE BEEN SEARCHING ALL THROUGH THE CITY / SEE YOU IN THE MORNING DOWN BY THE JETTY"

THE TWIN TOWERS FELL OUT OF FAVOUR. FOR DINO DE LAURENTIIS WTC WAS A SPECTACLE FOR A NEW AGE, THE EMPIRE STATE TIMES TWO. FOR SAM RAIMI, THIRTY YEARS LATER, IT WAS RETRO KITSCH, A PIECE OF 1970S SPACE FURNITURE THAT HAD BEEN DESIGNED FOR A FUTURE YET TO ARRIVE, FUTURES RARELY TAKING THE SHAPES DESIGNED FOR THEM. ARRIVE NOW THE FUTURE WOULDN'T FOR 9/11. ON THE TOP OF THE SEVENTIES FURNITURE WAS THE SEVENTIES KING KONG, MORE *MAGNUM P.I.* THAN MIGHTY PRIMATE. IT WAS BIGGER THAN ITSELF AT THIS POINT, AND THE ONLY SPECTACLE BIG ENOUGH TO FOLLOW IT WOULD BE ITS COLLAPSE, AND ALMOST COLLAPSE IT DID IN 1979, WHEN THE TOWERS WERE DECIMATED IN SIR RUN RUN SHAW'S DISASTER MOVIE, *METEOR*, STARRING SEAN CONNERY.

IN THE FILM, ONE OF THE SATELLITES OF AN 8KM WIDE METEOR NAMED ORPHEUS RIPS THROUGH WTC, A SCENE THAT WAS USED ON THE BACK COVER OF A TIE-IN MAGAZINE PUBLISHED BY WARREN, A BOLD AND GRAINY CLOSE-UP LOOKING LIKE THE BAD PORN I DID NOT FIND IN TIMES SQUARE.

IT WAS A VIOLENT AND CRAZED MOMENT.

THE TEXT IN [PARENTHESIS] ABOVE ARE EXTRACTS TAKEN FROM A "SOUNDSCAPE" OF NEWS REPORTS RELATING TO THE 9/11 ATTACKS, COMPILED BY I:WOUND/VERATO PROJECT. THE CD-R IS AVAILABLE FROM SUGGESTION RECORDS [W] WWW.SUGGESTION-RECORDS.DE

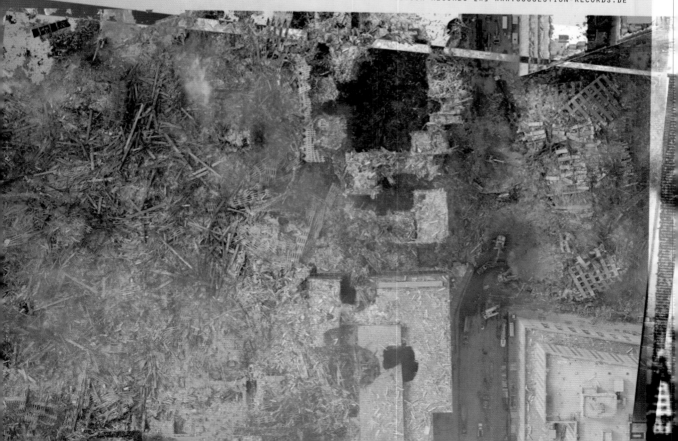

Chelsea Hotel Manhattan

A babelogue from JOE AMBROSE about one hotel, its superstars, bohemians, junkies, losers and outsiders.

SKANK IN BED WITH A FASHION BOY

Five hundred French have invaded the Chelsea Hotel. Now I know how the Algerians must have felt. Soon they'll establish torture chambers on the third floor, install speakers in the corridors forcing us to listen to Francoise Hardy, and distribute free copies of the "thoughts" of Bernard-Henri Lévi in the lobby.

All I can hear is middle aged women in black suits saying "Ah, oui." to one another like it's going out of style. A nation of thieves, mediocrities, and psychopaths (not unlike the English — or the Irish — when you come to think about it). Not for nothing the French invented the words "bourgeois" and "provincial." I hate Paris in the springtime, every moment of the year. I never go to Paris except to make money. Ergo I rarely find myself in Paris.

I meet a young black girl called Meredith who is handing out political flyers on the street in front of the hotel so I bring her back to my room. Like the whole of New York under the age of thirty she has never been inside the Chelsea Hotel and would love to visit. I turn on the radio and we get undressed. They're playing a tune I can't place which I can't help but notice has been used as a sample by Revolting Cocks. It goes: "This is out of the house, and out of the house music." I just love that elegant double flick of the feet with which women kick off their panties.

"So… what do you like?" I ask Meredith, a student political activist who was promoting a Zapatista movie and discussion due to take place four doors up from the Chelsea this very evening when I tempted her into my lair.

"I like to skank in bed with a young fashion boy." she says, her parent's Jamaican accents shining through her Upper East Side gloss and fancy use of the English language.

"Oh," I say, taken aback, "I'm afraid I may be a disappointment to you then."

Two sons batter their father to death with a baseball bat on the radio. Where also there is a dramatization of *Peyton Place*. And when is it morally right to shoot somebody?

I feel like phoning in the answer: "When it is morally right, of course."

DOWN IN DUBLIN

I was down in death, I was down in Dublin, I was down in the ground, I was going someplace only dead men go, a bleak black place only dead men know. I was down in the depths of the deepest sea, down where there was no you or me. I went down down down like Elvis Presley. I was down and out. I thought you'd rescue me?

NICO CHELSEA GIRL

Nico: "I made a mistake… I said to some interviewer that I didn't like negroes. That's all. They took it so personally… although it's a whole different race… I mean, Bob Marley doesn't resemble a negro, does he? He's an archetype of a Jamaican… but with the features like white people. I don't like the features. They're so much like animals… its cannibals, no?"

I have this live album by Nico released on cassette-only format during her lifetime. On it she does Femme Fatale and at the end of the song, when all the nostalgia vultures are applauding in quiet relief the fact that she has finally played something they recognize, she says, "That song must be a hundred years old."

What I always liked the most about Nico was the fact that, in common with some other German women I've met, old or young, pretty or ugly, she had lots of vim or get up and go about her. Though it was tough being a woman in a band back then, though her life was difficult in general, I always saw her as brave. Her bravery is underlined by Iggy Pop's comment that, even when he came across her in the 60s, she was already a slightly older woman struggling upstream to stay in the cool zone. She stayed that icon she wanted to be up to the very end.

Once I had a pal who booked in the bands at the university I went to. I helped him writing his election literature so my kickback — when he got elected to the job — was that he'd book in Nico to do a show for me. Five times he booked her in and five times she failed to show up. Never left her squat in Manchester or her squat in Brixton or she was ill or the van broke down or there was blood on the saddle or the portents were bad. Too much junkie business.

Eventually my pal gave up; he got me Bo Diddley instead. A very fair Velvets-style replacement since Maureen Tucker and the drang of the Velvets are entirely Bo Diddley. Nico never crossed the Irish Sea but eventually she crossed the endless sea. (Bo, of course, showed up and played for ninety minutes plus an encore.)

By the time I moved to Brixton in the late 80s she'd stopped living there with John Cooper Clarke but people were still talking about her. An impoverished icon who'd come amongst her own people.

Iggy Pop: "She was probably running away from something. That's pretty possible. But she knew how to dress, and she was one cool chick… I came back to New York to do some gigs — we had progressed and we were starting to play more like we played on *Fun House*, a harder sound and a little time had gone by. I came to stay at the

Chelsea. She was staying there, and she always had a cute man around — she had some new man, a French guy, and I was kind of like, "Who is this French guy, anyway? What are you doing with some French guy? Let's have a look at him." and I went to visit her in her room. I was really excited to see her, and she was sitting there, she had a harmonium. I'd never seen her play her harmonium, it was just a little thing, about three feet long and three and a half feet high, and she was playing on it, and she played this song Janitor of Lunacy, which is on one of her records, and she sang the words: "Janitor of Lunacy, paralyze my infancy." Just like, you know, very good poetry, just kind of like hearing her doing that right there, complete, in the Chelsea, and that was the way it was gonna go on the record. I was very impressed with that... I saw her later, and we had our differences, I got stoned with her many years later on some heroin and it was not pleasant, she did not look well, and I did not react well. I wasn't much of a gent about that and so there's some regrets there."

Extracts from the book **Chelsea Hotel Manhattan** by Joe Ambrose. Published by Headpress
UK £10.99 US $19.95
ISBN 9781900486606
www.headpress.com

HAPPINESS STARTS HERE

I was possessed by very bad and evil in my body. I was very ill. I could not work. Never had friends. I had lost everything including my faith. I have searched for help and no-one could help me, for the evil I had was too powerful and controlled my life. **SISTER MARY** was my last hope. After six visits, I am cured.

A Skywald Night in Chicago with Gargoyles

It was a 1970s rainy night like the rainy nights in the horror stories they created, but this night was real, terrifyingly real, for "AR-CHAIC" ALAN HEWETSON and "DYING" DOUG MOENCH, two figures in the modest publishing house called Skywald. DAVID KEREKES wasn't there but navigates regardless.

The Skywald corporation published b&w horror comics out of New York circa early 1970s, and was part of a burgeoning horror comics boom that included publishers Marvel, Warren and the less prestigious Eerie Publications. Skywald lasted only a few years but in those years, under the editorship of the late "Archaic" Al Hewetson, the Skywald flagship titles _Psycho_, _Nightmare_ and _Scream_ became psychogenic fuel for the mind and elevated Skywald and horror comics to "a satanic, blackly humorous art form of the greatest aesthetic integrity," to quote Stephen Sennitt in his introduction to his book _The Complete Illustrated History of the Skywald Horror-Mood_.

They received little critical or media attention in the 1970s and nothing more than that in the three decades that followed. Yet Skywald are a success story, impact and influence being the measure of their success. The art on pages 130 and 131 — by James Fletcher — is an example of one among many new artists warped to the Skywald back catalogue and its tales of swamp mansions and undead things, of creatures amuck, and isolation and madness and cannibalism.

The Complete Illustrated History of the Skywald Horror-Mood was published in 2004 by Headpress. It collected nineteen of the best strips from Skywald and provided a unique insight into the publishing house by "Archaic" Al Hewetson himself. In the book was one episode recounted by Al of the night he and fellow Skywald scribe Doug Moench had a run-in with the law. Doug (who scripted the stories The Proverbial Killer, The Night Of The Corpse Bride and The Midnight Slasher) contacted Headpress with a somewhat different take on what happened that dark and raining night in Chicago. Here follows the stories of both Al and Doug…

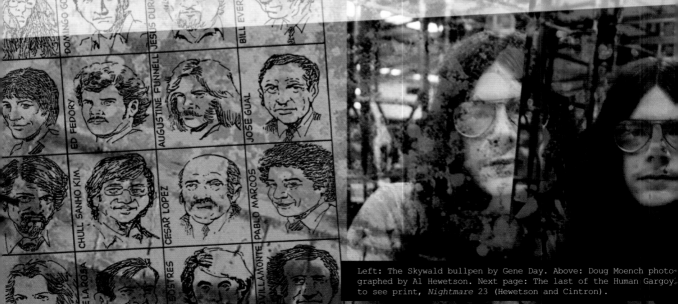

Left: The Skywald bullpen by Gene Day. Above: Doug Moench photographed by Al Hewetson. Next page: The last of the Human Gargoyle to see print, _Nightmare_ 23 (Hewetson and Cintron).

next: KIDNAPPED!

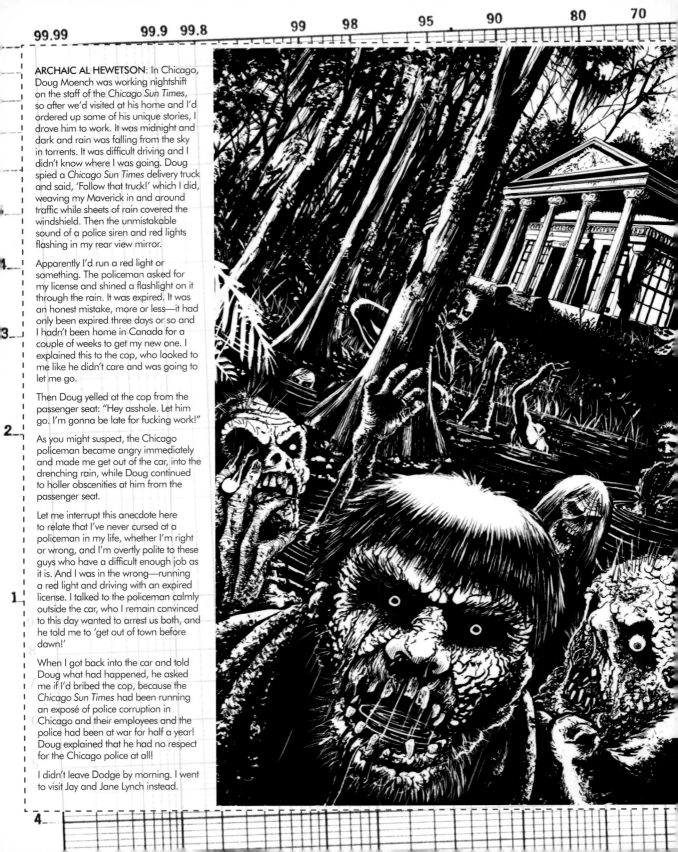

ARCHAIC AL HEWETSON: In Chicago, Doug Moench was working nightshift on the staff of the *Chicago Sun Times*, so after we'd visited at his home and I'd ordered up some of his unique stories, I drove him to work. It was midnight and dark and rain was falling from the sky in torrents. It was difficult driving and I didn't know where I was going. Doug spied a *Chicago Sun Times* delivery truck and said, 'Follow that truck!' which I did, weaving my Maverick in and around traffic while sheets of rain covered the windshield. Then the unmistakable sound of a police siren and red lights flashing in my rear view mirror.

Apparently I'd run a red light or something. The policeman asked for my license and shined a flashlight on it through the rain. It was expired. It was an honest mistake, more or less—it had only been expired three days or so and I hadn't been home in Canada for a couple of weeks to get my new one. I explained this to the cop, who looked to me like he didn't care and was going to let me go.

Then Doug yelled at the cop from the passenger seat: "Hey asshole. Let him go. I'm gonna be late for fucking work!"

As you might suspect, the Chicago policeman became angry immediately and made me get out of the car, into the drenching rain, while Doug continued to holler obscenities at him from the passenger seat.

Let me interrupt this anecdote here to relate that I've never cursed at a policeman in my life, whether I'm right or wrong, and I'm overtly polite to these guys who have a difficult enough job as it is. And I was in the wrong—running a red light and driving with an expired license. I talked to the policeman calmly outside the car, who I remain convinced to this day wanted to arrest us both, and he told me to 'get out of town before dawn!'

When I got back into the car and told Doug what had happened, he asked me if I'd bribed the cop, because the *Chicago Sun Times* had been running an exposé of police corruption in Chicago and their employees and the police had been at war for half a year! Doug explained that he had no respect for the Chicago police at all!

I didn't leave Dodge by morning. I went to visit Jay and Jane Lynch instead.

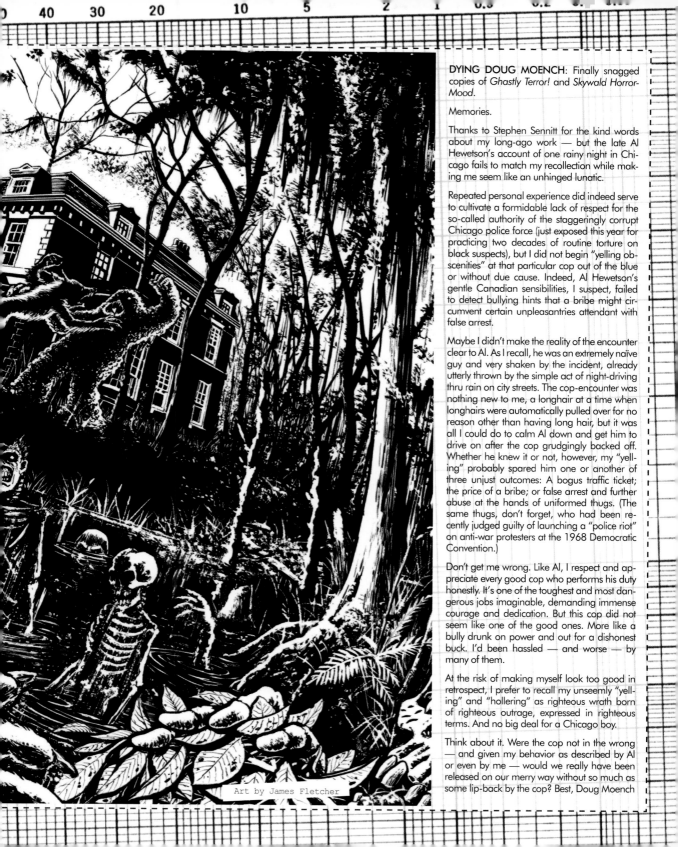

Art by James Fletcher

DYING DOUG MOENCH: Finally snagged copies of *Ghastly Terror!* and *Skywald Horror-Mood*.

Memories.

Thanks to Stephen Sennitt for the kind words about my long-ago work — but the late Al Hewetson's account of one rainy night in Chicago fails to match my recollection while making me seem like an unhinged lunatic.

Repeated personal experience did indeed serve to cultivate a formidable lack of respect for the so-called authority of the staggeringly corrupt Chicago police force (just exposed this year for practicing two decades of routine torture on black suspects), but I did not begin "yelling obscenities" at that particular cop out of the blue or without due cause. Indeed, Al Hewetson's gentle Canadian sensibilities, I suspect, failed to detect bullying hints that a bribe might circumvent certain unpleasantries attendant with false arrest.

Maybe I didn't make the reality of the encounter clear to Al. As I recall, he was an extremely naïve guy and very shaken by the incident, already utterly thrown by the simple act of night-driving thru rain on city streets. The cop-encounter was nothing new to me, a longhair at a time when longhairs were automatically pulled over for no reason other than having long hair, but it was all I could do to calm Al down and get him to drive on after the cop grudgingly backed off. Whether he knew it or not, however, my "yelling" probably spared him one or another of three unjust outcomes: A bogus traffic ticket; the price of a bribe; or false arrest and further abuse at the hands of uniformed thugs. (The same thugs, don't forget, who had been recently judged guilty of launching a "police riot" on anti-war protesters at the 1968 Democratic Convention.)

Don't get me wrong. Like Al, I respect and appreciate every good cop who performs his duty honestly. It's one of the toughest and most dangerous jobs imaginable, demanding immense courage and dedication. But this cop did not seem like one of the good ones. More like a bully drunk on power and out for a dishonest buck. I'd been hassled — and worse — by many of them.

At the risk of making myself look too good in retrospect, I prefer to recall my unseemly "yelling" and "hollering" as righteous wrath born of righteous outrage, expressed in righteous terms. And no big deal for a Chicago boy.

Think about it. Were the cop not in the wrong — and given my behavior as described by Al or even by me — would we really have been released on our merry way without so much as some lip-back by the cop? Best, Doug Moench

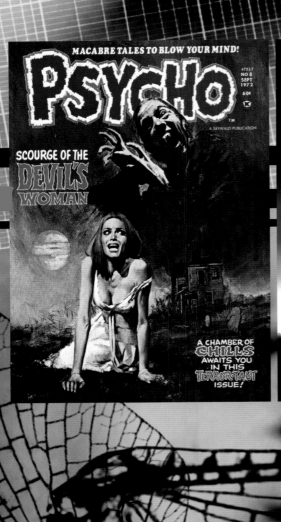

MACABRE TALES TO BLOW YOUR MIND!

PSYCHO

47357
NO 8
SEPT
1972
60¢

™

A SKYWALD PUBLICATION

SCOURGE OF THE
DEVIL'S
WOMAN

A CHAMBER OF
CHILLS
AWAITS YOU
IN THIS
TERROR-TAUT
ISSUE!

THE HUMAN GARGOYLES

CINTRON HEWETSON ARNDT

...A HORROR-

NIGHT

This is the
EVIL LUNATIC
THING
OF THE
PRINCESS
OF
EARTH!

A SKYWALD HOR

CONCLUDING THE HUMAN GARGOYLES

One of the best loved and most enduring strips to emerge from the Skywald Horror-Mood was The Human Gargoyles, a story concerning a stone family come to life and the normal life they try to lead while hounded by the authorities and the minions of Satan. The series ran for nine episodes across *Nightmare* and *Psycho*, and ended mid series when Skywald folded. Now the complete story is due to emerge in a brand new volume from supergggraphics, which features a revamp of the original Human Gargoyles series and an all new conclusion by original series artist Maelo Cintron together with new scripter Richard Arndt.

"Macabre" Maelo Cintron is one of the unsung heroes of the b&w horror comics boom of the 1970s. He utilises a combination of line work and wash, and as well as a key contributor to Skywald Maelo has worked over the years for *Famous Monsters of Filmland* (notably the cover for issue #140), produced many covers for the Star Trek line of paperbacks and *Castle of Frankenstein* magazine. He has also worked with the legendary Arthur Suydam for the now defunct *Penthouse Comix*.

"Archaic" Al Hewetson was the co-creator along with Maelo of the Human Gargoyles. Maelo was Al's favourite artist to work with and the only artist with whom Al co-plotted any stories.

Into this mix comes "Ravenous" Richard Arndt, a comics fan and author of short stories, non fiction and poetry, who is presently penning the conclusion to the original Gargoyles saga. Richard and Al worked closely together on the checklist and appendix for Headpress' *The Complete Illustrated History of the Skywald Horror-Mood*, and corresponded on a regular basis up to and including the day of Al's untimely death on January 6, 2004.

The idea for the resurrection of the Human Gargoyles originated in 2003, when both Al and Maelo made headways into a new story arc called *Gargoyle Justice*. But that project stalled and is unlikely to see the light of day following Al's passing.

"Grotesque" George E Warner, the entity known as superggraphics, rediscovered the Skywald line of magazines in October 2006, and contacted Maelo about the Gargoyles saga.

"No publication date has been set as of yet," George told Headpress of the superggraphics Human Gargoyles. "I am still restoring the original series art to print and send off to Maelo as he would like to retouch the original pages. The plot is finished and I believe all Skywald fans and comic fans not familiar with this material are going to be blown away! Plus I have ninety eight pages of new art and script to deal with along with some linking chapters." ∎

An Exhibition of Atrocities

J G Ballard talks about mondo films

News reporter turned film director, Gualtiero Jacopetti kick started the trend for outrageous documentaries — "shockumentaries," if you will — back in 1962 when he made *Mondo Cane*. MARK GOODALL talks to J G BALLARD, a fan, about *Mondo Cane*, its successors and its influence on his own work as a writer.

*"I was a great admirer of <u>Mondo Cane</u> and the two sequels, though if I remember they became more and more faked, though that was part of their charm. We, the 1960s audiences, needed the real and authentic (executions, flagellant processions, autopsies etc) and it didn't matter if they were faked — a more or less convincing simulation of the real was enough and even preferred. Also, the more tacky and obviously exploitative style appealed to an audience just waiting to be corrupted — the Vietnam news-reels on TV were authentically real, but that wasn't 'real' enough. Jacopetti filled an important gap in all sorts of ways — game playing was coming in. Also they were quite stylistically made and featured good photography, unlike some of the ghastly compilation atrocity footage I've been sent. It is lovely to think that he had his retrospective in a British university (as in <u>The Atrocity Exhibition</u>, which is not set in the US, as some think). ** *

"I think that Jacopetti was genuinely important, and opened a door into what some call postmodernism and I call boredom. Screen the

Overpowering, fascinating — often shocking!

LIFE says— "The season's most argued about film."

MONDO CANE

Produced by Gualtiero Jacopetti A TIMES FILM RELEASE

enter a hundred incredible worlds where the camera has never gone before!

* A Gualtiero Jacopetti retrospective occurred as part of the 2003 National Museum of Photography Film and Television's Bradford International Film Festival. The retrospective was collaboration between the festival and the department of postgraduate studies at the School of Art and Design, Bradford College.

JFK assassination enough times and the audience will laugh." – *J G Ballard*

MARK GOODALL: What were your initial impressions of the films of Gualtiero Jacopetti (*Mondo Cane, Mondo Cane 2, Women of the World, Africa Addio* etc.); where did you see them; what was the audience like?

J G BALLARD: I was very impressed by Jacopetti's films — I saw all of them from 1964 or so onwards — they were shown in small cinemas in the West End, and to full or more or less full houses, and my impression is that the audiences completely got the "point". As far as I remember, the response of the people sitting around me was strong and positive. I think there was comparatively little sex in the first *Mondo Cane*, and I can't recall even one dirty raincoat. The audience was the usual crew of rootless inner Londoners (the best audience in the world) drawn to an intriguing new phenomenon. At the time, some twenty years had gone by since the war's end, and everyone had seen the WWII newsreels — Belsen, corpses being bulldozed, dead Japanese on Pacific Islands and so on. All grimly real, but safely

Top: A Calabrian religious practice depicted in *Mondo Cane*. Above: Gualtiero Jacopetti at the press cnference for the Japanese release of *Mondo Candido*. Following images: *Mondo Pazzo* aka *Mondo Cane 2* and Beach lovelies in *Mondo Cane*.

STRANGER THAN MONDO CANE

Gualtiero Jacopetti

Franco prosperi

Jacopetti's New Shocker: "MONDO PAZZO"

distanced from the audiences by a sign that said "horrors of war." What the *Mondo Cane* audiences wanted was the horrors of peace, yes, but they also wanted to be reminded of their own complicity in the slightly dubious process of documenting these wayward examples of human misbehaviour. I may be wrong, but I think that the early *Mondo Cane* films concentrated on bizarre customs rather than horrors, though the gruesome content grew fairly rapidly, certainly in the imitator's films.

But the audiences were fully aware that they were collaborating with the films, and this explains why they weren't upset when what seemed to be faked sequences (they might have been real in fact) started to appear in the later films — there was almost the sense that they needed to appear "faked" to underline the audience's awareness of what was going on — both on screen and inside their own heads. We needed violence and violent imagery to drive the social (and political) revolution that was taking place in the mid 1960s — violence and sensation, more or less openly embraced, were pulling down the old temples. We needed our "tastes" to be corrupted — Jacopetti's films were part of an elective psychopathy that would change the world (so we hoped, naively). Incidentally, all this was missing from the way audiences (in the Curzon cinema I think) saw another 1960s shockumentary — *The Savage Eye* (directed by Joseph Strick) — when I saw it I, like the audience, shuddered but felt no complicity at all. A fine film.

MG: Can you recall any critical or other 'professional' reactions to Jacopetti's films when they were released?

JB: I remember the critical/respectable reaction to the Jacopetti films was uniformly hostile and dismissive. As always, this confirmed their originality and importance.

MG: Jacopetti has distanced himself from the films that later copied *Mondo Cane* labelling them "counterfeit". What were/are your impressions of the copies of his films?

JB: I can't remember any specific imitations, though I must have seen one or two. They were too obvious, ignoring the delicate balance between "documentary" footage on the one hand, and on the other the need to remind the audience of its role in watching the films, and that without its intrigued response the films wouldn't function at all. The balance between the "real" and the ironic simulation of the real had to be walked like a tightrope.

MG: How did mondo films influence your own work/ideas/thought processes (in particular *The Atrocity Exhibition*)?

JB: For me, the *Mondo Cane* films were an important key to what was going on in the media landscape of the 1960s, especially post the JFK assassination. Nothing

was true, and nothing was untrue (*The Atrocity Exhibition* tried to find a new sense in what had become a kind of morally virtual world) — "which lies are true?"

MG: What in your view was important about Jacopetti's films? Do you think the films have any relevance to the present day, or to the future?

JB: I suspect they're very much of their time, but that isn't a fault, necessarily. But there are many resonance's today as in the Bush/Blair war in Iraq — complete confusion of the simulated, the real and the unreal, and the acceptance of this by the electorate. Reality is constantly redefining itself, and the electorate/audience seems to like this — a Prime Minister, religiously sincere, lies to himself and we accept his self–delusions. There's a strong sense today that we prefer a partly fictionalised reality onto which we can map our own dreams and obsessions. The *Mondo Cane* films were among the first attempts to provide the collusive fictions that constitute reality today. Wartime propaganda, and the *Believe it or Not (Ripley)* comic strip of bizarre facts in the 1930s, were assumed to be largely true, but no one today thinks the same of the official information flowing out of Iraq — or out of 10 Downing Street and the Pentagon and significantly this doesn't unsettle us.

"An Exhibition of Atrocities: J G Ballard on Mondo Films" is taken from the book ***Sweet & Savage: The World Through the Shockumentary Film Lens*** by Mark Goodall. Published by Headpress
UK £9.99 / US $19.95
ISBN 1900486490
www.headpress.com

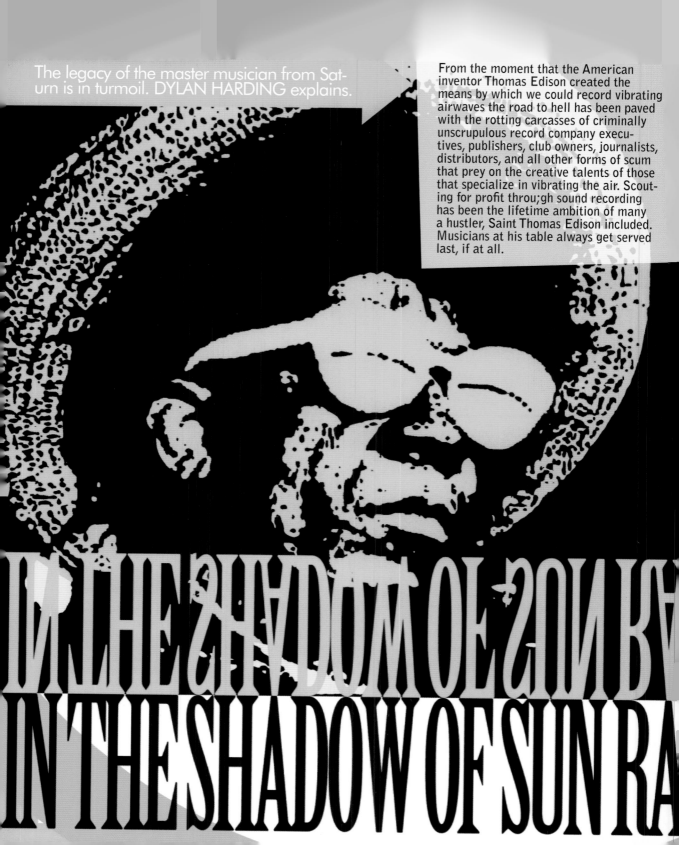

The legacy of the master musician from Saturn is in turmoil. DYLAN HARDING explains.

From the moment that the American inventor Thomas Edison created the means by which we could record vibrating airwaves the road to hell has been paved with the rotting carcasses of criminally unscrupulous record company executives, publishers, club owners, journalists, distributors, and all other forms of scum that prey on the creative talents of those that specialize in vibrating the air. Scouting for profit throu;gh sound recording has been the lifetime ambition of many a hustler, Saint Thomas Edison included. Musicians at his table always get served last, if at all.

IN THE SHADOW OF SUN RA

Musicians create music through the medium of sound and ideas; scientists invent the technology to record and detect those sounds; beings from the murky world of commerce take that union and turn it into a business. A business based on allowing us the privilege of hearing those sounds. Recorded sound and musical ideas become property and with all property it has an owner.

Edison (son of a Canadian), the Bill Gates of his time, perfected the gramophone in 1877. His intention was to sell them and get rich. Subsequently, having one has become all the rage. One of the side effects of his invention was that a viral epidemic of ale swilling English children from the 1940s, invaded their own bedrooms and with unbelievable names like John, Keith, or Brian, began to revive the learning of old forgotten American blues tunes from vinyl recordings. Without any guidance, except perhaps from brutish older boys, many drunken British children would spend hours alone in their cold musty piss sodden bedrooms, listening to and learning from spinning black disks that enchanted them significantly. This unsupervised disaster ultimately led to them congregating in rather large crowds; and as if gripped by a deranged fever, like being on drugs, they would in chorus, chant some hippy shit about peace and love. Apparently, we should refer to this Dark Age of learning as the Renaissance. Thankfully, this persistent fever was finally eradicated by medical science with a substance commonly known as Disco in the year 1977.

To keep myself at a safe distance from the above mentioned, I am writing this whilst my eye occasionally glances at a palm sized 80GB sound storage device. It is connected to the internet and potentially, therefore, an enormous supply of source material, which has through the magic of nerd power turned to digital information and is, at a cost, at my disposal. For no other reason than to expand my curiously small mind, I hope one day, to have access to every sound, film, television show, documentary, book, essay, poem, song, thesis, photograph, and painting ever created. As I type this my eardrum is vibrating to sounds created in the 1950s by Sun Ra (1914-93).

John Coltrane, Andre 3000, Frank Zappa, Cecil Taylor, Sylvester Stewart, and Charles Mingus all speak of Sun Ra's influence. Although acclaimed in the rest of the world, Sun Ra was, and is, little known in his country of birth the US. As with many American musicians ahead of their time, Sun Ra found his audience elsewhere. Music fans, particularly in Europe, not only found his musical freedom and experimentation fascinating, but also understood his showmanship as being in line with some of Europe's more daring avant garde artistic movements. When attending a Sun Ra concert, you would not watch a group of self absorbed free jazzers hoping to be revolutionary; you witnessed

a theatrical and musical masterpiece that was unlike anything else. Depending on the circumstances he may well have had up to sixty musicians on stage with him.

Although issued a birth certificate from the state of Alabama, Sun Ra's actual birthplace was the planet Saturn. At a time, when white America's fear of commies, invasion from outer space, and civil rights was at its highest point, being black and from another planet must have made some sit uncomfortably on the old rocking chair, as they looked upon the fading of their world. It is the classic, was he or was he not joking, double bluff.

Only a master trick-

ster like Sun Ra could pull off a lifetime of provocation intended, musical performance, which combined pedigree improvisers and Dadaist/vaudeville antics. If you did not get it then it was not his role to explain it to you. Although his name does not appear alongside Armstrong, Parker, Ellington, Davis or Coltrane in standard jazz histories as one of the greats, his place and influence as a musician, composer, educator, and performer, within the history of twentieth century American music should not be reduced to a footnote. The above mentioned gods knew of him, he was one of their own, and understood implicitly what he was playing at. They too could feel like beings from another planet, one road trip through the Deep South would ensure that.

Another eventual consequence of Edison's invention was to reduce the need to attend live music performance to hear music. Sun Ra's life was dedicated to keeping the core of his band working, the economics of running a big band, let alone one as outside the spheres as his, can only seem strange to any good citizen that has a regular job. Many of Ellington's international tours were funded by the State Department; he was considered a good will ambassador abroad, yet curiously enough, although a living genius was unable to attend some hotels at home due to having incorrect skin pigmentation. Finding paying work while sticking to your artistic principles is a financially risky pursuit. Sun Ra was so unique that fortunately his iconic status allowed his band to stay afloat, just.

When Lennon and McStarbucks would write a song it would be transcribed by an employee to sheet music, registered with their publisher, and ownership would be established. They would then share royalties according to whatever contract they had signed. This is a standard procedure that most song writers follow. However, what procedure do you follow if the driving force behind your musical output is to create musical improvisations based on sketches and loose instructions from a conductor or composer? Sun Ra worked and created in the latter scenario, and as a result, as could be expected, his estate is in disarray. An example of his instructions and sketches, taken from a 1985 work entitled "Manifesto – Purpose and Intent," is as follows: "*21st Century of sound. In a diverse dimension and derivative sub-tones and over-tones.*" This is followed with further "*musical indicators*" throughout the piece, such as, "*city in the clouds,*" "*love in outer space,*" "*bridge of the outer darkness.*" There is not a musical note in sight yet musicians could perform under his guidance.

I currently have in my group of friends a man that was a friend and confidant of Sun Ra. Haf-fa-Rool travelled alongside Sun Ra and his band for many years. He has witnessed first hand the life lived by musicians, brave and crazy enough, to follow in the shadow of Sun Ra. Musical improvisation is hazardous to the financial health of those that create it and equally so to those that inherit the rights to it. Haf-fa has been entrusted by Sun Ra to administer his legacy and he is currently doing this without financial recompense. Without the aid of music business lawyers he battles against a chaotic paper trail of dubious origin in an attempt to establish his rightful role. He has been doing this since 1993. Sun Ra's music is being played constantly all over the world, where the royalties for this are going is anyone's guess. Haf-fa would love this to be resolved, as income generated could be spent spreading the philosophical, intellectual, comic, and cosmic message of Sun Ra to new generations of music devotees. Perhaps, all it possibly will take is the generous help of a person with a little bit of expertise in music publishing. A few helpful hints and some simple guidance would possibly change this situation enormously.

It is saddening to see the legacy of one of music's true originals in such turmoil. Although many of us try to help Haf-fa when we can, we are all, first and foremost, musicians and worshipers of music and not experts on the ins and outs of music publishing royalties. Sun Ra has left us all better off by vibrating the airwaves in a way that only a being from Saturn can. It is a great shame that the fruit of his legacy and cultural creation, may possibly, wither on the vine. Strange fruit. Strange fruit indeed.

Help!

CULTURE Guide

A small selection of books, zines and comics reviewed by DAVID KEREKES and JOE SCOTT WILSON whilst wearing macramé plant hangers.

THE BEATLES FILM & TV CHRONICLE 1961-1970 / By Jörg Pieper & Volker Path

"Ringo recalls how he learned to play chess during the Pepper sessions."

There is no end of books mining the pit of Beatles lore. Every conceivable angle of the Fab Four's career, as well as family, friends, feuds, and places they visited, have been appraised and reconstituted for the better part of thirty years. And yet there is fresh Beatles minutiae from hitherto untapped veins making it into print on an almost weekly basis. All of this made me consider what reaction a budding author would receive if they applied such obsessive dedication to a lesser group, say Group 1850? What would happen if I got up and admitted to being an avid collector of Group 1850 ephemera and was determined to see it in print? I would probably be shunned as a total crank. Beatle fans are not shunned as cranks because everyone knows who the Beatles are and the world is full of Beatle fans. Yet books like *THE BEATLES FILM & TV CHRONICLE 1961-1970* are about as obsessive as it gets. A nicely produced hardback, it gives out precisely the information it claims it will, in staggering blow by blow detail. It starts with an entry on three minutes of silent 8mm footage of the Beatles performing at the Top Ten Club in Hamburg circa April–June 1961 (film that has never seen in public), through hundreds of newsreels (a few seconds duration much of it), up to the epic 580 minutes *Anthology* series that was aired around the world in 1996 and responsible for the biggest bidding war in TV history. Strangely enough, Premium, the publishers of *Film & TV Chronicle* have recently announced a book on — you guessed it — Group 1850. Ha ha ha, not really; my big joke!

UK £15 | 448pp | hbk | ISBN 9189136055 | Premium Publishing 2005 | Premium Publishing, Box 30 184, S-104 25 Stockholm, Sweden | www.premiumpublishing.com

BRUTARIAN QUARTERLY No 48/49

"Reality is sad to us because we don't get it."

Always a diverse collection of material to be had in *Brutarian*, and at only $4.95 a pop none of that fancy layout business, either. This most recent issue has an interview with Ramsey Campbell and a gaunt, amphetamine addict killer in a titty bar called Bobby. Mary Harron's *The Notorious Bettie Page* (2005) gets a slagging in the reviews section.

$4.95 | 88pp | Staplebound | Spring 2007 | Dom Salemi, 9405 Ulysses Cour, Burke, VA 22015, USA

BUBBLEGUM IS THE NAKED TRUTH: THE DARK HISTORY OF PREPUBESCENT POP, FROM THE BANANA SPLITS TO BRITNEY SPEARS / Edited by Kim Cooper & David Smay

"Never Mind the Bollocks, Here's the Banana Splits."

Bubblegum music is music that is catchy and remains catchy, and makes you smile. It is fitting that The Archies should be the band to open this book, as their hit Sugar Sugar is a classic bubblegum record. (As a child for a long time it was the only single I owned, and I played it to death one summer in

France I did, on a portable bright orange record player.) But while bubblegum music itself is bright and breezy, typically for a Feral House book there is nothing light here about the writing. *BUBBLEGUM IS THE NAKED TRUTH* provides lots of detail — fun, salacious and otherwise — courtesy a broad spectrum of respected pop cult type figures. After reading one contribution from cartoonist Peter Bagge, I was compelled to check out Hanson, the shaggy haired brothers from Tulsa, Oklahoma, who scored the number one bubblegum hit of the nineties, MmmBop, and whom Bagge claimed, live, "rocked like a motherfucker." Spotting Hanson's CD *Middle of Nowhere* in a charity shop, along with a tour disc video of theirs called *Tulsa, Tokyo and the Middle of Nowhere*, I was compelled to make a purchase. Both CD and video are lightly entertaining, and while I kind of understood what Bagge was on about, given that most bubblegum acts are manufactured and Hanson could actually play, I soon tired and felt disappointed (if not a little dirty in myself) for buying Hanson. I'm not disappointed in this book, however, which is hugely comprehensive and includes articles on Jonathan K and Gary Glitter, so too Mexigum, J-Pop, Strawberry Studios, The Partridge Family, Boyce & Hart, Eurovision, cereal box records, and plenty more. I don't bear grudges. Peter Bagge's long running comic series, THE BRADLEYS, collected and published by Fantagraphics, is still occasionally funny, whatever the fuck volume it's up to now. And Bagge has a letter printed in *Schizo*, which makes for a tenuous link to Ivan Brunetti's autobiographical comics, collected

...s of Ivan Brunetti's *Schizo*, published as *Misery Loves Comedy* by Fantagraphics.

and published by Fantagraphics as *MISERY LOVES COMEDY*. Brunetti's world stinks and his comics are a terrible burden on us all, if occasionally very funny. Jim Goad likes him, so that should serve as warning enough. [w] www.fantagraphics.com

US $19.95 | 328pp | pbk | ISBN 0922915695 | Feral House 2001 | www.feralhouse.com

CINEMA SEWER No 18 / Editor Robin Bougie

"The fact that it is set in a reformatory for girls is totally secondary to the plot."

Nobody makes zines like this anymore. That is, handwritten zines with murky hand-me-down ad mats several generations old (plus some original drawings and comic strips thrown in). *CINEMA SEWER* contains funny and educational coverage of exploitation movies and the people involved in their making. Never bowing to the strains of Political Correctness, No 18 (not the most recent issue) is devoted to Women In Prison flicks, a maligned genre about which editor Robin Bougie observes, "No critic walked out of the *Jurassic Park* movies and cried because palaeontology was being relegated to an inferior exploitation genre, so why do they always do it with WIP?" A great mag with great covers.

US $5 ppd in North America & $7 overseas (paypal available at mindseye100@hotmail.com) | 40pp | Staplebound | Robin Bougie, #320-440 E. 5th Ave., Vancouver, B.C., V5T-IN5, Canada

A COMMODITY CALLED SEX / By Various

"The victim becomes pornography. The selfish drive for satisfaction becomes paramount."

This is a book with no contact information and no ISBN number (books don't exist without an ISBN number), written by people without names. Even the handwritten note that accompanied this particular copy gives nothing away but an illegible signature. It's not difficult to understand why such an air of secrecy: *A COMMODITY CALLED SEX* is a masturbation fantasy — although I think "reaction fantasy" would be better suited —whose emphasis is coercion and underage girls, not a subject that inspires much sympathy within the public arena. In other words, a book for the people that have become jaded with Deep Throat and musicals scripted by Ben Elton. The pieces are relatively short; some of it observations, and some of it material compiled of news reports about rape, or lists of names (signposted: "Objects of fantasy for the purpose of masturbation..."). One piece involves a woman being raped in a pub Gents toilets whilst guys stand round filming it on their mobiles, and another purports to be an interview with a couple that organise bukkake events, some of which involve the physically

and mentally "retarded." The book presents all this without a moral stance (unless morals are fuel to the fantasy), because to do otherwise would be a weakness and these writers are not weak. They are strong. Stronger than girls almost of school leaving age. I considered the book's cold presentation and whether it had the potential to "groom" its readership into accepting the unacceptable, but then this is a ghost book found on obscure internet trails that are haunted only by people who know about such things: Its content is not likely to hold any surprises for its readership. The Net is where rules for grooming a child for abuse can be found (said rules having been downloaded and reprinted in this book), and the cloak of anonymity that the Net can provide makes the decision to put this material into hard print a telling one. Why would a person do such a thing, take the risk, if not for a belief in themselves as an artist, a writer, and their work deserving of a place on the bookshelf? It's a limited edition book, too, so it's "collectable." There is a mannered approach to much of the writing in *A Commodity Called Sex*; a clipped, sanitised, distancing style that is the predilection of those with nefarious tastes and inflated egos. They. They love it. Draw from cock pencil. Tits. Tits on babies. Bra-less. A fondness. For the work of Peter Sotos. Lollipop pisspots. Word-hurt specialists. They are. Anonymous. Writing down extremists.

288pp | pbk | Natural Basis Of Order 2005 | www.naturalbasisoforder.com (this website is no longer valid, but a search for "naturalbasisoforder" will present some information on this and other books by the publisher)

CULT TV: THE GOLDEN AGE OF ITC / By Robert Sellers. Introduction by Sir Roger Moore. Afterword by Gerry Anderson

"OK, what if we blow the moon out of orbit?"
"Fantastic — you're on."

Space 1999, The Prisoner, Jason King, Stingray, Thriller, Randall & Hopkirk (Deceased), Joe 90... For twenty five years ITC were responsible for a huge number of television shows that collectively almost define the term "cult TV." Unfortunately, the term carries with it a certain vapidity and authors on the subject of cult TV shows tend to write accordingly: Puff pieces for a readership bent on nostalgia. Not so Robert Sellers. His book *CULT TV* is an informed study of what made ITC great, enlisting many of its key players to help tell the story, with plenty of anecdotes, such as the one about Kenneth Cope, the "ghost" in *Randall & Hopkirk*, putting a lubricated condom inside Annette Andre's script. Andre takes the condom to a restaurant, fills it with water and asks a waiter to deliver it to Roger Moore under a silver salver. Moore, seated at a table in a meeting, in turn passes it to Peter Wyngarde, who is sat at the bar. And so on.

UK £14.99 US $19.95 | 288pp | pbk | ISBN 9780859653886 | Plexus 2006 | www.plexusbooks.com

DECADENCE! 300 YEARS OF JAPANESE FETISH ART / Edited by Carol Gnojewski & Davis Bromwell

"Two courtesans pleasuring themselves with sex toys."

"Japanese arts are lucky enough to boast a piece of history that chose to celebrate rather than repress the sex impulse."

So begins this brief illustrated tour, which encompasses *ukiyo-e* and *shunga*, two words I learned whilst touring: a wood block print and prints of an erotic nature, respectively. Topics in this slim, if attractive coffeetable art book include bestiality, tattoos, orgies, lovers and courtesans. I suppose any new volume would need to have Cosplay and that dodgy stuff I've been told about on the internet. Curiously, the press release for *DECADENCE* incorporates the word "lowbrow" in the title and cites the editor as one W Melvin Longfellow.

UK £17.99 US $24.95 | 88pp | hbk | ISBN 1560975652 | Fantagraphics Books 2004 | Fantagraphics Books, 7563 Lake City Way, Seattle, WA 98115, USA | www.fantagraphics.com

THE ENCYCLOPEDIA OF SWEDISH POGRESSIVE MUSIC 1967-1979: FROM PSYCHEDELIC EXPEIMENTS TO POLITICAL PROPAGANDA / By Tobias Petterson & Ulf Henningsson (editor)

"Mount Everest was formed in Gothenburg in 1971…"

Fuzz guitar groups through to experimental and festival bands, for over a decade progressive music flourished in Sweden. This book provides a document of that era and the 400 artists who were a part of it, courtesy of easy to navigate entries, discographies, record valuations and glorious full colour photos. This is not a book for the casual reader but one aimed squarely at the discerning music fan, social historian and persons from Sweden. And me. Comes with a CD by Baby Grandmothers, recorded live at the Filips café in Stockholm, shortly before the place was closed by police in 1967. "Usually, there weren't too many people left in the audience at this hour," recalls guitarist Kenny Håkansson.

No price | 238pp | hbk with CD | ISBN 9789189136229 | Premium Publishing 2007 | Premium Publishing, Box 30 184, S-104 25 Stockholm, Sweden | www.premiumpublishing.com

FROM THE TOMB No 21 / Edited by Peter Normanton

"A bubbling cauldron of something resembling an Oriental demon."

A celebration of horror comics past and present, but mostly past, *FROM THE TOMB* is a rare thing in the world of comics criticism: I like it. Written with genuine love and attention to detail (anything by Frank Motler carries with it a year's supply of source notes and references), No 21 is fairly typical in its extensive coverage of publishers, art and artists, as well as entertaining insight on the Collector Condition. Contents include a Maelo ("Human Gargoyles") Cintron interview [see p.133], Rich Corben's mini series *Edgar Allan Poe Haunt of Horror*, the nightmare visions of Terrance Lindall, whose work inspires comparisons with Bosch, and last but not least New English Library's all but forgotten *Dracula* bi-weekly comic. There is welcome coverage of British material, and the story of Alan Class in recent issues has been exemplary.

UK £4.95 US $7.95 (payable Peter Normanton | 72pp | staplebound | ISSN 1740-8550 | Soaring Penguin January 2007 | Peter Normanton, 619 Whitworth Road, Lower Healey, Rochdale, Lancs., OL12 0TB, UK | www.fromthetomb.co.uk

GUN IN MY FATHER'S HAND: SELECTED LYRICS 1977-2006 / By Billy Childish

"we live in a square world / we love with square girls / we all got square eyes / we live in a square high-rise"

You must know Billy Childish by now. He is the prolific, if reluctant, champion of garage rock for bands like the White Stripes and readers of the *Guardian Guide*. He has a catalogue in excess of 100 albums, from early days in The Pop Rivets through to The Musicians of the British Empire, and so if any songwriter is deserving of a book of selected lyrics then, you know, Billy Childish must be him.

UK £8.99 | 170pp | pbk | ISBN 1871894131 | The Aquarium 2006 | The Aquarium, 10 Woburn Walk, London, WC1H 0JL, UK | www.thequariumonline.co.uk

IS IT… UNCUT? No 21 / Editor Paul J Brown

"Sexy even with armpit hair."

Reviewing horror and exploitation films released to DVD and video, with international comparisons, *IS IT… UNCUT?* provides informed, bullshit free coverage of everything from independent dross (*Zombie Honeymoon*, 2004) to mainstream dross (*Death Wish II*, 1981), with a gem in between (*Lady in a Cage*, 1964). The Nigerian film *Agbako* (2000) sounds great to me, with its turn of the century special effects and moral conundrums.
Travelling to the other side of the pond (the USA) in search of more horror and exploitation film zines, we find that *PSYCHOTRONIC VIDEO* sadly appears to be no more. But thankfully we still have the wonderful *SHOCK CINEMA* from Steve Puchalski. No 32 has interviews with actor Ronny Cox (*Deliverance*, *RoboCop*) and film editor Bud Smith (*The Exorcist*, *Sorcerer*). [w] www.shockingcinemamagazine.com *ULTRA VIOLENT* No 7 is 100 pages of articles and interviews with the old and the new, including Ed Adlum (*Invasion of the Blood Farmers*), Gasper Noé (*Irreversible*), and *The Redsin Tower* (aka *My Second Rape*, from August Underground films)… [w] www.uvmagazine.com

UK £6.95 US $12 | 56pp | staplebound | Midnight Media 2006 | Midnight

Images this page and next, taken from *The Encyclopedia Of Swedish Pogressive Music 1967-1979*, published by Premium.

Media, Ringstead Business Centre, 1-3 Spencer Street, Ringstead, Northants, NN14 4BX, UK | www.midnight-media.demon.co.uk

NIGHTMARE USA: THE UNTOLD STORY OF THE EXPLOITATION INDEPENDENTS/ By Stephen Thrower

"Shockwaves into Love and Madness."

As brilliant as it is big and beautifully illustrated, *NIGHTMARE USA* is a book that positively drools with its passion for a type of movie that few right minded people would give two hoots about: low budget exploitation schlock made in America in the years 1970 to 1985. Not only does it cover in depth 175 of these films, it also provides lengthy interviews with a number of their directors. Some of the films fall into the favoured categories of gore and sleaze, but there are many others from this, cinema's Tin Age, that defy categorisation completely; the product of minds that knew not what they were doing and lacked the resources to do it. The cool and the cult are here alongside ultra obscurities such as *Victims* (Daniel DiSomma, 1977), *Another Son of Sam* (Dave A Adams, 1977) and *Madame Zenobia* (Eduardo Cemano, 1973). I read for the first time about Chester N Turner's *Black Devil Doll From Hell* (1984) back in Herb Schrader's early photocopied zine *Video Drive-In!* Since then I have encountered references to the film elsewhere perhaps only twice. The film is described in this book as the second most inept movie ever to be shot direct to video, and its director an elusive figure who has at least one other movie to his name (*Tales from the Quadead Zone*, 1987). For the *Black Devil Doll*s of this world and for directors like Frederick Friedel, Robert Endelson, Don Jones, and Irv and Wayne Berwick, speaking at length about their work, some for the first time, this book stands high as a landmark piece of work. Author Stephen Thrower, a regular in the pages of the late *Shock Xpress* and editor of *Eyeball*, is a meticulous and diligent researcher who divests a ton of fresh information on films that once were unknown beyond the capsule comments of self published zinesters. The first volume in a proposed two volume set, *Nightmare USA* is the book of the year.

£39.99 | 528pp | hbk | ISBN 1903254469 | FAB Press 2007 | FAB Press, 7 Farleigh, Ramsden Road, Godalming, Surrey, GU7 1QE, UK www.fabpress.com

NO HOPE No 4 / By Jason Dean

"Giant Willy Slide."

Writer and artist Jason Dean describes *NO HOPE* as a "crude, offensive, puerile, unfunny, unoriginal, piece of crap." This fourth issue certainly qualifies as that, but, as in the case of *Viz*, with which *No Hope* bears some resemblance, it isn't necessarily a bad thing. Plenty of references to shit, snot and genitalia, and Dean takes some vile liberties with Roger Hargreaves' *Mr Men*, but I Hate Daniel Butler, a lengthy autobiographical strip, and The Horrific Filmography Of Freddy Valentine, an account of a fictional actor and his fictional films, hint at something more complex in Dean's future work.

UK £1.50 (incs p&p; payable Jason Dean) | 48pp | staplebound | Dead Dog Press 2007 | Jason Dean, 5 St Dials Road, Old Cwmbran, Cwmbran, Gwent, NP44 3AN, UK | deanjason143@aol.com

PURE INSANITY No 12 / Edited by Tom Brinkmann

"Special op art issue."

Tom Brinkmann is author of *Bad Mags* [see p.***]. In the meantime he publishes several extremely limited artzines, of which *PURE INSANITY* is but one (the copy under review is numbered five of fifty). This issue features the work of different artists (each work a full page with no text), but earlier editions feature only Tom's fierce b&w kaleidoscopic mutations, betraying a certain Haight Ashbury influence. Tom's other artzines, many one shots, include *Ordered Chaos*, *Zibdap Rebop*, and more recently *Brinkmann's Oddities*, which is limited to twenty five signed and numbered copies.
Zene S Clough provides hallucinatory art that is light and loose in issues No 3 and 4 of his self published zine *PETSTATIC*, while back in No 2 it is dark and heavy. I prefer the latter, with its dense cross hatching and tenuous approximations of a narrative. [w] www.zumcomics.info/petstatic/index.html

No price | 10pp | staplebound | Tom Brinkmann December 2006 | write to Tom for details c/o his Bad Mags website www.badmagss.com

THEY CAME AS THEY WENT AND OTHER SEXUAL DISASTERS / By Pat Sheil

"Michael Hutchence in happier days."

John Wayne Bobbitt and Conservative politicians, Catherine the Great of Russia and impotence, these are part and parcel of the sexual disasters discussed in this bit of silliness by Pat Sheil, who writes with punch and humour. Throwaway for sure, but will raise a smile if not your cock. *THEY CAME AS THEY WENT* is edited by Chris Mikul, who also plays dead on the cover, and so happens to be editor of the always excellent zine *BIZARRISM*, the latest edition of which (No 9) has articles on dictator Papa Doc and William Seabrook, who is "almost forgotten today but once one of the most famous writers in the world." [w] www.bizarrism.com

UK £5.95 | 14pp | pbk | ISBN 1871204240 | Comerford & Miller 2005 | Comerford & Miller, 36 Grosvenor Road, West Wickham, Kent, BR4 9PY, UK

WITCHCRAFT THROUGH THE AGES: THE STORY OF HÄXAN, THE WORLD'S STRANGEST FILM, AND THE MAN WHO MADE IT / By Jack Stevenson

"After that opinion divided sharply."

Jack Stevenson's name is a trademark of quality in the world of film writing. Any book or article that carries it will be a thoroughly researched document offering hitherto unknown facts and a compelling critique on the subject in hand. This latest endeavour is no exception. It is an amazing chronicle of the career of Danish film director Benjamin Christensen and his contentious 1922 film *Häxan*, from inception and creation, through to its revival by Anthony Balch and William Burroughs as an arthouse oddity in the late 1960s.
Another title in the FAB Press Cinema Classics Collection series is *A VIOLENT PROFESSIONAL: THE FILMS OF LUCIANO ROSSI* by Kier-La Janisse, a cool, full colour tribute to a face familiar to fans of Italian movies of the sixties and seventies — *Violent Naples* (1976), *Django The Bastard* (1969) and *Death Smiles On A Murderer* (1973) being just three of them.

UK £6.99 US $11.95 | 128pp | pbk | ISBN 1903254426 | FAB Press 2006 | FAB Press, 7 Farleigh, Ramsden Road, Godalming, Surrey, GU7 1QE, UK www.fabpress.com

More reviews can be found on the Headpress website and in the book *Headpress Guide to the CounterCulture* [w] www.headpress.com

YONAPONDA : jeune hybride, il saute de
cumulus en nimbus, pour le seul plaisir du jeu.

ZENICTONOME : sentinelle depuis des lunes
il observe attentivement les mouvements du hasard

l'abécé daire chime- rique

by Progeas Didier